Afterall Autumn 2010
A Journal of Art,
Context and Enquiry

Foreword

— Pablo Lafuente

The notion of authenticity doesn't have much critical currency today, neither in art nor in politics. It is true that claims to authenticity are often made in relation to artists' work, in discussions of citizenship and nationality and in connection with ethical issues in general. Such claims are one of the basic mechanisms through which the art system creates and maintains its value, and they further fuel institutional arguments and sometimes policies. But, associated with essentialist positions and dogmatic approaches, with closing down critique rather than opening up to it, authenticity doesn't appear the argument of choice when defending artistic or political practices that prioritise equality, critique, enquiry or change.

This wasn't always the case. While Theodor Adorno dismissed the jargon of authenticity in 1964 — in existentialism in general and Martin Heidegger's writing in particular — as complicit with fascism,[1] before this rejection, and before the use of authenticity by Heidegger, Jean-Paul Sartre, Albert Camus and earlier Søren Kierkegaard, the concept was discussed by Montesquieu and Jean-Jacques Rousseau. And just a few years after Adorno's dismissal, Marshall Berman tried to bring back that discussion, and through it to recuperate what he identified as a key emancipatory tool. Berman traced in his book *The Politics of Authenticity: Radical Individualism and the Emergence of Modern Society* (1970) the emergence of the notion of authenticity in the work of those two early thinkers of the new, modern world, through the basic thesis that the search for authenticity is, in modern times, 'bound up with a radical rejection of things as they are', that 'the social and political structures men live in are keeping the self stifled, chained down, locked up'.[2] The notion of the authentic in relation to the self, Berman writes, serves as a trigger for a critique of a status quo that is systematically unequal and for an impulse to disrupt, change or transform unjust social structures. Seen in this way, authenticity is arguably at the origin of every ideological construction that has proposed reform or revolution and, on this basis, at the core of the history of political emancipation for the last 300 years.

Authenticity, as Berman finds it in Montesquieu and Rousseau, is a response to the new climate of modernity — a climate that 'threatens the tree of man with mutilation or destruction' but that at the same time 'holds out a promise of unprecedented fruitfulness'.[3] This response is not a rejection of the modern in favour of a pre-modern human nature, but an embrace of the complexities of modernity that cannot but reflect them through a series of tensions and contradictions. A few years later Berman offered a detailed and captivating book-length elaboration on how this modernity is experienced, in *All That Is Solid Melts into Air* (1982):

> to be modern ... is to experience personal and social life as a maelstrom, to find one's world and oneself in perpetual disintegration and renewal, trouble and anguish, ambiguity and contradiction: to be part of a universe in which all that is solid melts into air.[4]

The 'melting' of the title is then the result of a dynamic process of creation and destruction within which the individual can never find a stable position. In the face of this situation —

1 See Theodor W. Adorno, *The Jargon of Authenticity* (trans. Knut Tarnowski and Frederic Will), London: Routledge & Kegan Paul, 1973.
2 Marshall Berman, *The Politics of Authenticity: Radical Individualism and the Emergence of Modern Society*, London and New York, Verso, 2009, p.xxvii.
3 *Ibid.*, p.168.
4 M. Berman, *All That Is Solid Melts into Air: The Experience of Modernity*, London and New York: Verso, 1983, pp.345—46.

and if we conflate Berman's two books — to be modern is to be authentic, where this means being able to change and also to resist, to embrace and take advantage of the creative force of modernity and to fight against being annihilated by it.

In the editorial meeting in early spring 2009 that shaped this issue of *Afterall*, we pictured today's situation in quite different terms from Berman's: we also shared at that time the impression that all that was solid had melted, but that melting we saw as a blurring of differences and a loss of horizons and certainties. After the end in 1989 of Real Socialism as an alternative to the liberal capitalist system, and with the collapse of that system as it became apparent almost two decades later in the autumn of 2008, a certain void of power opened up, one that made it hard to find referents — either positive or negative. This conversation was partly triggered by Afterall's involvement in FORMER WEST, a research, education, publishing and exhibition project that aims to reflect upon the changes affecting the world, and within it the so-called West, since 1989.[5] But reading, a year, later the essays we commissioned as a follow up to that discussion — after several debt crises, widespread austerity measures and some changes of government — that impression has vanished. Certainly Berman's rhetorical ability is partly to blame for this change in perspective, but the 'softness', the blurring we discussed in our editorial meeting has dissipated and instead what comes across is a brutal, partial dialectic of modernity, in which movements of creation have been anaesthetised, and only the destructive impulse remains.

From that frame of reference, the selection of artists and issues that we have gathered here offer less some means of orientation in a pervading fog and rather a series of strategies for resisting the destructive impulses coming from a market that has slipped out of any past reins or from a politics that not only exerts control but also a raw violence. In relation to these two sources of destructive impulses, a distinction may be made between the four artists featured. The work by two of the artists — Judith Hopf and Zoe Leonard — can be seen to focus on exposing the homogenising force of the neoliberal market, and its undoing of communities like those established in Berlin in the 1990s or New York's Lower East Side in the 1980s. In this, they could be said to be re-enacting the struggle for New York City during the 1950s and 60s that Berman recounts in *All That Is Solid Melts into Air*: that between the city of cars, highways, tunnels and flyovers as associated with Robert Moses and the city of neighbourhoods and communities that Jane Jacobs championed in *The Death and Life of Great American Cities* (1961).

The work of Rabih Mroué and Želimir Žilnik, by contrast, seems to stem from a focus on the other factor: the destructive violence of politics. They show how, as a result of Lebanon's civil conflicts (Mroué) and of the social structures in former Yugoslavia and Germany (Žilnik), a local system of positions, roles and hierarchies is established in a manner that forces the individual inhabiting these societies into very specific modes of visibility, or even disappearance. But the destructive force of the market also appears in their work, as does that of politics in Hopf's and Leonard's.

In the end, what these projects suggest is that a rearrangement of the social body might be necessary in order to make possible the emergence of forms of individuality that are emancipatory. However, even in the current circumstances, it is possible to perhaps give shape to such forms, through the appropriation and collaging of visual and linguistic forms (as shown by Karl Holmqvist in his performances or his 2009 book *What's My Name?*, also discussed in this issue) or through the positing of an I that is perhaps fictional, perhaps not (as stressed by Mroué in his recent exhibition at BAK, Utrecht, titled 'Rabih Mroué: I, the Undersigned').[6]

That said, it would be imprudent to leave the argument here, for it would be wrong to conclude that the project of emancipation can only be conducted through the sheltering and development of the figure of the individual. The relationship between the individual and the collective is key to the development of the modern project, and the emergence of the mass as a political subject is perhaps as important for this project as the notion of authenticity is according to Berman. The emergence of the urban world he pictures in his 1982 book brings with it the emergence of a new type of politics, allowed, simply, by a mass

5 As part of this involvement, Afterall will be publishing for the next three years a series of texts in the journal and in Afterall Online elaborating on the motifs and findings of the project. For more information on FORMER WEST, see http://www.formerwest.org/ (last accessed on 31 August 2010).
6 'Rabih Mroué: I, the Undersigned', BAK - basis voor actuele kunst, Utrecht, 21 May—1 July 2010.

of people coming together in the same place at the same time. At least since John Locke, political theory, and later sociology, has insisted on characterising that mass in terms of irrationality, disorder, lack of discipline and even criminality.[7] But Elias Canetti's crowd, or Gustave Le Bon and Gabriel Tarde's *foule*, even if necessarily short-lived, impulsive, paranoid, driven by emotions and in constant need of discharge, is also the modern political subject — one that comes together in a specific context and as a response to a specific situation, in order to actually change it.[8] The crowd is one of the few instances in which differences disappear, and, as Canetti writes in *Crowds and Power* (1960), within it, at a certain point, all who are part of it feel equal.[9]

The two contextual essays printed in this issue discuss examples of group activity that show how this collective political subject can form and operate. Marion von Osten's essay on the 'project exhibition' examines new forms of interdisciplinary exhibition practice that consolidated during the 1990s and which might shift our understanding of work within the artistic and, by extension, cultural arena.[10] That moment of equality that Canetti points towards is perhaps most radically present in the essay that opens this issue, in which Ana Longoni examines the visual strategies adopted by the Mothers of the Plaza de Mayo and other human rights groups in Argentina in their fight to raise awareness about the crimes committed by the dictatorship in power during the 1970s and early 80s, and to reclaim the return of those who had disappeared during those years. The activist groups that emerged during that time and which continued once a democratic system was reinstated — a system that for many years failed to recognise the crimes of the military regime — were formed as a response to a political system of annihilation of dissent or resistance. The Mothers and those around them reactivated that resistance through visual strategies that encapsulated the modern tension between the recognition of the individual (the missing person, through the passport or family photograph) and his or her incorporation within the mass acting together as a body of political significance. In their actions, the Mothers embraced that ideal of authenticity that, as Berman writes, articulates men and women's 'deepest responses to the modern world and their most intense hopes for a new life in it'.[11]

7 Louis Chevalier, in *Classes laborieuses et classes dangereuses à Paris pendant la moitié du XIX siècle* (Paris: Editions Perrin, 1958), maintains that there is such a similarity between the dangerous classes and the working classes that it is difficult to tell them apart.
8 See Elias Canetti, *Crowds and Power* (trans. Carol Stewart), New York: Farrar, Straus and Giroux, 1984; Gustave Le Bon, *Psychologie des foules*, Paris: Quadrige/Presses Universitaires de France, 1963; and Gabriel Tarde, *L'Opinion et la foule*, Paris: Éditions du Sandre, 2008.
9 E. Canetti, *Crowds and Power*, *op. cit.*, p.17.
10 This essay is also the first of the series of texts that Afterall will be commissioning during the next three years as a contribution to the FORMER WEST project.
11 M. Berman, *The Politics of Authenticity*, *op. cit.*, p.312.

Photographs and Silhouettes: Visual Politics in the Human Rights Movement of Argentina

— Ana Longoni

'They wanted to be seen. It was an obsession. [...] They realised that their own image as mothers was, in its own way, imposing a different reality.'[1] This quote is taken from the comprehensive history of the Mothers of the Plaza de Mayo, an association of mothers that formed in 1977 to draw awareness to the disappearance of their sons and daughters during the Argentinian dictatorship of 1976–83.[2] The excerpt, from a history of the movement by Ulises Gorini, makes explicit how crucial the visual dimension was to their strategy from the outset — that is, the production of symbols that would identify and unite the Mothers as a group, and at the same time grant them the visibility to appeal to other families whose relatives had also disappeared, to Argentinean society and to the international community. The quote also signals the distinct will and awareness that were put into play when it came to conceiving these symbolic resources of visibility. In the midst of the 'concentrationary' terror,[3] during which the state's terrorism established nearly 500 repression and extermination centres, where about 30,000 people disappeared — and even before a collective name had been assumed for the group — the first Mothers recognised each other by carrying a carpenter's nail in their hand. Soon afterwards, they started wearing the white headscarves that became their emblem. Later, they started embroidering these headscarves with the names of their loved ones and the fateful dates of their disappearance.

Among the different creative strategies developed by the Mothers and other relatives within the human rights movement under the dictatorship, we can identify and compare two matrixes in the visual representations of the disappeared: on the one hand, the photographs; and on the other hand, the silhouettes, outlines of hands and masks.[4] These matrixes emerged (almost) in parallel, and each possesses a long history that I will try to summarise here without setting them in opposition to each other. Instead I will focus on the meanings mobilised by their different resources and modes of symbolic production, and will try to recover the historical coordinates in which these visual elements gained the status of signs that, both inside and outside Argentina, refer unequivocally to the disappeared — as they have now become, for many people, 'part of a universal symbolic language'.[5]

Ana Longoni looks at the aesthetic implications of the visual strategies of the Mothers of the Plaza de Mayo, in their protests and remembrances of those who disappeared under the Argentinian dictatorship of the 1970s and 80s.

Photographs

The Mothers first took recourse to photographs to represent the disappeared in the early days of the dictatorship, when they visited police stations, hospitals, government offices

1 Ulises Gorini, *La rebelión de las Madres*, vol.1, Buenos Aires: Norma, 2006, p.117.
2 This military dictatorship, which called itself the 'Process of National Reorganisation', carried out the selective killing of their political opponents.
3 This is a direct translation of the term *'concentracionario'*, which Pilar Calveiro uses to refer to the paralysis that took hold of Argentinean society when state terrorism was activated, spreading its semi-clandestine activity well beyond the nearly five-hundred concentration camps where thousands of people disappeared. See Pilar Calveiro, *Poder y desaparición*, Buenos Aires: Colihue, 1997.
4 In Ana Amado's words, 'the relatives of the victims of the genocidal dictatorship made use of creative forms of expression in their public interventions in order to combine agitation and denunciation of the crimes with intimate images of pain and the work of mourning'. Ana Amado, 'Órdenes de la memoria y desórdenes de la ficción', in A. Amado and Nora Domínguez, *Lazos de familia*, Buenos Aires: Paidós, 2004, p.43.
5 Victoria Langland, 'Fotografía y memoria', in Elizabeth Jelin and Ana Longoni (ed.), *Escrituras, imágenes y escenarios ante la represión*, Madrid: Siglo XXI Editores, 2005, p.88.

and churches searching in vain for news of their sons and daughters. In these quests the Mothers capitalised on the function that photography has performed for over a century within the family realm — that is, to document family life — while also using photography as many have done in the spontaneous search for any lost person.

Very soon after their formation, the Mothers made small posters with these photographs, wearing them on their bodies or holding them up as they demonstrated around the Plaza de Mayo or on their visits to officials. In this way, the Mothers inaugurated a prolific genealogy for the public use of photography in the struggle of the human rights movement against the official denial of the killings. These images of the disappeared reaffirmed the existence of a biography that predated these subjects' kidnapping, an existence that was categorically negated by the regime. Those who disappeared had names, faces, identities, as well as families who were looking for them and reclaiming their appearance. The photographs (usually an individual portrait) possessed a proof value — they are 'that minimal proof of existence in the face of a growing incertitude'.[6] Paraphrasing Roland Barthes's famous proposition, the photograph declares *that this was, this took place: this person existed*.[7] As Nelly Richard points out, 'if the photographic apparatus contains this temporal ambiguity of what *still is* and what *no longer is* (of that which is suspended between life and death, between appearing and disappearing), such ambiguity gets over-dramatised in the case of the photographic portrait of the disappeared'.[8]

In their use by the Mothers, these images departed from their intimate use as family remembrances and moved towards mass exhibition in a public space. In that shift, each individual image left behind 'its private rituality to become an active instrument of public protest'.[9] The photographs of the faces became a collective sign, each one of those traces of a singular life metonymically representing all of the disappeared. The shift from intimate to public use began with the Mothers' decision — at the beginning of their organisation, during a still spontaneous and decentralised stage — to wear the photographs of their beloveds on their bodies during the demonstrations, thus denoting the strength of the family tie that linked the missing with the one wearing his or her portrait. The photograph also condensed in an image the reason for the Mothers' being there, and (re)generated the bond between those who dared to demonstrate in the midst of terror.[10]

In April 1983, the parents of a disappeared young woman, two committed human rights activists who had a small photography laboratory at home, came up with an idea, a mammoth task that they undertook and financed on their own:[11] to gather all the photographs of the disappeared, to blow them up to a considerable size (70 by 50 centimetres) and to mount them on cardboard over a T-shaped wooden plank for public viewing. Taken on by the Mothers, this simple procedure turned each photograph into a placard, onto which they wrote the name and the date of the kidnapping and sometimes information about the person's profession. In some cases, the information pertained to the person's family — for instance, that someone was the 'mother of two babies'. Other photographs had no information printed on them. In a few cases, the placards were made up of a collage of several photographs: individual pictures of a couple and their children, all of whom were missing.

This idea initiated a crucial moment: the photographs were removed from the intimate (familiar) body in order to become a collective device. The photographs were literally raised to a height from which they could possibly address and interpellate an even larger number of people. Moreover, a *collectivisation* of the resources for exhibiting the photographs took place. For, from then on, both the production and the carrying of placards in demonstrations extended beyond the personal circle of the victims who were represented

6 Jean-Louis Déotte, 'El arte en la época de la desaparición', in Nelly Richard (ed.), *Políticas y estéticas de la memoria*, Santiago de Chile: Cuarto Propio, 2006, p.156.
7 See Roland Barthes, *Camera Lucida* (trans. Richard Howard), New York: Hill and Wang, 1981.
8 N. Richard, 'Imagen-recuerdo y borraduras', in N. Richard (ed.), *Políticas y estéticas de la memoria*, *op. cit.*, p.166.
9 *Ibid.*, p.168.
10 Nora de Cortiñas, a mother from the Plaza de Mayo recalls: 'When we first began carrying a photograph with a name on the marches, we found that lots of friends of our children came up to us, they were not even aware that they had disappeared. [...] This is because their friends used nicknames to refer to them, so it was only when they saw the photograph with the real name that they found out. [...] That's how they identified us, they knew then "that is the mother of such and such boy or girl".' Unpublished interview with Nora de Cortiñas by Cora Gamarnik, Buenos Aires, 2009.
11 They were Santiago Mellibovsky and Matilde Saidler de Mellibovsky, whose daughter Graciela, a young economist, had disappeared in 1976.

in them. This shift had two important consequences. The first was a practical one: the production of a more-or-less centralised archive of photographs of the disappeared. The second was the definition of a visual politics: the sharp awareness of the impact that these faces — as they march among the crowd, or rather, above it — would have on the viewers.

Provenances

The photographs the Mothers marched with were either photographs taken from family albums or blown-up versions of photographs from national identity or institutional cards. These two provenances have given rise to contrasting readings of the images. The photographs taken from family albums showed happy individuals in the midst of highlights in family histories (a wedding, a birthday, a holiday trip, the birth of a child, the beginning of a courtship, a friends' gathering, etc.). When they were chosen, they not only signalled the family ties that linked victims to those who demanded their reappearance, but also gave a glimpse of what had been a domestic order, before it was shattered by the violence of the state. As Richard has pointed out, in these photographs 'the latent tension between the past carelessness of the face that remains unaware of the imminent drama at the moment when the photograph was taken, and the present time from which we look tragically at the picture of someone who has subsequently become a victim of history, generates the desperate *punctum* that makes these photographs from the album of the disappeared so moving'.[12] On the other hand, she points out that those images taken from official documents isolate the missing person's identity, blurring his or her personal ties and placing him or her in an impersonal register.[13] While family photographs show a person protected by the preserved atmosphere of his or her private life, images with a bureaucratic origin show bodies that have been forcefully and unwillingly exposed to the violence of the state machinery. These photographs, says Richard, are evidence of the way individuals had been numbered, registered and pre-judged by the mechanism of the state apparatus before, during and after the dictatorship. In them, she finds 'a matrix for the mass production of death that makes the subject "disappear" by deleting everything unique that he or she possesses (his or her life, face, name), making it identical to that which is repeated and standardised about the undocumented crowd of No Names'.[14] Therefore, 'the faces of the arrested-disappeared [...] have stamped on them the subjectification to the photographic and bodily apparatuses of social control that, after identifying and watching them, erased all traces of identification so that violence could not leave a trace of material execution nor authorship'.[15]

In their use by the Mothers, the photographs departed from their intimate use as family remembrances and moved towards mass exhibition in a public space. In that shift, each individual image left behind 'its private rituality to become an active instrument of public protest'.

However, I believe that when the Mothers and other relatives chose those photographs they subverted them, distancing them from their origins in state bureaucracy. This has the unexpected effect of interpolating the very state that ordered the disappearances, for it was the same state that had earlier fulfilled an identifying function, registering those individuals whose disappearance was later arranged and whose existence was now denied. The fact that the relatives used those photographs as evidence served to reveal and dramatise the paradoxical overlap between the state's control machinery and the state's machinery for the extermination and disappearance of its subjects, between identification and destruction, control and denial.[16] In this sense, the identity photographs belonging to

12 N. Richard, 'Imagen-recuerdo y borraduras', *op. cit.*, p.168.
13 'De-individualisation is a feature both of legal photography and social repression.', *Ibid.*, p.166.
14 *Ibid.*, p.167. Translator's note: The original uses the expression 'N.N.', as standing for the Latin *Nomen nescio* or 'name unknown'. In Latin America 'N.N.' is often used to refer to the nameless victims of dictatorial regimes.
15 *Ibid.*, pp.166—67.
16 This paradoxical logic was present as well inside the Argentinean concentration camps, where they carried on systematically photographing the prisoners and registering their confessions in writing (confessions that had been obtained by torture) in spite of the fact that the camps were illegal and clandestine. One can get a sense of this from the handful of secret documents that escaped the destruction of the archives ordered by the dictatorship before it withdrew from power.

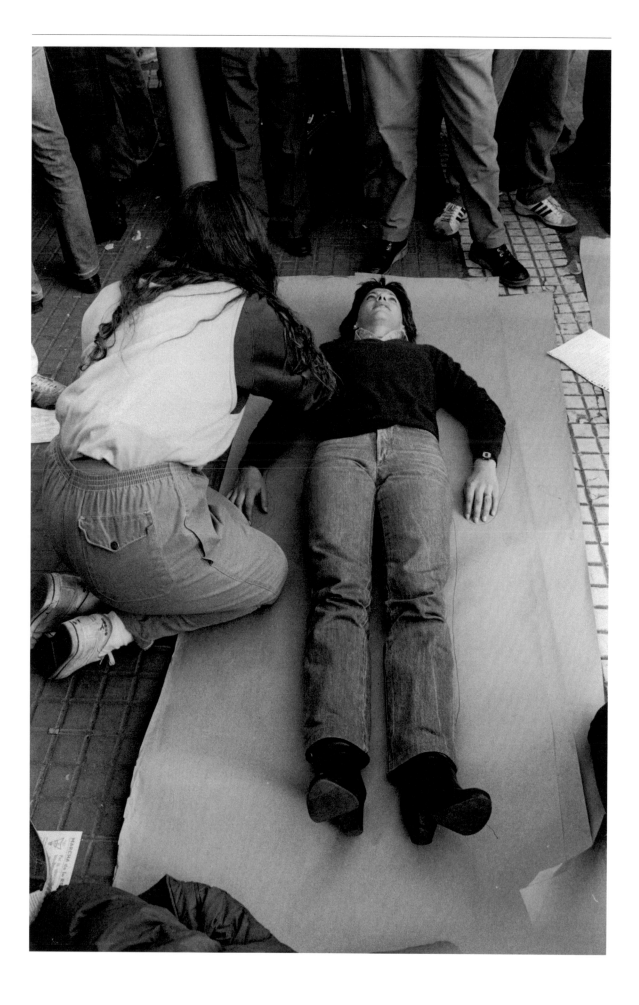

the disappeared 'resignified the traditional uses of the type of photography that had been introduced in the country in the 1880s in order to identify criminals, which was later extended to the totality of citizens'.[17] Moreover, they contained 'a rare probative principle, characteristic of photography, of the "document" that bears witness, certifies and ratifies the existence of that individual'.[18] On the other hand, in some cases, it was not possible to choose which photographs would be used. Those photographs were the only ones the family had kept, due to the destruction and plundering of the raids on their homes, or to the fact that the undercover life of many militants in the years that led up to their disappearance had prevented the photographic register of their everyday lives. Thanks to the wide public circulation of these photographs, thousands of black-and-white portraits of generally young men and women, sometimes with recognisable features of the time (certain clothes, make-up or hairstyles — in particular, moustaches), have become clearly identifiable symbols. We might not remember most of the names, we might remain unaware of specific biographies, but in certain contexts those faces take us inexorably back to a historical time, to a feat and to a tragedy.

The Silhouettes

While some Latin American exiles used silhouettes in Europe at an earlier date in order to denounce the dictatorships' atrocities, the widespread use of life-size silhouettes to represent the disappeared can be traced back to the events of 21 September 1983, still under the dictatorship, in what has come to be known as the *Siluetazo*.[19] Within the hostile and repressive atmosphere of that time, a (temporary) space for collective creation was liberated — something that can be thought of as a redefinition of artistic and political practices. The *Siluetazo* was an event in the fullest sense of the word: an exceptional moment in history in which artistic initiative coincided with demand coming out of social movements, and which gained momentum thanks to the support of a multitude. The protest involved a vast, improvised, outdoor workshop that lasted until well past midnight, in which demonstrators lay down in the Plaza de Mayo, offering their bodies for others to trace and outline. The resulting silhouettes were pasted onto walls, monuments and trees, despite the threatening police presence that surrounded the participants.

The making of these silhouettes reclaimed a simple technique used to teach children to draw — the simple tracing onto paper of the empty shape of the human body. These were later fly-posted throughout the city centre as a way of representing 'the presence of an absence'. As the silhouettes were left on street walls after the demonstration had finished, those who were missing acquired a public presence, until the dictatorship made them disappear again. The key to this gesture is quantification: pointing to the empty space that the 30,000 absent bodies left among us.[20] Moreover, the silhouettes articulate a visual apparatus that returns representation to that which has been negated, hidden or forced to disappear. Eduardo Grüner conceives of the silhouettes as *attempts to represent* the disappeared:

> *that is, not simply what is 'absent' — for all representation is, by definition, a representation of an absent object — but rather, what is intentionally made absent, that which has been made to disappear through some form of material or symbolic violence; in this case, the representation of the bodies of the disappeared by a systematic policy or a conscious strategy.*[21]

The logic that underpins this gesture, Grüner concludes, is that of the *restitution* of the image as *substitution* for the missing body. With the production of silhouettes, the subject

17 Emilio Crenzel, 'Las fotografías del Nunca Más: Verdad y prueba jurídica de las desapariciones', in Claudia Feld and Jessica Stites Mor (ed.), *El pasado que miramos*, Buenos Aires: Paidós, 2009, p.285.
18 Ludmila Catela, 'Lo invisible revelado: El uso de fotografías como (re)presentación de la desaparición de personas en Argentina', in C. Feld and J. Stites Mor (ed.), *El pasado que miramos*, op. cit., p.349.
19 In Argentinean history, the augmentative suffix '-azo' is used to refer to a whole series of popular uprisings: the *cordobazo*, the *rosariazo*, the *viborazo*, the *argentinazo*, etc.
20 This is the number given by the Mothers.
21 Eduardo Grüner, 'La invisibilidad estratégica, o la redención política de los vivos: Violencia política y representación estética en el Siglo de las Desapariciones', in Ana Longoni and Gustavo Bruzzone (ed.), *El Siluetazo*, Buenos Aires: Adriana Hidalgo, 2008, p.285.

returns to the body, even if this is a different subject — a broader subject, cohesive and multiple: the multitude that gathered to support the Third Resistance March initiated on the 21 September by the Mothers.

The *Siluetazo* was conceived by three visual artists — Rodolfo Aguerreberry, Julio Flores and Guillermo Kexel — while the Mothers, the Grandmothers of the Plaza de Mayo, and other human rights organisations and political activists took part in its material realisation. The initial proposal that the artists offered to the Mothers did not speak of 'art', but rather of 'creating a *graphic fact* that will have an impact thanks to its large size and its unusual construction, serving to renew the attention of the media'.[22] The idea was accepted and reformulated by the Mothers and materialised by the demonstrators, who made the procedure their own. According to the three artists, the 'initial project included the personalisation of each of the silhouettes by detailing clothes, physical features, sex and

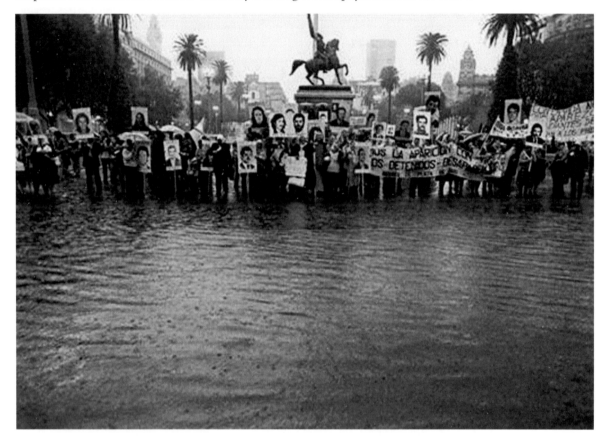

age, using collage, colours and portraiture'.[23] The idea was to produce a silhouette for each missing person. However, the Mothers pointed out that this posed a problem, as the lists of victims were incomplete at the time (as they still are). The group instead decided to keep all the silhouettes identical, without any inscription that could distinguish one from another. The artists took 'countless rolls of Kraft paper, all kinds of paints and spray-paints, paintbrushes and rollers' and some 1,500 silhouettes already made. They also took some stencils so that a uniform silhouette could be reproduced. The Plaza de Mayo became, for several hours, a giant improvised workshop for the production of silhouettes. The Grandmothers of the Plaza de Mayo pointed out that children and pregnant women should also be represented, so Kexel, one of the artists, placed a cushion on his belly and they traced his silhouette in profile. His daughter was the model for the child's silhouette. The babies were simply drawn freehand.

The original plan of uniformity was modified by the process of collective construction. Aguerreberry's testimony narrates a massive and spontaneous participation by the demonstrators that, from early on, made the artists 'redundant'. 'I reckon that we could

Protest of the Mothers of the Plaza de Mayo, taken at the Plaza de Mayo, Buenos Aires, 1983. Photograph: Daniel García

22　Guillermo Kexel, Julio Flores and Rodolfo Aguerreberry, 'Propuesta presentada a las Madres de Plaza de Mayo', in A. Longoni and G. Bruzzone (ed.), *El Siluetazo, op. cit.*, p.63.
23　Carlos López Iglesias, interview with the group in A. Longoni and G. Bruzzone (ed.), *El Siluetazo, op. cit.*, p.333.

have left just half an hour after getting there,' he is quoted as saying, 'as we weren't needed at all.' [24] Despite the decision not to give the silhouettes any identifying features, some demands were made to differentiate or individualise them, to endow them with a specific feature, that is, qualities of actual existence. Some demanded to be able to find *their* silhouette amidst the sea of silhouettes — that of their missing father, mother, child, friend, brother. A boy walked up to one of the draughtsmen and said, 'Make my dad.' They asked, 'What does your dad look like?', and the draughtsman drew him with a beard and a moustache. The participants made couples, mothers and children, a group of factory workers — drawing 'what they want or what others ask for in a process of collective construction'. [25]

Throughout this process, the silhouette became the trace, the index of two missing bodies: one belonging to the person who lent his or her body so that the silhouette could be traced and, through a process of transferral, the body of the disappeared. In this way, as Roberto Amigo Cerisola has written, 'the broken ties of solidarity are reconstructed in a powerfully moving symbolic act'. [26] The gesture of lending one's body carries a certain ambiguity, as to take the place of the missing person is to accept that anyone could have taken the place of the disappeared, that anyone could have suffered the same uncertain and sinister fate. On the other hand, a corporality, a body and a life — however ephemeral — is returned to the disappeared. The condition of subject is also returned to the missing, a condition that the perverse repressive methodology of disappearance refused to grant them. The body of the demonstrator taking the place of the disappeared as a live support for the construction of the silhouette makes it possible to think of the silhouette as a 'breathing trace'. [27]

The *Siluetazo* involved the appropriation and occupation of the Plaza de Mayo and its surroundings. [28] The Plaza de Mayo not only is centrally located, but also is of strategic importance to the network of political, economic and symbolic power of Buenos Aires and Argentina. Amigo understands this event not only as a political 'taking over the square', but also as an 'aesthetic takeover' — an offensive move towards the appropriation of urban space. What was produced there had an impact not just on those who took part in its making, but on many others, thanks to the silent scream projected the next morning by the silhouettes covering the walls of nearby buildings, which remained for a short time, until they were torn away by the police. The media pointed out that passers-by voiced their discomfort or surprise at being interpellated, *stared at* by those faceless figures. A journalist wrote that the silhouettes 'seem to point from the walls to those who are to blame for their absence, silently demanding justice. Through a scenic effect, the families, the friends, the portion of the public that reacted to it and those who were taken away appeared together for the first time.' [30] The silhouettes made evident that which the public opinion ignored or would rather ignore, breaking a pact of silence about the repression and those who were guilty of it, which had installed itself in Argentinean society during the dictatorship; something that could be summed up by the familiar disclaimer: 'We did not know.'

The symbolic effect of the *Siluetazo* turned the production of silhouettes into a powerful, recurrent and public visual strategy. Silhouettes became a distinctive symbol for representing the disappeared. As with the photographs, the silhouettes have had a prolific and varying existence since 1983. The procedure was socialised and disseminated throughout the country and even outside its borders; unplanned *siluetadas* (the public use of silhouettes) took place without any direct links to the original event or direct control by the Mothers or the artists. The silhouettes are often understood as the visual manifestation of the slogan 'Aparición con vida' ('Appearing alive') that the Mothers chanted from 1980

24 Quoted in Hernán Ameijeiras, 'A diez años del Siluetazo', in the journal *La Maga*, Buenos Aires, 31 March 1993, in A. Longoni and G. Bruzzone (ed.), *El Siluetazo, op. cit.*, p.189.
25 C. López Iglesias, interview with the group, *op. cit.*, p.309.
26 Roberto Amigo Cerisola, 'Aparición con vida: Las siluetas de detenidos-desaparecidos', in A. Longoni and G. Bruzzone (ed.), *El Siluetazo, op. cit.*, p. 275. See also his essay 'La Plaza de Mayo, Plaza de las Madres: Estética y lucha de clases en el espacio urbano', in *Ciudad/Campo en las artes en Argentina y Latinoamérica*, Buenos Aires: CAIA, 1991, pp.89—99.
27 See Gustavo Buntinx, 'Desapariciones forzadas/resurrecciones míticas', *Arte y Poder*, Buenos Aires: CAIA, 1993, pp.236—55.
28 The term 'appropriation' is used by Fernando Bedoya y Emei in 'Madres de Plaza de Mayo: Un espacio alternativo para los artistas plásticos', in A. Longoni and G. Bruzzone (ed.), *El Siluetazo, op. cit.*, pp.149—86.
29 See R. Amigo Cerisola, 'Aparición con vida', *op. cit.*, p.265.
30 Anonymous, *Paz y Justicia Bulletin*, September 1983.

(in addition to the chant 'Con vida los llevaron, con vida los queremos', or 'Alive they took them, alive we want them'). The slogans responded to the rumours circulating at the time about how the regime was keeping the missing detained in clandestine camps.[31] However, the relationship between the images and the text is slippery, and has given rise to opposing readings even among thinkers sympathetic to the human rights movement. Amigo points out that the silhouettes 'made present the absence of the bodies in a *mise en scène* of state terror',[32] while Gustavo Buntinx understands them as proof of the fact that the Mothers were still hopeful about finding the missing alive. 'This was not a mere artistic illustration of a slogan, but its live actualisation,' he says.[33] Conversely, Grüner writes that the silhouettes contain an element that 'unsettles those who look at them: they reproduce that familiar police procedure in which a dead body that has been taken away from the scene of the crime is drawn in chalk on the floor'.[34] This could be read as 'a *political* gesture

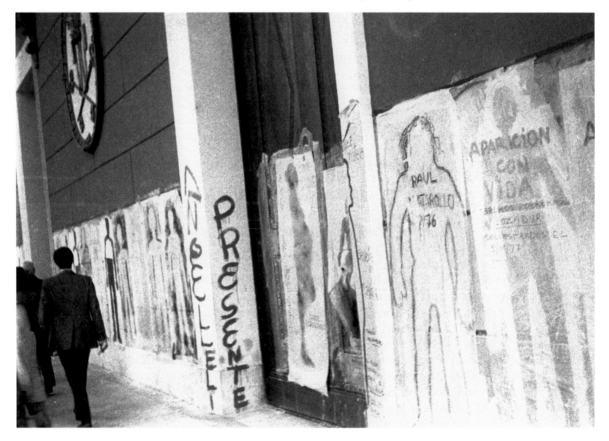

The *Siluetazo*,
Buenos Aires,
21 September 1983.
Photograph:
Alfredo Alonso/
CeDInCI

that appropriates the investigative methods of the enemy — of the so-called "forces of law and order" — creating a continuity that seems to be saying, "It was you"'. But it is also 'an *unconscious* gesture that accepts, sometimes contradicting a discourse that would rather keep talking about the "disappeared", that those silhouettes stand for *corpses*'. Therefore, 'the (conscious or unconscious) attempt to *represent* the disappearance is carried out in order to *promote* the death of the material body'. Aware of the likely association between silhouettes and death, particularly via police procedures, the Mothers rejected the initial artists' proposal to glue the silhouettes to the floor (which was presented among other options) and demanded that the silhouettes always be kept upright. As soon as they were finished, the demonstrators pasted them on the buildings lining the square.

31 The expectation that some of the disappeared might still be alive began to evaporate as time went by, with the discovery of mass graves with the No Names and the increasing number of testimonies from the very few survivors about the cruelty of the extermination procedures. Pilar Calveiro has reflected on the social difficulty of taking on board the dreadful truth the survivors revealed: they did not speak of the disappeared, but of the dead, of bodies that had been systematically devastated. See P. Calveiro, *Poder y desaparición, op. cit.*
32 R. Amigo Cerisola, 'Aparición con vida', *op. cit.*, p.203.
33 G. Buntinx, 'Desapariciones forzadas/resurrecciones míticas', *op. cit.*, p.253.
34 E. Grüner, 'La invisibilidad estratégica', *op. cit.*, p.285.
35 F. Bedoya y Emei, 'Madres de Plaza de Mayo', *op. cit.*, p.149ff.
36 G. Buntinx, 'Desapariciones forzadas/resurrecciones míticas', *op. cit.*, p.253.
37 E. Grüner, 'La invisibilidad estratégica', *op. cit.*, p.285.

Thanks to its dynamic of collective and participatory creation, the *Siluetazo* also allowed, if only for a brief moment, for the effective collectivisation of the means of production and distribution of art, inasmuch as the demonstrators were incorporated as producers, and images had a free and public circulation. The visual fact was 'made by everyone and belongs to everyone'.[35] This radical participatory practice — for which no special knowledge of drawing was required — was made evident in the dissemination of an idea or concept, in simple but effective artistic forms and techniques, in the repetition of an image and in the very act of producing it.

Buntinx reads in this collectivisation of the means of artistic production a 'radical liquidation of the category of modern art as an object-of-pure-contemplation, an instance-away-from-life', as well as the recuperation of a 'magical-religious dimension of art that modernity had taken away'.[36] This restores auratic charge and thaumaturgic and

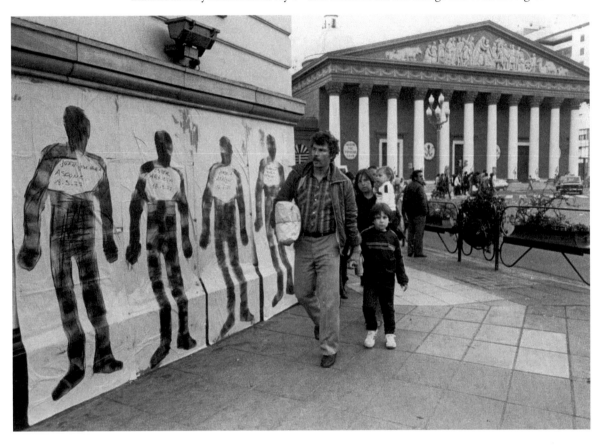

The *Siluetazo*, Buenos Aires, 21 September 1983. Photograph: Daniel García

prodigious value to the image. Buntinx is not the only author who proposes a reading of the silhouettes in terms of a restitution of the aura. Grüner also points out that 'the idea of an objectified form that contains a vacuum that *looks at us* is related to (or at least, *can be* related to) Walter Benjamin's concept of auratic art', defined by 'the expectation that what one is looking at is looking back at one'.[37] Buntinx goes even further:

> *the occupation of the square clearly possesses a political and an aesthetic dimension, but it is also a ritual, in the most charged and anthropological sense of the term. It did not just attempt to raise awareness of the genocide, but also tried to reverse it: to reclaim the loved ones trapped in the phantasmagorical borders of death for a new life. [... it became a] messianic and political experience where resurrection and insurrection merge [...] The idea is to turn art into a force that can act in the concrete reality. But there is also a magical gesture in that direction. Against the renewed political power of empire, an unsuspected mythical power: a ritual pact with the dead.*[38]

37 E. Grüner, 'La invisibilidad estratégica', *op. cit.*, p.285.
38 G. Buntinx, 'Desapariciones forzadas/resurrecciones míticas', *op. cit.*, p.253.

The hundreds of demonstrators who took part in that action had no artistic conception of their actions, and, in fact, for several years the memory of the artistic origin of the initiative was lost.[39] We are faced with a collective action whose becoming dilutes (or even forgets) its 'artistic' origin. The distinctions between the socially allocated roles of the artist, the activist and the spectator were radically undifferentiated, not just through the simple participation in somebody else's initiative, but by turning everyone into a 'maker' of a common imaginary.

It is not relevant whether the *Siluetazo* was understood in its time as an artistic action or not. What is important is that the *Siluetazo* achieved the socialisation of a visual tool that opened a new 'social territoriality'.[40] Although it was born in the midst of the human rights movement and under the leadership of the Mothers of the Plaza de Mayo, its irruption was far from assimilated into a prefixed political project.[41] It is precisely that indeterminacy which grants the *Siluetazo* its singularity as an event.[42]

Hands, Masks

It is possible to establish a clear continuity between the silhouettes and two other strategies promoted by the Mothers in the first days of democracy: the hands and the white masks. The campaign 'Lend a hand to the disappeared' travelled all over the world and managed to gather almost a million hands in the Southern Hemisphere summer of 1984 to 1985. The procedure was similar to that of lending one's body to trace the silhouette; part of the gesture was lending one's hand so that a Mother or another activist could trace it on paper. Afterwards, the participant would write something on the paper — a name, a slogan, a letter. Thousands of hands were hung on string, creating long garlands that waved over the Plaza de Mayo during a march held on 24 March 1985, the ninth anniversary of the coup. The hands were also fly-posted across different urban spaces. During the March of the White Masks, on 25 April 1985, thousands of white masks, all identical, were distributed among the demonstrators. This procedure made the demonstrators — each carrying a mask and thus becoming anonymous — once again stand in for the missing persons, each demonstrator lending his or her body and life to the disappeared. Hands and masks reinforced the associations that the silhouettes had already established: the crowd put its hands or faces in the place of the missing ones. 'Like the silhouettes, the tracing of hands multiplies the individual trace and turns it into a multitude; like the silhouettes, the masks evoke the anonymity of the figure
of the No Names and interpellate the spectator, silently and crudely.'[43]

This strategy received contrasting assessments from the Mothers and some political groups, who felt that it denied any political identity to the disappeared.[44] Hebe de Bonafini, one of the leaders of the Mothers,

> *explains at that point — and subsequently — that the use of masks tried to produce an effect. For her and for other mothers, the mobilisations should not become routine [...] they had to be a* mise en scène *that made an effort to introduce a high-impact*

39 In order to avoid using the term 'art actions', Roberto Amigo proposed that the *Siluetazo* and other similar strategies could be called 'aesthetic actions of political praxis'. R. Amigo Cerisola, 'Aparición con vida', *op. cit.*, p.203. The artist León Ferrari used similar arguments: 'the *Siluetazo* [was a] masterwork, formidable, not just politically, but also aesthetically. Several elements were at play: it was an idea proposed by some artists, but developed by a multitude that carried it out *without any artistic intention*. We were not coming together to do a performance, not at all. We were not representing anything. This was a work that everyone felt, whose material was inside the people. *It was irrelevant whether it was art or not.*' Unpublished interview with León Ferrari, Buenos Aires, 24 May 2005.
40 This is a term proposed by Juan Carlos Marín in *Los hechos armados*, Buenos Aires: Ediciones PICASO/La Rosa Blindada, 2003.
41 This socialisation of the production of the imaginary is allied to the notion of 'post-avant-garde', as used by Brian Holmes in reference to contemporary versions of artistic activism: 'I am not interested in avant-garde movements, but in post-avant-garde ones; these are movements that are diffused, allowing a large number of people to take part in the construction and dissemination of images and new languages.' Quoted in 'Entrevista colectiva a Brian Holmes', *ramona. revista de artes visuales*, no.55, October 2005, p.9.
42 This reflection derives from a text I wrote in collaboration with Jaime Vindel, 'Fuera de categoría: La política del arte en los márgenes de su historia', *Tercer Texto: Conceptualismos del Sur: Antagonismos desde el arte y nuevas formas de la política en América Latina entre los 60 y los 80*, no.4 (ed. Miguel A. López and A. Longoni), 2010.
43 Estela Schindel, 'Siluetas, rostros, escraches: Memoria y *performance* alrededor del movimiento de derechos humanos', in A. Longoni and G. Bruzzone (ed.), *El Siluetazo*, *op. cit.*, p.411.
44 Instead, they proposed the opposite strategy: 'to unmask the disappeared so that everyone knows who they are, to disseminate their goals and struggles'. U. Gorini, *La rebelión de las Madres*, *op. cit.*, vol.2, p.386.

novelty [...] Some other mothers did not agree with the use of the masks because they 'erased' the individual identity of each one of the disappeared. They compared this resource with the use of placards bearing the photographs, names and dates of disappearance of each one of the missing children. Those placards, like photographs with similar inscriptions they used to carry on their necks, or the white scarves bearing the names and dates of disappearance of their children, had been used under the dictatorship. Aside from signifying a clear and precise denunciation about the identity of the victims of the repressive regime, the placards established with each one of the mothers a powerfully affective force. [45]

Gorini sees in this position a resistance to leaving a stage behind, in the path towards adopting a 'collective motherhood'. 'With the identical masks [...] a *new stage* was acknowledged: the disappeared was no longer one's own child, or, at least, all the disappeared constituted a single child with the same face. Collectivised motherhood *transcended* that singular motherhood that was expressed by the individual photographs in the placards.' [46]

Counterpoint

The two matrixes of representation sketched above cannot be thought of as consecutive or opposing alternatives, for both of them coexisted and unfolded at the same time. At times, they even overlapped. Rather, the discrepancies or distances between both strategies signal different political positions within the same social movement. While photographs emphasise life before the disappearance, the biography (that this person existed), the silhouettes, the hands and masks emphasise the circumstances of the kidnapping and disappearance (30,000 people disappeared), foregrounding the emptiness, the massive absence generated by that violence. In line with this, we can also distinguish a different emphasis on *individualisation* on the one hand and *quantification* on the other.

Although, in practice, it was not realised in this way, the initial idea of the *Siluetazo* was to produce identical silhouettes, without faces, specific features or names, so as to reinforce the anonymity of the victims. The same can be said about the masks that erase the face of the living, levelling them with the disappeared. But the photographs set out from a strong sign of individualisation within the history of each of the disappeared (although they became a collective symbol when thousands of these photographs are brought together), in order to activate the possibility of recuperating an individual biography, an unrepeatable face, a singular history. As Ludmila Catela has written: 'These photographs bring back an idea of personhood, the one that in our societies condensates our most essential features: a name and a face [...] they remove the anonymity of death in order to recover an identity and a history.' [47]

> *While the photographs emphasised life before the disappearance (that this person existed), the silhouettes, hands and masks emphasised the circumstances of the kidnapping and disappearance, foregrounding the emptiness, the massive absence generated by that violence.*

If the silhouettes insist upon the quantification of victims — through the physical space that their absent bodies would occupy, were they still among us — the photographs proceed from the particular identity of each victim, in order to compose a collective sign amidst the magnitude of the tragedy that was inflicted upon Argentinean society by state terrorism. Both speak of the mourning of families, of their battle against the erasure that a disappearance imposes. They speak of specific subjects, fathers, brothers, partners, children: of a life before the kidnapping, of a family that is still searching and does not forget, demanding justice.

On the other hand, silhouettes, hands and masks fuse in the transference between the demonstrators and the disappeared. They share the constructive procedure of the *body*

45 *Ibid.*, p.385.
46 *Ibid.*, p.387. Italics the author's.
47 L. Catela, 'Lo invisible revelado', *op. cit.*, p.341.

of the demonstrator put in the place of the missing body. They share a common act (both intimate and collective), a performative or even ritual act that involves a commitment of the body, the decision to put one's self in the place of the absent one, lending him or her a breath of life. The silhouettes, hands and masks become a trace of two absences: that of the person who is represented and that of the person masked or traced in the place of the absent. The photographs, on the other hand, are traces of another time, taken by different hands and for different ends, now reinscribed in a new context, where they have become a public concern.

Finally, it also is possible to perceive in this visual politics the tension between different positions among the Mothers: basically, the difference between a *private mourning* and a *collectivised motherhood*. From 1980 onwards, debates took place within the organisation regarding certain political definitions, especially regarding their attitude towards the state.

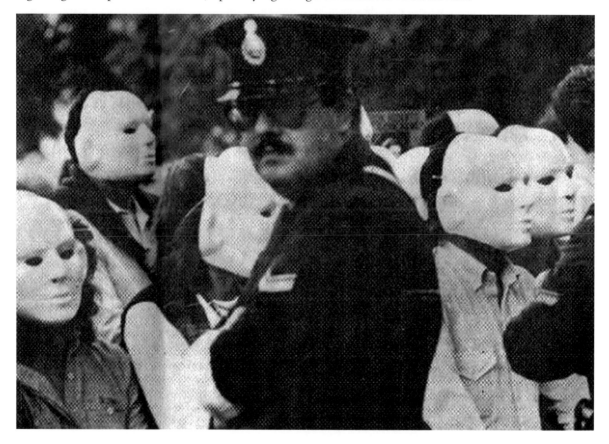

A portion of the Mothers, led by Bonafini, was opposed to the exhumation of the No Names mass graves, to economic compensation for relatives and to any act of mourning that individualised the victims.[48] Needless to say, those disputes had an impact upon the symbolic strategies used by the Mothers. In the name of a 'collectivisation of motherhood', no individual's name could be worn on the scarves, be noted in the memorials that were published daily in the national newspaper *Página/12* or inscribed into any plaque or monument. From this perspective, the photographs could be considered an individualising element that worked against the collectivising logic of the silhouettes, the hands or the masks. The following paragraph from an interview with Bonafini illustrates this position:

The March of the Masks, April 1985, Plaza de Mayo, Buenos Aires. Photograph: Domingo Ocaranza Bouet

> *one day, we met and talked with other comrades, and said that we had to socialise motherhood and become everyone's mothers. […] We took our children's names from the scarves and stopped wearing the photographs bearing their names […] In this way, when anyone questions one of the mothers, she can reply: 'Yes, we have 30,000 children'[…] When we arrived at the square, we exchanged our children's placards […] Afterwards we decided we should not carry their picture on their chest, as they*

48 These debates eventually led to the division of the Mothers into two groups in 1986, the Asociación Madres de Plaza de Mayo and the Madres de Plaza de Mayo Línea Fundadora.

bore a name, and journalists tended to focus on them. We say that we are socialising motherhood because, like our children taught us, we are all equal and all children are equal, but there are so many children with no photographs! So many mothers who don't have a photograph of their children! This is why we have to be identified with all of them: with no name or anything like that. All of them means all of them.[49]

In demonstrations, when the Mothers and other relatives could not find the placard of a certain loved one among the hundreds that had been made, they were happy to carry others'. Many relatives of missing persons often have spoken about the strangeness and emotion they felt when they stumbled upon a picture of their loved one being held up high by a complete stranger. In this sense, when hundreds of people were preparing to produce the silhouettes, they did not remain anonymous. In fact, and regardless of the initial plans and guidelines, the crowd that took part in the *Siluetazo* brought the silhouettes closer to the photographs. Bearing the photographs as a response to the anonymity and denial imposed by the state revealed an impulse similar to the one that spontaneously made the demonstrators add particular features and names to many of the silhouettes in that historic day: even in a protest about 30,000 missing people, the pain of friends and family has a specific face and name.

Photographs and silhouettes, hands and masks. These two recurrent strategies for the representation of the disappeared can be compared in a series of oppositions: collective versus particular; anonymous versus named; violent disappearance versus previous biography. At the same time they overlap, contaminate and reinforce each other. Neither of them turned out to be more appropriate or effective than the other. Rather, their disagreements help us think about different paths in the collective and intimate elaboration of this difficult mourning and this ongoing struggle, and perhaps of other struggles against state crimes.

49 Interview with Hebe de Bonafini by Graciela Di Marco and Alejandra Brener in Nathalie Lebon and Elizabeth Maier, *De lo privado a lo público: 30 años de la lucha ciudadana de las mujeres en América Latina*, Madrid: Siglo XXI Editores, 2006, n.p.

Translated by Yaiza Hernández.

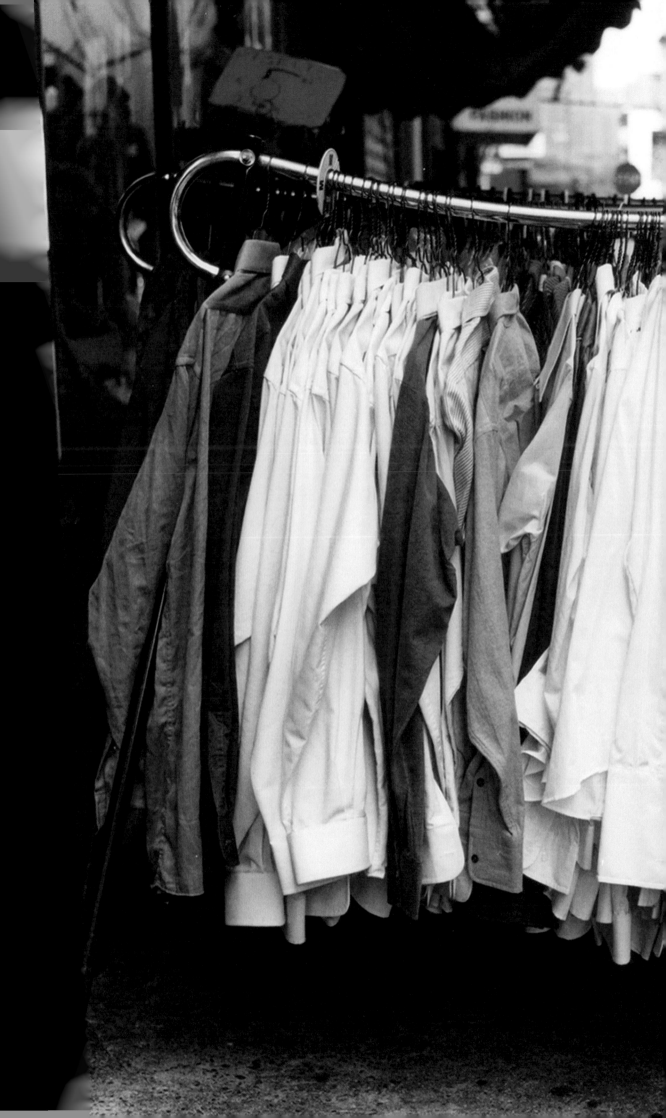

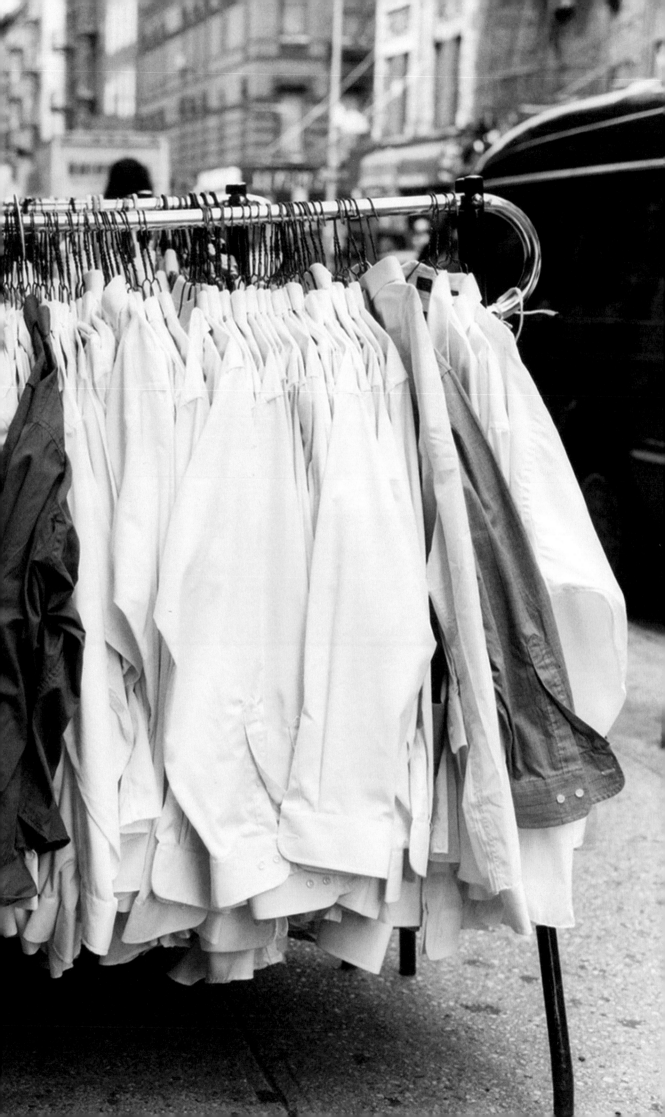

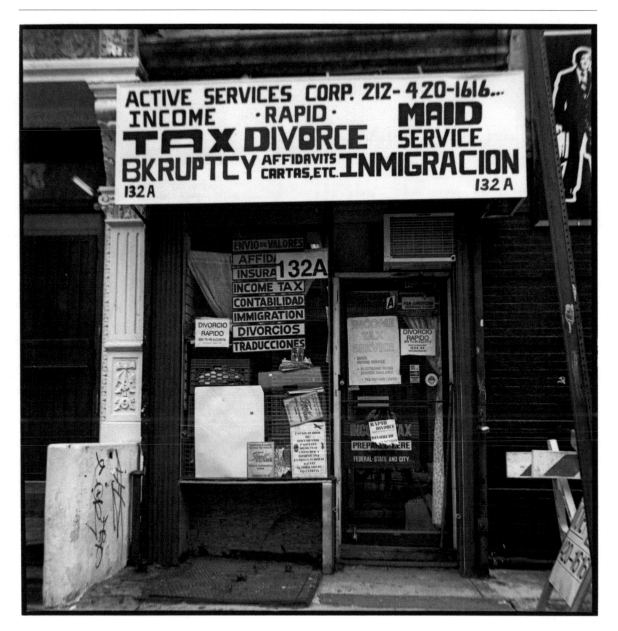

Zoe Leonard,
Analogue, 1998—
2009, 412 C-prints
and gelatin silver
prints, each print
28 × 28cm. Courtesy
the artist and Galerie
Gisela Capitain,
Cologne

Previous spread:
Zoe Leonard,
Analogue,
1998—2009,
detail

The Archivist of Urban Waste: Zoe Leonard, Photographer as Rag-Picker

– Tom McDonough

Analogue (1998—2009), Zoe Leonard's decade-long survey of the landscape of small-scale commerce and urban services in New York and other cities around the globe, began with the simple choice to photograph the streets around her apartment on the Lower East Side of Manhattan. As she recently recalled: 'I began this project in an attempt to understand by observing and recording the very humble everyday surroundings of my everyday life.'[1] What would grow into an archive of more than 400 images, displayed in serial grids organised in loosely thematic

In this close reading of Zoe Leonard's *Analogue*, Tom McDonough considers its mapping of reclamation and exchange as a model for artistic practice.

groupings, originated with this impulse to document the changing texture of her traditionally working-class and ethnically diverse district as it was being overtaken by the deterritorialising force of capital: 'My own neighbourhood is filled with the signs of a local economy being replaced by a global one,' Leonard remarked, 'small businesses being replaced by large corporations, multinationals taking over.'[2] A relatively early photograph from the series (from 1999), depicts a small storefront, seen straight on, in a square-format black-and-white print. The address — on Ludlow just above Delancey Street — was occupied in the late 1990s by the Active Services Corporation, which performed a variety of functions for its primarily Spanish-speaking clientele, from income tax preparation to rapid divorces, all of which was spelled out in a patchwork of signage posted in its windows and hand-painted on the awning above.

The visitor to this address today will find instead itsasickness, a boutique selling gifts and accessories loosely themed on addiction (the shop's website encourages users to indulge their 'obsessive behavior'). The transformation is indicative of the disappearing social world Leonard set out to capture, and of what is replacing it.

As a document of the contemporary urban landscape, *Analogue* could be said to stand at the intersection of competing regimes of representation. With their deadpan gaze, standardised format and gridded presentation, the photographs owe an obvious debt to conceptual precedents. They often have been compared, for example, to the industrial typologies assembled by Bernd and Hilla Becher, and the two bodies of work do indeed share a kind of archaeological impulse, a desire to picture what are often obsolescent forms before their final disappearance. But Leonard's focus on the city, and in particular on its working-class quarters, might also recall Hans Haacke's investigations of New York real estate as a 'social system', most famously in *Shapolsky et al. Manhattan Real Estate Holdings, a Real Time Social System, as of May 1, 1971* (1971). That controversial work, at the centre of the Guggenheim Museum's last-minute cancellation of Haacke's solo exhibition the year of its production, mapped out the transactions of a shadowy real estate firm centred upon one of the largest holders of slum properties in Manhattan. *Shapolsky et al.* consisted of 142 photographs of the buildings and lots owned by the firm — most on the Lower East Side and in Harlem — each of which was accompanied by a text panel describing its location and the financial deals involving the building, along with six charts cross-referencing the properties, an explanatory wall panel and

1 Zoe Leonard, quoted in Drusilla Beyfus, 'Zoe Leonard: Deutsche Börse Photography Prize 2010',
 The Daily Telegraph, 11 February 2010; see http://www.telegraph.co.uk/culture/photography/7205995/
 Zoe-Leonard-Deutsche-Borse-Photography-Prize-2010.html (last accessed on 24 May 2010).
2 Z. Leonard, quoted in 'Eminent Domain: Contemporary Photography and the City', at the New York Public
 Library, 2008; see http://exhibitions.nypl.org/exhibits/eminent/leonard (last accessed on 24 May 2010).

maps. The effect of the work was to make legible the opaque connections between various dummy corporations that together controlled an exploitive market for lower-income housing. There can be no questioning of the distance that separates Haacke's rigorous investigation of this particularised social system from Leonard's wide-ranging visualisation of the ecology of small-scale commerce, and it would be facile to locate a morphological similarity between the works by isolating Haacke's photographs and comparing them with Leonard's. Nevertheless, a connection between these two disparate works remains.

The conjunction lies less perhaps in Haacke's piece itself than in its reception in New York in the mid-1980s, when, in an influential reading, Rosalyn Deutsche argued that it sited itself critically within 'a specific interface between economic and artistic concerns — the relations between dominant aesthetic discourses and the interests of real estate capital in New York'.[3] *Shapolsky et al.* held particular resonance in a city that was finally absorbing the successful outcome of a half-century of efforts by large landowners to rid it of industrial employment as part of a broader reorganisation of the division of labour on national and international scales. By the end of the 1980s manufacturing had given way to the characteristic contemporary mix of jobs in services and finance, insurance and real estate, a process that was accompanied by the marginalisation of the people who had been employed in small industry as low-rent properties disappeared. 'The latest phase of urban redevelopment,' Deutsche concluded, 'also engineers the destruction of the material conditions of survival — housing and services — for those residents no longer needed in the city's economy.'[4] In this manner *Shapolsky et al.* was articulated as a precedent for projects by Group Material and Martha Rosler, which took up gentrification in 1980s New York in a similar manner, critically engaging both the urban landscape and a cultural apparatus that all too often was complicit with the redevelopment process. *Analogue*

can be seen as marking the latest, and perhaps last, movement in this arc: by the early 1990s the deindustrialisation of Manhattan was a *fait accompli*, and the housing battles of the previous decade had been lost. What remained was to capture on film a residual environment of cheap clothing shops, appliance stores and the like that served a surplus population, before it, too, was obliterated by the bubble economy of the late 1990s and 2000s.[5]

However the factographic rigour of these conceptual precursors of *Analogue* coexists — rather uneasily — alongside a more poetic lineage of street photography, which constitutes another crucial interlocutor for the project. Lee Friedlander's 1960s photographs of shop windows might come to mind, although his interest in the ambiguity between reflection and actuality is largely foreign to Leonard's series. We do occasionally glimpse her mirrored image in a store's glass frontage, standing at a certain distance from her subject — as in the photograph showing the corner of Ludlow and Rivington Street (from 1999), in which we can just make her out, perching at the edge of the curb as she peers down into the focusing screen of her Rolleiflex camera. Her form, silhouetted dimly against the empty jackets arrayed in the window, creates that intermingling of outside event with inside displays so typical of Friedlander. But this is something of an anomaly; throughout *Analogue* Leonard generally avoided these sorts of effects, photographing in the cool, even light of early morning and minimising reflections. A closer parallel might be found in the rather lesser-known colour photographs of working-class storefronts taken by Harry Callahan in Chicago in the mid-1950s. Like Leonard's, these pictures were motivated by knowledge of the impending doom of the spaces depicted, slated as they were for 'renewal' at an earlier moment of municipal reorganisation. Callahan was teaching at the time at the Institute of Design, where he had befriended Ludwig Mies van der Rohe; the modest vernacular commercial architecture captured by Callahan's photographs, and the fine-grained urban texture it established, stood as an implicit

3 Rosalyn Deutsche, 'Property Values: Hans Haacke, Real Estate and the Museum', in Brian Wallis (ed.), *Hans Haacke: Unfinished Business*, New York, Cambridge, MA and London: The New Museum of Contemporary Art and The MIT Press, 1986, p.23.
4 *Ibid.*, p.24.
5 For a complementary reading of this work, see Jenni Sorkin, 'Finding the Right Darkness', *frieze*, issue 113, March 2008; also available at http://www.frieze.com/issue/article/finding_the_right_darkness (last accessed on 24 May 2010).

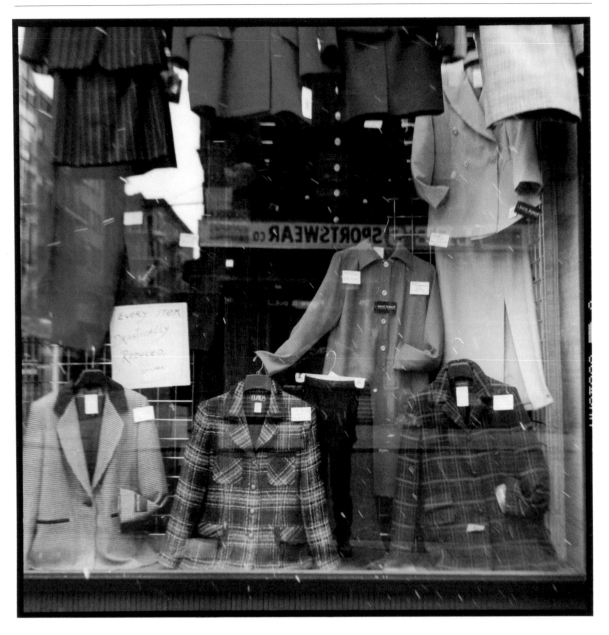

Zoe Leonard,
Analogue, 1998—
2009, 412 C-prints
and gelatin silver
prints, each print
28 × 28cm. Courtesy
the artist and Galerie
Gisela Capitain,
Cologne

riposte to the latter's crystalline vision of a city purged of density — a vision that was built, in the form of his Lake Shore Drive apartments, only a mile or so away on the affluent Gold Coast from the strip shown in Callahan's photographs. They confront the subjects straight on, the door positioned at the centre of the picture, so that the image became an intricate composition of squares and rectangles. Leonard's photographs of Pitt Street or of Clinton Street (both taken in 1999 in New York City) echo, perhaps inadvertently, Callahan's formats in their compositional rigour.

But of course the great photographic precedent for *Analogue*, as so many of its commentators have remarked and as Leonard herself has attested, lies in the documentation of 'Old Paris' undertaken by Eugène Atget at the start of the twentieth

century. The photographs of Broadway and Grand Street or of Orchard Street (both 1999), with their stacked bolts of fabric or groaning racks of dress shirts, bear close comparison to the series of photographs taken by Atget in 1910 and 1911 at the Marché des Carmes on the Place Maubert, where clothing merchants displayed their wares. What Leonard sees in the French photographer is neither the celebration of the 'social fantastic' lauded by Pierre Mac Orlan nor the revelation of the uncanny admired by the Surrealists, but the documentation of a particular kind of selling: that of secondhand goods, of salvage, of reutilisation. Atget's market, or his dealers in used wares, depicts a form of commerce that developed out of necessity to serve the Parisian underclass, and stands in sharp distinction to the

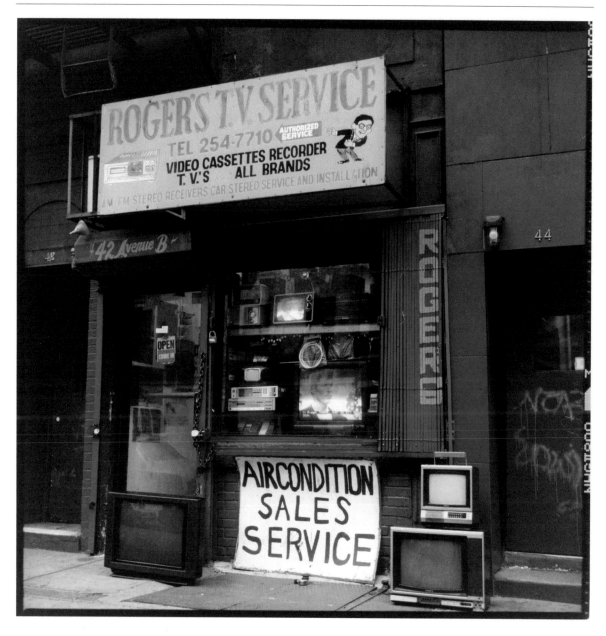

spectacle of the department store and its deployment of the narcissistic mirror of consumption.[6] So too Leonard's small shops are counterposed to those national chains, unseen, that were spreading throughout New York in those years, choking off this local ecology of family businesses. This aspect of *Analogue* only became more pronounced as the project developed, and assumed an increasingly self-reflexive quality: one significant subset of images depicts shops selling and repairing obsolescent visual technologies — as in Roger's TV Service in the photograph of Avenue B (2000), seen from a slightly oblique angle with its array of

televisions, stereo equipment and radios posed in its window and on the sidewalk. (Roger's has since given way to Shampoo Avenue B, a hair salon boasting Lady Gaga as a client; cuts start at $80 for women.) These disappearing visual technologies, and the material spaces that sold and repaired them, are indemnified in memory through another threatened technology — Leonard's Rolleiflex camera — producing a kind of triangulated mirroring between the camera lens, TV screens and the shop window.

Zoe Leonard began *Analogue*, as stated earlier, by walking through her neighbourhood and similar working-class commercial districts in Manhattan

Zoe Leonard, *Analogue*, 1998— 2009, 412 C-prints and gelatin silver prints, each print 28 × 28cm. Courtesy the artist and Galerie Gisela Capitain, Cologne

6 See Clive Scott, *Street Photography: From Atget to Cartier-Bresson*, London and New York: I.B. Tauris, 2007, p.74, for a useful discussion of Atget's images of Parisian commerce. Leonard's primary reference was to Molly Nesbit, *Atget's Seven Albums*, New Haven and London: Yale University Press, 1992.

and Brooklyn. Favouring the morning, when the sidewalks were empty of pedestrians, she photographed those derelict or down-at-heel storefronts that caught her eye. Her peripatetic gaze is a distant echo of one of the founding paradigms of modernist artistic production: that which compared the artist to the *chiffonnier*, the rag-picker who scavenged the daily cast-offs of the great city:

> Here is a man entrusted to gather up the remains of a day in the life of the capital. All that the metropolis has rejected, all that it has got rid of, all that it has scorned, all that it has broken, he catalogues, he collects. He examines the archives of debauchery, the capharnaüm [a dump, a pigsty] of trash. He makes a selection, an intelligent choice; he gathers, like a miser a treasure, the refuse that, when ground again between the jaws of the goddess Industry, will become objects of utility or of delight.[7]

That was Charles Baudelaire writing in his 1851 essay 'On Wine and Hashish', at the very dawn of those forms of consumer capitalism that today flourish

These disappearing visual technologies, and the material spaces that sold and repaired them, are indemnified in memory through another threatened technology — Leonard's Rolleiflex camera.

so abundantly. Perhaps the most radical aspect of this profile of an 'archivist' of urban waste was its implicit redefinition of art-making under the transformed conditions of modern urban life and the incipient regime of the commodity, which would now of necessity become a labour of scavenging, of making meaningful what happened to be left at one's disposal.[8] Baudelaire sensed this to be the case already in his lifetime, and eulogised the rag-picker in his poetry: the two shared a secret complicity, as the discarded clothing the latter collected was sold to be remade

into paper, the very physical support for the poet's work; but more importantly, Baudelaire positioned his writing in an analogous relationship to the city, salvaging bits of urban detritus in his poems. 'Lumpensammler oder Poet — der Abhub geht beide an,' Walter Benjamin remarked in regard to this Baudelairean analogy: 'rag-picker or poet — refuse concerns both'.[9] We might say something similar of *Analogue* and its maker, that *Abhub* — refuse, garbage, the discarded and scorned — is at the centre of their concerns.

These connections are perhaps most clearly articulated in a series of photographs that began in 2001, when Leonard was exploring the streets of Williamsburg in Brooklyn. Walking through a district of warehouses, small-scale industry and wholesalers found just north of the Brooklyn-Queens Expressway, she found large bales of used clothing stacked up on the sidewalk, of which she made a number of colour and black-and-white images, such as the photograph of Leonard Street, in Williamsburg, Brooklyn (2001), with its sculptural array of bundles shot at an angle against the red-brick wall of the building behind. Three years later, Leonard was able to trace the itinerary of these used clothes, which — like the majority of garments donated to charitable organisations in the US — were destined for markets in the developing world. In 2004 she visited Uganda and photographed the stalls and displays of local vendors, the end point of a long trajectory that began in donation bins in New York, to the kind of wholesaler she encountered on Leonard Street in Brooklyn, through worldwide buyers, and on to the streets of cities like Kampala. What is unwanted trash in the US returns as coveted goods in the Global South, in an early twenty-first century update of Baudelaire's *chiffonnier*. For this trajectory is indeed very contemporary: only since the early 1990s, and the imposition by the US

7 Charles Baudelaire, 'On Wine and Hashish', *Artificial Paradises* (ed. and trans. Stacy Diamond), New York: Citadel Press, 1996, p.7. Translation modified by the author.
8 These terms are derived from Ewa Lajer-Burcharth's outstanding discussion of this Baudelaire essay, found in her 'Modernity and the Condition of Disguise: Manet's "Absinthe Drinker"', *Art Journal*, vol.44, no.1, Spring 1985, pp.21—22.
9 Walter Benjamin, *Charles Baudelaire: A Lyric Poet in the Era of High Capitalism* (trans. Harry Zohn), London: New Left Books, 1973, p.80. Translation modified by the author.

and the IMF of trade liberalisation on the formerly protected economies of much of the developing world, has this trade in used clothing flourished. What Leonard captures in her Kampala photographs is in a sense the opposite of what she had been documenting in New York — not a residual economy being eradicated by global capital, but an emergent formation linked precisely to those transnational flows of money and commodities.[10]

This is not to claim that the politics of this global trade appears as Leonard's 'subject' in these photos, much less that she is offering a critique of this dynamic; the rise of an international trade in used clothes constitutes the horizon of possibility for these images, but their resolute focus on the point-of-sale in conjunction with the earlier images of bales in New York perhaps suggests her interest lies in what Arjun Appadurai has called 'the social life of things', or in a 'biographical approach to things' (a particular approach that has long existed within Leonard's oeuvre, from the *Trophies* and *Wax Anatomical Models* to *Strange Fruit* and *1961*, works spanning the late 1980s through the later 1990s).[11] In this sequence of *Analogue* she takes a processual view of her subject, tracing something like the life history of this commodity; we grasp the passage from clothing-as-use, to its withdrawal from usage, to its re-inscription within a commodity circuit, and a presumed second life in Africa. *Mitumba* and *salaula* (Swahili words for 'used clothing') become the latter-day echo of New York's *schmatte zamlers* — as the used-clothing dealers were known in this predominantly Jewish neighbourhood — and Paris's *chiffonniers*. And once again a self-reflexivity — an analogy between clothes and photographs — can be apprehended here: the circulation of these used garments stands in some relation to the circulation of her images. (And wasn't there something fated in the coincidence of encountering the used-clothing processor on a street name, Leonard, that is also hers?) 'Images' is

the wrong word in any case, since she insists on the materiality of the photograph and its support, in distinction to the contemporary turn toward digitised mobility and the dematerialisation of the image in projection: 'I [...] love how tactile a photograph is; [its] physical presence is very beautiful to me.'[12] Hence her predilection for the postcard — whose collection and display has occupied her almost exclusively in the years since completing *Analogue* — in which the photograph becomes a physical means of exchange and communication through space, a kind of token passed from hand to hand. It is perhaps relevant to add here that, in addition to its presentation as a large-scale installation and as a smaller portfolio of prints, *Analogue* exists as an artist's book, whose buckram cover recalls the standard library binding of older volumes and hence emphasises its passage among multiple readers.

Appadurai, in tracing the social life of things, was interested not only in their movement along well-trodden paths of commodity exchange but also in the possibilities for more eccentric diversions or subversions. Take the collector, for example, who removes or protects objects from the commodity context, who 'enclaves' them in a special zone outside the regulated flow of things. But that gesture, as he notes, is fundamentally ambivalent, since 'such diversion is not only an instrument of decommoditisation of the object, but also of the (potential) intensification of commoditisation by the enhancement of value attendant upon its diversion'.[13] The rag-picker as an analogue of the artist contains something of the same duality, on one hand embodying devotion to what has been rejected, cast off from the circulation of the capitalist economy — since 'it is precisely when they no longer circulate, as well-behaved commodities should, that things begin to give signs of a more subversive potential' — while on the other hand occluding what Theodor Adorno called, in a famous riposte to

10 The best account of this trade is found in Karen Tranberg Hansen, *Salaula: The World of Secondhand Clothing and Zambia*, Chicago and London: University of Chicago Press, 2000, although its focus on identity formation and consumer choice obscures the broader political dynamic. A good, journalistic account may be found in George Packer, 'How Susie Bayer's T-Shirt Ended Up on Yusuf Mama's Back', *The New York Times Magazine*, 31 March 2002. For the context of post-1989 trade liberalisation, see Naomi Klein, *The Shock Doctrine*, New York: Picador, 2007.
11 See Arjun Appadurai, 'Introduction: Commodities and the Politics of Value', in A. Appadurai (ed.), *The Social Life of Things: Commodities in Cultural Perspective*, Cambridge and New York: Cambridge University Press, 1986, p.13.
12 Z. Leonard, quoted in 'Zoe Leonard Interviewed by Anna Blume', in Kathrin Rhomberg (ed.), *Zoe Leonard* (exh. cat.), Vienna: Secession, 1997, p.12.
13 A. Appadurai, 'Introduction', *op. cit.*, p.28.

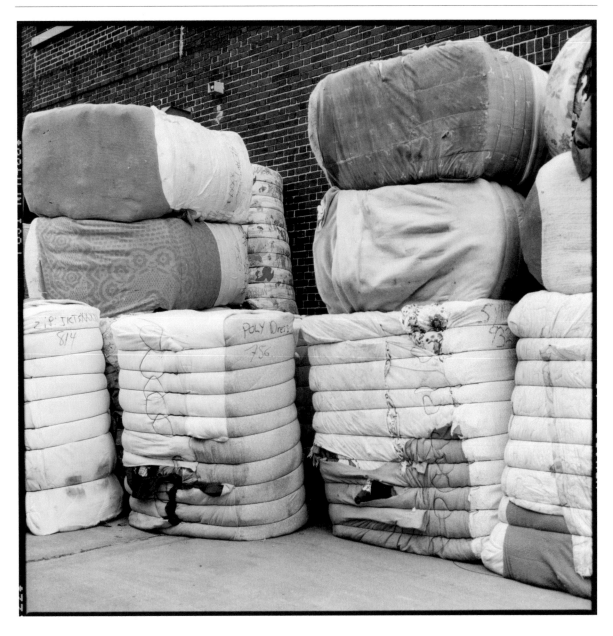

Zoe Leonard,
Analogue, 1998—
2009, 412 C-prints
and gelatin silver
prints, each print
28 × 28cm. Courtesy
the artist and Galerie
Gisela Capitain,
Cologne

Benjamin's characterisation, 'the capitalist function of the rag-picker — namely, to subject even rubbish to exchange-value'.[14] If poverty is not exactly made beautiful in *Analogue*, the dereliction of the urban landscape is brought within the precincts of the museum, where it coexists uneasily with its surroundings.

One more word is in order, however, before we leave this account of the artist-as-*chiffonnier*. For the analogy has been, throughout its history, a resolutely masculine one, closely bound up with that literature of modernity that has character-ised the modern city as a male preserve and

relegated women to the domestic sphere.[15] Indeed, such an explanation of *Analogue* risks separating it entirely from Leonard's longstanding queer and feminist practice, but there are compelling links between this project and the larger concerns of her work that allow us to see it, too, as somehow continuous with her gender politics. Most notably, the elegiac quality of *Analogue* — the mourning for a lost city — binds it to other works of mourning tied to the AIDS crisis; this is clearest in the photographs depicting abandoned storefronts where just the ghost of old signage remains, such as the image of Grand Street in Brooklyn (2001)

14 See Irving Wohlfarth, 'Et Cetera? The Historian as Chiffonnier', in Beatrice Hanssen (ed.), *Walter Benjamin and* The Arcades Project, London and New York: Continuum, 2006, p.15. For the Adorno quote, see Theodor Adorno and W. Benjamin, *The Complete Correspondence, 1928—1940* (ed. Henri Lonitz, trans. Nicholas Walker), Cambridge, MA and London: Harvard University Press, 1999, p.284.
15 The classic analysis remains Janet Wolff, 'The Invisible Flâneuse: Women and the Literature of Modernity', *Theory, Culture & Society*, vol.2, no.3, 1985, pp.37—46.

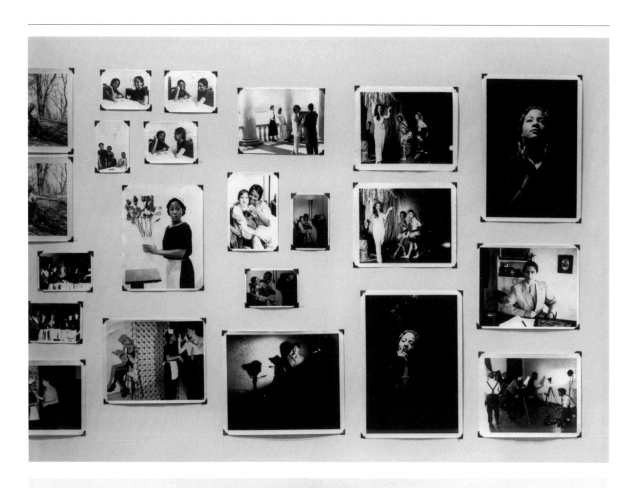

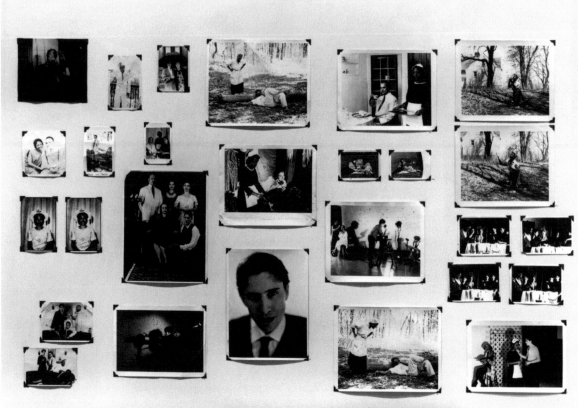

or Manhattan Avenue in Greenpoint, Brooklyn (2006), which recall the dried husks of *Strange Fruit* (1992—97), a body of work begun in the wake of David Wojnarowicz's death. Something similar may be detected in the prevalence of analogues for the human body or, to be more precise, for absent couples — pairs of empty chairs in the image of Rivington Street or of Avenue A, or two pairs of shoes in the photograph of Praga Market in Warsaw (all 1999). But we could say that there is something generally queer about the archive constituted by *Analogue*, that its conjunction of conceptual documentation and personal idiosyncrasy derives precisely from an awareness that lesbian and gay history has made clear that an archive 'must preserve and produce not just knowledge but feeling', that in fact the archive is a site of 'profoundly affective power'.[16] *Analogue*, like her explicitly queer documents such as *The Fae Richards Photo Archive* (1993—96), mobilises memory and affect to compensate for institutional neglect, now on the urban scale itself.

stark dichotomy of small business/large corporation implies what we might call an ecological view of the urban economy, with local stores that created a responsive, equilibrated ecosystem being eradicated by the invasive species of multinational brands, the 'honest' commerce of the former undone by the wastefulness of the latter. These views were already taking shape upon her return from a trip to India in late 1992, where she 'was impressed with how each scrap of paper [...] was used to its maximum, to the very end of its possible useful life', and further elaborated during her long sojourn in backwoods Alaska.[17]

The link is made clear in a recent interview, in which Leonard elaborates a series of questions implied in the photographs, and in her approach toward her subjects: 'How am I connected to people who make my clothes, to people who buy and sell my clothes and food? Who benefits from the connection? Who suffers from the connection?'[18] But the contemporary urban landscape is no distortion, and the dynamic transformation of the city recorded in

Waste, ruin, destruction are constitutive of present order, not mere surplus negativity, and capitalism thrives on crisis, not equilibrium. Analogue *brilliantly captures the surface of this world, the regrettable symptoms of an irrational economy.*

If this series looks back to a longer history of recording the lived effects of capitalism on modern urban agglomerations, and constitutes one of the most challenging and remarkable photographic documents of the present, we may nevertheless discern some of its ideological limits in the quoted description with which we began. There is much force in the statement 'my own neighbourhood is filled with the signs of a local economy being replaced by a global one, small businesses being replaced by large corporations, multinationals taking over', but perhaps also as much misrecognition; it was not only multinationals that were pushing out her mom-and-pop businesses, but more typically, as we have seen, other small, entrepreneurial shops now serving an entirely different social class. Leonard's

Analogue is no alien excess imposed on a more natural arrangement. 'People who denounce incitements to wastefulness as absurd or dangerous in a society of economic abundance do not understand the purpose of waste,' noted Guy Debord some four decades ago.[19] Waste, ruin, destruction are constitutive of present order, not mere surplus negativity, and capitalism thrives on crisis, not equilibrium. *Analogue* brilliantly captures the *surface* of this world, the regrettable symptoms of an irrational economy, but it cannot name the cause itself. And in that, it truly marks the ideological limits of a certain practice of photography as well.

16 Ann Cvetkovich, 'In the Archives of Lesbian Feelings: Documentary and Popular Culture',
 Camera Obscura, no.49, 2002, pp.109—10.
17 Z. Leonard, quoted in 'Zoe Leonard Interviewed by Anna Blume', *op. cit.*, p.17.
18 Z. Leonard, quoted in Beyfus, 'Zoe Leonard', *op. cit.*
19 Guy Debord, *The Society of the Spectacle* (trans. Donald Nicholson-Smith), New York: Zone Books, 1994,
 p.140.

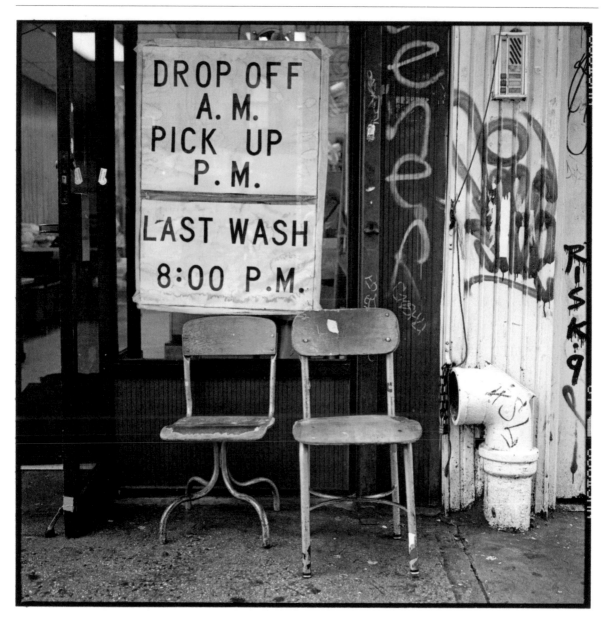

Zoe Leonard,
Analogue, 1998—
2009, 412 C-prints
and gelatin silver
prints, each print
28 × 28cm. Courtesy
the artist and Galerie
Gisela Capitain,
Cologne

Goats, Lamb, Veal, Breast: Strategies of Organisation in Zoe Leonard's *Analogue*

— Sophie Berrebi

Ironing boards come in fours, but mattresses and washing machines in threes, toeing the sidewalk and teasing the passer-by. TV sets regularly show up dumped in wheelbarrows. Chests of drawers, still wrapped in plastic, are heavily discounted, already obsolete. Shop windows flaunt spectacular compositions of washing-up liquid and Kleenex boxes, while white pumps (once-worn wedding shoes?) are a constant of market displays, like a muted running gag.

Sophie Berrebi looks at the structure of collage that informs Zoe Leonard's *Analogue* in its reflection on the history of documentary photography.

And so unfolds the world of Zoe Leonard's *Analogue* (1998–2009), a collection of over 400 photographs documenting small-scale local commerce and parallel circuits of global exchange. The significance of the project has been recognised since its first presentations at the Wexner Center for the Arts in Columbus, Ohio and at documenta 12 in 2007, yet what the series addresses, beyond the sheer breadth of the investigation, can only be recognised by exploring all of its modes of presentation. Existing concurrently as a book of colour plates, an archive installation of images and a series portfolio of individual prints, *Analogue* can be understood as a critical reflection on the history of photography and, even more pointedly, on the history of documentary photography.

Leonard has traced the origins of her project to 1998, when she began to record on camera the local shops gradually disappearing from the streets of her New York neighbourhood. From there she moved to a systematic exploration of a visual language of retail that ran parallel to the world of high-street chains and logos.

Exhibited together in image sequences of varying number — most often twelve prints and above — the photographs all display a black edge that indicates the negative of the print. This acts as a frame enclosing the shop fronts and the seemingly unlimited permutations of everyday objects within their displays. The square prints are arranged in grids, allowing the eye to travel up, down and diagonally, noting recurrences and subtle visual puns. So pervasive is the format that when Leonard's camera moves from urban window display to warehouses and then to rural market stalls, the black edge continues to suggest an invisible shop window, home to an intricate and ever varying assemblage of forms, textures and colours. Individual pictures respond to one another — up, down and across — revealing uncertain combinations of words, absurd poems and illogical slogans.

> GOATS
> LAMB
> VEAL
> BREAST

A list of goods on offer in a butcher shop's window reads as arbitrarily as those ready-made poems that Louis Aragon found on the walls of cafes in the soon-to-be destroyed Passage de l'Opéra, and which he meticulously reprinted in his novel *Le Paysan de Paris* (1926). Collage, however, is not just absurd or poetical. Another French writer, Georges Perec, likened the technique of collage to the form of the grid and invested it with an exploratory potential: in his words, 'a promise and a condition of discovery'.[1] Perec's proposition invites the viewer to read *Analogue*'s grid-like collage of photographs as a research project investigating the changing forms of commercial display from 1998 to 2009 along with its local economics and (geo)politics: recessions and

1 Georges Perec, cited by David Bellos in *Georges Perec: A Life in Words*, Boston: David R. Godine, 1993, p.347.

rehabilitations, shops closing down and moving out.

Having begun with recording the changing situation of local shops in the Lower East Side of Manhattan, Leonard eventually trailed off to pick up a different yet contiguous strand. In this second narrative, she followed bundles of used clothes collected in Brooklyn and sent off to other parts of the world. She observed and recorded secondhand retail in places such as Kampala, Mexico City, Warsaw and Budapest. From charity shops to market stalls, her photographs track an economy derived from gleaning akin to what Agnès Varda began to explore in her film essay *Les Glaneurs et la glaneuse* (2000). In Leonard's project, that ancestral rural tradition of picking up wheat left over after the harvest, which Varda chronicled, has taken on a global and economic turn and, moving from warehouses in Brooklyn to markets in Uganda, *Analogue* follows bundles of clothes from charity to resale. In this strand, the project invites comparison with that great narrative of global economic circuits: Allan Sekula's *Fish Story* (1990—95). There, following cargo ships in different harbours and the sailors who worked on them, Sekula provided a tangible view of the globalising economy. But where *Fish Story* is driven by an interest in global capitalism and its effects on people, and is underpinned by a didactic narrative and militant tone, the story recounted in *Analogue* progresses sideways, through analogies of forms and repetition of objects, through interwoven thematic strands that occasionally come together or dissolve altogether. And while Sekula's story is truly global, Leonard's project is steeped in New York, and more specifically even in that great portal for immigration that had been the Lower East Side from the end of the nineteenth century to the middle of the twentieth. The circularity of the journey made by these goods — sold in shops set up by immigrants from around the world and resold or donated to some of the countries where those shop owners originate from — is suggested by the juxtaposition of displays of New York shop windows and Polish or Ugandan market stalls.

Being immersed in New York and its history, Leonard's project is also infused with earlier photographic documentation of a mutable city. *Analogue* evokes those photographers from the 1930s, such as Walker Evans or Berenice Abbott in her

book *Changing New York* (1939), who, already at that time, aimed at recording a vanishing popular culture and architecture — both following in this the footsteps of Eugène Atget in Paris at the turn of the nineteenth and twentieth centuries. Leonard, however, does not cater to the American fixation on the vernacular. This distance may account for her absence from the Museum of Modern Art's exhibition 'Walker Evans and Company' (2001), which sought to present the artistic legacy of Evans precisely along those lines, turning him into a vivid hero and herald of North American culture. And there is nothing elegiac or fetishist in the references to earlier photographers that some critics of *Analogue* have noted. Indeed, streams of artists come to mind when leafing through Leonard's collection of images, from Ed Ruscha to Claes Oldenburg and Barbara Kruger (witness the sign reading 'TRUE DESIRES FOR BEAUTY' in the window of a beauty parlour).

Leonard's allusions to Abbott, Atget, Evans and others do not form a surplus of references but rather point to something that runs deeper throughout *Analogue*: a reflection on the photographic document, and beyond, on documentary photography and its history. This concern can be traced in Leonard's essay for the book version of *Analogue*. Written in the first person singular, 'A Continuous Signal' — a title that refers to a dictionary definition of 'analogue' reproduced in the essay — is made from a collage of quotations from writers, photographers and art historians. The text steers through the history of photography, beginning with early definitions of the medium as document and moving through to its applications. Charles Marville and Atget's work on Paris are evoked through their own words and that of their exegetes, alongside texts about the exploration of the territory of the United States through photography in the nineteenth century. Photography's role in colonialism and its use in ethnography are evoked by academics alongside writers such as Aimé Césaire and V.S. Naipaul, and are followed by reflections by modernist writers and photographers on their skill and trade. The words of Berenice Abbott and Gisèle Freund intertwine with those of Marcel Proust, Virginia Woolf and James Baldwin in a fascinating kaleidoscope in which recognisable citations alternate with lesser-known ones. All similarly

Zoe Leonard, *Tree + Fence, Out My Back Window*, 1998, gelatin silver print, 47 × 33.3cm. Courtesy the artist

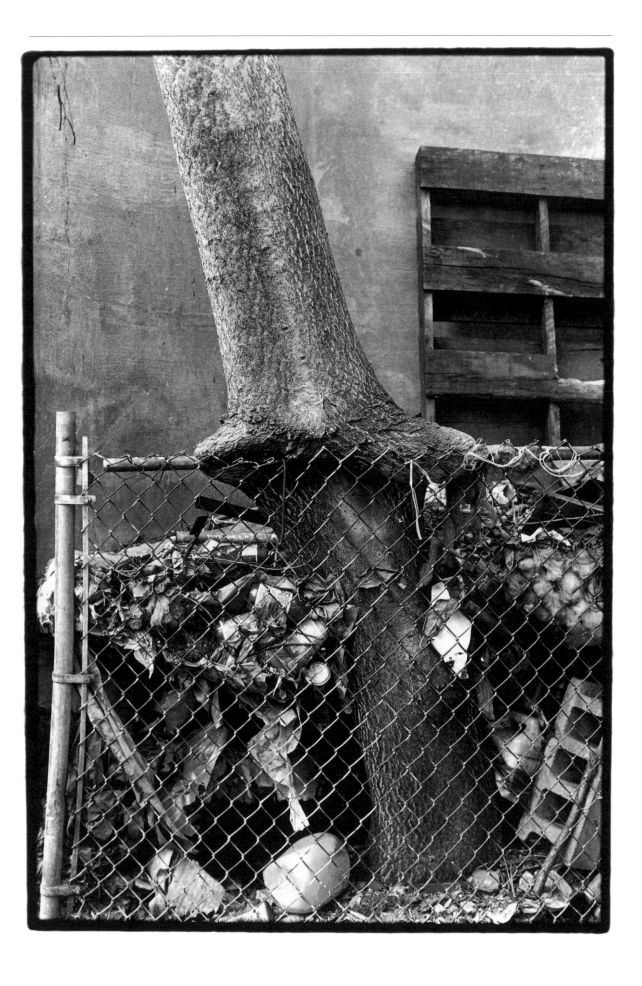

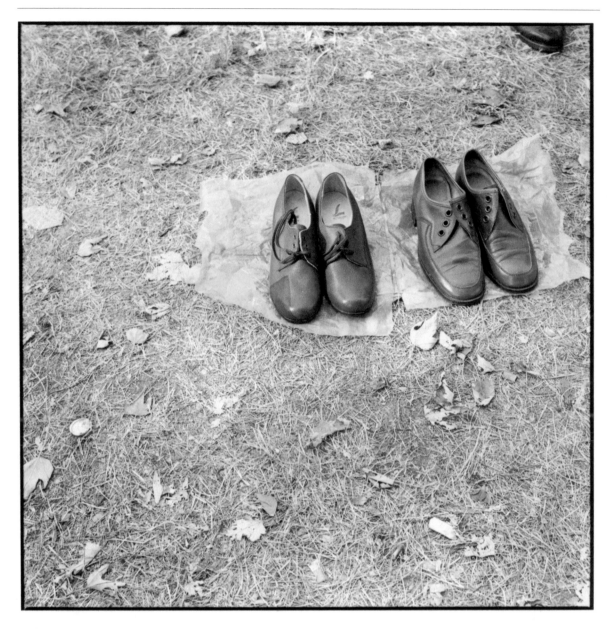

Zoe Leonard,
Analogue, 1998—
2009, 412 C-prints
and gelatin silver
prints, each print
28 × 28cm. Courtesy
the artist and Galerie
Gisela Capitain,
Cologne

constructed in the first-person singular, these quotations take on an oddly personal character, as if they were voice of the artist herself.

The literary form used by Leonard, with its strange mix of intimacy and distance, recalls Perec's exploration of impersonality in his novel *Un Homme qui dort* (1967), an autobiographical work paradoxically composed entirely from literary quotations. 'A Continuous Signal' is evocative in many ways of an impersonal autobiography *à la* Perec, above all in the way quotations provide an invitation to read and apprehend Leonard's manifold artistic production through the voices of multiple photographers and artists. But one may also read the essay as a textual analogue to the photographs in the book, in short, as *their* autobiography. The quotations propose a reflection on the definition and purpose of photography in different periods and places. More than the variety of sources as with the photographs, it is the very principle of collage that is significant here in the fragments of texts. To the idea that collage, like the grid, offered a 'promise and a condition of discovery', Perec added that collage underscored 'the will to place oneself in a lineage that takes all of past writing into account. In that way, you bring your personal library to life, you reactivate your literary reserves'.[2]

Such appears to be the self-assigned task of *Analogue*. As 'A Continuous Signal' integrates literally the voices of past photographers, Atget, Abbott and others from Leonard's personal library are 'brought to life', and appear to speak through Leonard in her particular choices of subject matter, editing and framing. As she takes in the history of documentary photography, she similarly takes on and interrogates the visual conventions that make up its history and have come to define the document, the documentary and the archive.

To the question of what documentary photography is today, *Analogue* answers that above all it is a genre permeated by its history, in which photographers fit into one another like Russian dolls. It is a genre in which Walker Evans discovers Eugène Atget through Berenice Abbott and in which Abbott notes that she wanted, in what eventually became *Changing New York* (1939), to 'do in Manhattan what Atget did in Paris', equipping herself with a view camera similar to his.[3] Decades later, picking up after Abbott and Evans, Leonard returns to Atget, making perceptible both a layering of references and a process of historical and cultural translation from one vision to another. The images that make up *Analogue* suggest both the nineteenth-century French idea of 'documentary', as well as its much later Anglo-American counterpart. The French notion derived from physicist François Arago's report to the Chamber of Deputies in July 1839, submitted to help fund the development of the Daguerreotype by having the French government purchase the patent. The report emphasised the purely descriptive qualities of the photographic image, putting forward the belief that photography could provide a more accurate visual descriptions of monuments than drawing. The Daguerreotype, Arago argued, provided an even scanning of surfaces that would show a greater fidelity of detail and a 'true reproduction of the local atmosphere'.[4] This idea of faithfulness to reality reappears several decades later in the first uses of the term 'documentary' in the French language, when in 1876 it was to characterise the Orientalist paintings of Eugène Fromentin and their ethnographic exactness.[5] Long before documentary became an actual genre, mostly photographic and cinematographic, the term documentary thus served to describe images or texts that provided information. Only much later did the term move from adjective to noun and become, thanks to film-maker and critic John Grierson, and subsequently Walker Evans and the WPA photographers in the United States in the 1930s, a genre. And documentary as genre also brought forth a set of issues about aesthetics and morality that would eventually prompt Evans, in the 1970s, to coin the ambiguous formula 'documentary style'.

2 *Ibid.*
3 Berenice Abbott, cited by Bonnie Yochelson in *Berenice Abbott: Changing New York*, New York: The New Press, 1997, p.14.
4 Francois Arago, 'Report', 3 July 1839, quoted in Alan Trachtenberg, *Classic Essays on Photography*, New Haven: Leete's Island Books, 1980, p.17.
5 Paul-Emile Littré, *Dictionnaire de la langue française*, tome 2, Paris: Le club français du livre, 1957, p.1789.

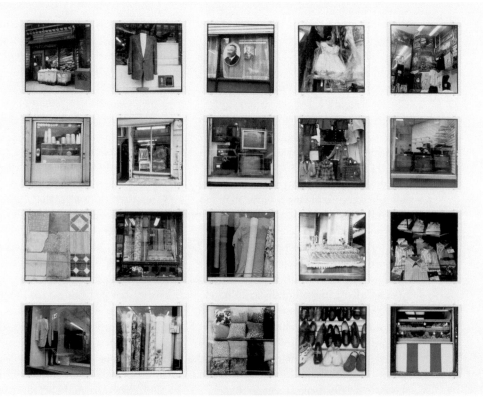

While Leonard's work has been produced and circulated mainly within an art context rather than a documentary or photographic one, an ongoing reflection on the document and the documentary can be seen in many of her projects, such as the *Tree + Fence* (1998–99) series of photographs of trees growing around fences. More specifically, however, the very diversity of her photographic practice as a whole — from the aerial views she produced in the late 1980s to the *Bubblegum* pictures of 2000 to 2003, or from her recording of street graffiti (1994–97) to the *Fae Richards Photo Archive* (1993–96) — shows a consistent investigation of different forms of the photographic document.

Reading *Analogue* from this perspective, the title of Leonard's project may refer primarily to photography as a descriptive tool, one that provides a visual equivalent to the world around it. The display of *Analogue*'s photographs shows the world mapped out and reconfigured into a series of visual signs on shop fronts, reduced to a similar format and arranged in a way that emphasises formal analogies and disruptions. Indeed, the systematised frontal shots and close-up views in sections of *Analogue* stress the images' flatness, and suggest an exhaustive scanning of the city for the purpose of a purely descriptive process.

Moving outside of the Manhattan grid and on to different geographies, the frame becomes looser, the viewpoint less frontal. The camera reveals here a little space around a market stall and points there downwards towards the floor to record a disparate collection of objects scattered across an old blanket. In these surroundings, unfamiliar to the artist, the camera seems to search for a position, to hesitate between what would be a more informative shot, both contextual and focused on its object, and a more systematic frontal view reminiscent of the New York images.

The awareness of photographic conventions is also built into the three modes of existence of *Analogue*, as a photography book, an archive installation and forty individual dye-transfer prints. While this division might result from practical concerns, it also corresponds to historically significant modes of preservation and circulation of photography. The archive refers to the collecting of photographic documents for investigative and recording purposes that originated in the nineteenth century. The photography book is the format that enabled the widest distribution of documentary photography, as opposed, for instance, to reportage or studio portraiture in the twentieth century. The exhibition print, finally, points to the presentation

Zoe Leonard, *Analogue*, detail. Installation view, Museo Nacional Centro de Arte Reina Sofía, Madrid, 2008—09. Courtesy the artist

of photography as art in the museum space, and refers to the enlargement of photographs to accommodate the posture of the standing viewer and the scale of the museum wall — an argument put forward by Hilla Becher to explain the different sizes of the prints she made with Bernd Becher, where the size of the images doubled from grid assemblages to single pictures on the wall. By contrast, the dimensions of Leonard's images are

Later series in Analogue *open up wider potential readings and their instability — as opposed to the strategies of the stable* fond d'archive *— is reminiscent of the principle of the database, in which categories can be called upon for particular requests, creating ever-changeable orderings of documents.*

relatively similar in each mode of presentation, suggesting that although *Analogue* reflects on the different purposes of photography, it ultimately locates itself beyond these different uses and concentrates instead on modes of circulation and distribution.

Testifying to this is the way in which *Analogue* reflects competing and concurrent ideas of the archive, from conventions of the nineteenth-century French *fond d'archive* to those of the contemporary database. The narrative that emerges through the dates given for each photograph and the temporally homogeneous sequences recalls the *fond d'archive*'s classification by provenance and in order of collection of documents. But this organisation, which historically was believed to yield the most coherent information, is supplanted in other thematic series in *Analogue* that result from permutations and rearrangements of documents culled from various sources and over different periods of time. These later series open up wider potential readings and their instability — as opposed to the strategies of the stable *fond d'archive* — is reminiscent of the principle of the database, in which categories can be called upon for particular requests, creating ever-changeable orderings of documents. The integration of divergent forms of the

archive echoes the coexisting strands of a project that explores not only the historical and geographical mutations of capitalism but also a multitude of local and global micro-histories identified by collections of shop signs, advertising posters, US flags and hand-painted logos. In this, *Analogue* epitomises the changing idea of the archive from a closed body of information for select users to an open one, an archive whose existence is defined by and dependant upon its public visibility, as epitomised by the extensive presentations of the project in Kassel, Madrid and elsewhere. Out of this dialogue with photographic conventions, histories and definitions of the archive, Leonard emerges with a project that exceeds its documentary function. As she constructs *Analogue* as an art project, Leonard relinquishes any particular purpose other than to question, deconstruct and expose the ambiguities of the archive and its documents.

Želimir Žilnik,
Rani radovi (*Early
Works*), 1969,
black-and-white
35mm film, 87min.

Previous spread:
Želimir Žilnik,
Nezaposleni ljudi
(*The Unemployed*),
1968, black-and-
white 35mm film,
13min. Courtesy
the artist

Shoot It Black!
An Introduction
to Želimir Žilnik

— Boris Buden

It's not easy facing up when your whole world is black.
— The Rolling Stones, 'Paint It Black', 1966

It is usually said that Želimir Žilnik is one of the most prominent directors of the Black Wave, a tendency in Yugoslav film that emerged in the wake of the political and economic liberalisation of the country in the 1960s and 70s, and presents the best that Yugoslavia had produced culturally in its short-lived history.[1] But what does it actually mean to be a protagonist in this cultural story from the communist past? To what does 'black' concretely refer in the phrase the 'Black Wave'? Let us start with this last simple question.

who had directly witnessed the actual reality but rather the 'condensed and suggestive artistic story and picture that this reality produced'.[3] In his view, this is why the future will have a black picture of Yugoslav society of the 1960s and 70s — because Yugoslav art, and above all Yugoslav film, painted this society black.

Isn't it interesting? In a society ruled by communists one would expect the voice of the Party to be at the same time the voice of the history itself — which *Borba*, the newspaper where this article appeared, undoubtedly was[4] — and not to tremble before this history helplessly expecting its final judgement. 'What will the future think of us?' This is not the question of those who

Boris Buden untangles the opposition to Želimir Žilnik's films and to Black Wave cinema, finding in the term's 1969 apparition a postmodern and post-communist turn indicative of Yugoslavia's shift towards identity politics.

The newspaper article from 1969 in which the notion of the 'Black Wave' was first introduced opens from a curious perspective.[2] The author looks at the reality of Yugoslavia from the perspective of several decades on — thus from today's present — and argues that this future will not be able to find 'our true picture'. That is, the authentic picture of Yugoslav society of that time is not in the 'yellowed yearbooks of the contemporary daily press', for 'this informative level stored in the archives and computer brains will fade into oblivion', but instead in the art made at the time. The future, as he states, will not believe those

are supposed to know the course of history and legitimise their rule precisely from this very future. Moreover, no law of historical materialism, no Marxist concept, however undogmatic and creatively enlightened, would endow art, that superstructural phenomenon, with the power to give the only 'true picture' of society and even to be the last word of history itself. And yet this is the logic on which the argument against the Black Wave film-makers relies. *Borba*'s critic accuses them of betrayal. But betrayal of what? Not, primarily, of reality: they are not so much blamed for having unfaithfully represented reality in their films — for

1 Inspired by Italian Neorealism and various new waves in European cinema, the authors of Black Wave rejected the norms and ideals of an optimistic, self-congratulatory official culture, and openly exposed the dark side of socialist society — above all its ideologically hidden capitalist truth that emerged with the implementation of market economy and its devastating social consequences, like unemployment, massive migrations of workers both within the country and abroad, poverty, crime, etc. The most prominent directors along with Žilnik were: Živojin Pavlović, Bata Čengić, Dušan Makavejev and Aleksandar Petrović.

2 Vladimir Jovičić, '"Crni val" u našem filmu', in *Borba*, 3 August 1969, pp.17—24. All translations the author's.

3 *Ibid.*, p.17.

4 For this reason I do not call attention to the name of the author of this particular article in this text. His personality is of secondary importance since his personal and public opinion at that time was immediately identified as the opinion of the Party itself.

painting it more black than it really is — but rather their real 'crime' consists in misrepresenting the society they belong to. So when the critic uses the notion of a 'true picture of our society', it is not so much the 'truth' that is at stake here — that is, a realistic representation of social life — but 'the picture of the society' that he is actually concerned about. He complains that society, in the Black Wave films, 'dresses in drag before taking pictures of itself'. But by that he obviously doesn't mean that it should take off its clothes and expose itself in full nakedness, as it really is.

This apparently slight shift in accentuation from 'truth' to 'picture' has far-reaching consequences. The real conflict between the critic and the 'traitors' doesn't take place where we usually project it from our post-communist perspective: between Communist ideology on one side and the autonomy of art on the other. The case of Yugoslav Black Wave is definitely not that of ideologically stubborn communist apparatchiks who try to impose the dogma of (socialist) realism on freedom-loving artists. Moreover, it is not even the socialist cause that the critic insists upon: the well-known discourse on the social function of art, of its programmatic role in building a new society, of its educational duties, for instance, or of its ability to boost optimism. A classical discourse of socialist realism is totally absent from this polemical text.[5] Instead, he argues that the problem with the pessimism of which he, and through his voice the Party itself, accuses the Black Wave film-makers is not that it spreads defeatism and so disarms the progressive forces of society, but rather that it spreads an unflattering picture of Yugoslav society. This is what the whole drama is about: how the society represents itself to the Other, both the Other abroad and the Other of posterity. Specifically, the authors of 'black films' are blamed for 'clownishly presenting the nation and the society for the sake of a cheap and ephemeral mundane fame'. In the eyes of the critic they are guilty of submission to the fashionable taste of the international market.

In support of his criticism he naturally calls on authorities. However, these are not Marx, Engels or Lenin, nor any of the Yugoslav Marxists or leading Party intellectuals. It is Bosley Crowther instead, legendary film critic for *The New York Times* and at that time art director of Columbia Pictures, who is quoted from an interview he gave at that time to a Yugoslav magazine: 'You Yugoslavs [...] you are so vital [...] you know how to look at women, you can laugh from the heart, you are open, there is an original joy of life in you. Why then are your films so bitter, so dark? What is the truth? You as I have seen you, or you as you present yourselves in the films? [...] Or is this all in your film a temporary fashion of pessimism which, with a certain delay, comes to your authors from abroad?'[6] Thus we have the official position of the Party on cultural issues at the time drawing its arguments from an identification with a Western-Orientalist gaze that imagined Yugoslavia as an exotic realm of authentic enjoyment of life and natural vitality.

But the question of representation becomes even more dramatic from the perspective of the future, or in relation to posterity. Again, at stake is the picture of the society that will survive it in works of art, or as *Borba*'s critic writes, 'a picture of us that is going to be bequeathed' to the future. He insists that we shouldn't be indifferent to this 'sort of recognition', for if the art is now painting this picture black, the future too will have a black picture of us.

Writing from a contemporary perspective, this all is to suggest that we must necessarily abandon our post-communist perspective if we really want to understand what that 'blackness' ascribed to a great deal of Yugoslav film production at the end of the 1960s was about. Not only because of all those unbearable clichés about the communist past (whose real ideological effect is not so much in blackening the utopia of the past but rather in brightening the actual one about liberal democracy and capitalism as the only exit solution of world history), but there remains one more, even better reason: the notion of the Black Wave was coined from this post-communist perspective itself.

5 Indeed, the author explicitly distances himself from any concept of an 'educational' function of art. For him it is 'didactically old-fashioned to ascribe any functional attribute to art'. He also labels the idea that art should deliver some sort of message as 'Zhdanovism', or the Party doctrine on Soviet arts and culture developed by Central Committee Secretary Andrei Zhdanov in 1946. Moreover, he openly writes that he would have some understanding for the 'blackness' of Yugoslav films only if they would stay within the 'art for art's sake' concept of art. V. Jovičić, '"Crni val" u našem filmu', *op. cit.*, p.19.
6 *Ibid.*, p.20.

Black Wave is obviously a concept forged in struggle, and implicates a certain instrumentalisation of art in that struggle. But what struggle? Not the one for a better — for instance, a just, classless, in short, communist — society. Here we are definitely not dealing with a story about art being (unjustly) caught in a social struggle. From the point of view of the critic who introduced the term 'Black Wave', the social struggle was already over, or more precisely, the social cause of the struggle had become obsolete. However, the struggle went on, but in another form, on another battlefield and for another cause. Now it was the struggle for recognition that was fought exclusively on the field of culture. What was at stake in this struggle was now *identity*.

The Black Wave was about a society struggling with art for the 'true' picture of itself, a society in the final struggle for its cultural survival.

It sounds paradoxical, but the position from which the voice of the Party announced its *j'accuse* against the Black Wave film-makers was the position of an already dead society — a society that had exhausted all its utopian potential and had reached the limits of its further expansion in terms of social justice and an overall social prosperity. It was a society that was facing its historical end, a society with no future whatsoever. It literally didn't see itself in the future, or better, it saw only an alienated picture of itself there, a picture that had been already appropriated by art, by the Black Wave films. This is why our understanding of the Black Wave cannot be reduced to a post-communist cliché about art struggling with society for its freedom. On the contrary, it is about a society struggling with art for the 'true' picture of itself, a society in the final struggle for its cultural survival. In launching this struggle in 1969, the communist critics of the Black Wave precisely proved to be post-communists long before all those democrats who would replace them later. They knew very well that they were no longer in command of history, but were still able to anticipate its development. Moreover, by occupying themselves exclusively with the question of cultural representations they had already accomplished that notorious cultural turn which would be later ascribed to postmodernism as one of its main features. Yugoslav communists of that time already looked at the society they were in charge of from the point of view of its cultural afterlife.

Of course, politically the Party was still identified with its historical mission — to radically change the society for the better — and still saw itself as being able to achieve this goal. But this, to use Lacanian terms, existed only on the imaginary level of their identification. In short, this was how Yugoslav communists identified with the ideal picture of themselves, with their ideal-ego. However, at the same time, but on a symbolic level, they identified with the gaze of the history itself — i.e. with their ego-ideal — in which they saw the society they had built surviving only in a cultural translation that fully escapes their control. They ruled society, but only in an imaginary realm. Symbolically they had already lost it — they had surrendered society to culture. For them, in 1969, the challenge was no longer to build a new, better society, but rather to properly represent the dead one. Thus, a true picture of social reality still seemed to be possible, but only in an anticipated cultural retrospective. This also marks a move within realism itself: from its socially prospective dimension (the concept of socialist realism deployed in the service of society as a utopian project) to a culturally retrospective realism. The latter is no less ideologically dogmatic than the former. The name of the dogma now is cultural memory — the only form in which social experience is still available to us today, in retrospect of course. The Party knew this in 1969.

Now we could probably answer the introductory question: to what does 'black' refer in the notion of the 'Black Wave' of Yugoslav cinema? It refers primarily to the end of society, to the experience of the abyss that opens up at this end, to that bottomless contingency one encounters after a social experiment — or, better, after the human experimentation with the social has been historically exhausted. It is the blackness that has absorbed all the utopian light that had hitherto clearly illuminated society's path to the future. In its subjective dimension it is the darkness of the fear we are filled with when we face, existentially, the terminality of society — that is, when we become aware of the possibility of its

total absence, in short, a social fear in its ontological dimension. [7] This is best expressed in the words of one of the most famous actors of the Yugoslav Black Wave, Bekim Fehmiu, who acted in European and Hollywood productions as well. In *Borba*'s article Fehmiu is quoted as saying: 'We have never lived better and yet, everything is black before our eyes.'[8]

However, to calm this fear and to pacify this ambivalence, a fetish was introduced: the fetish of cultural identity that also implied, within the political concept of sovereignty, national identity. At that time — the end of the 1960s and the beginning of the 70s in the former Yugoslavia — there was a major shift in the way Communists legitimised their rule. The narrative of class struggle was essentially abandoned. The Party stopped conceiving of itself as the vanguard of a universal history that would lead it to its classless end, communism. Instead it began to legitimate its rule within the history of a particular nation by identifying itself as its political elite, which, after having finally accomplished the goal of national liberation and achieved full national sovereignty,

was leading the (nationally framed) society into progress under the given historical conditions of a socialist regulated market economy and open participation in international *Realpolitik* and global capitalism. In short: the communist leaders of this era did not aim to adapt society to the communist utopia. Rather they adapted the communist utopia to a society that had fully identified itself with its nation. Of course, this fundamentally changes the situation on the so-called cultural front. The communists were no longer fighting in the trenches against the traditional bourgeois culture that was devoted to creating essentialist identities of the Yugoslav nations — Serbs, Croats, Slovenes, Bosnians, Macedonians, Montenegrinians, Albanians, etc. Rather they made a non-aggression pact with it — 'you leave politics to us, we leave national culture to you' (with a few clearly defined exceptions) — and so even strengthened their identitarian, that is, national legitimation. To stay in the saddle they had to mount a fresh horse of identity politics, and were now riding it blindly into the catastrophe of the 1990s.[9]

7 In terms of Heideggerian *Angst* that makes a subject experience society's being-toward-death.
8 V. Jovičić, '"Crni val" u našem filmu', *op. cit.*, p.20.

Above and left:
Želimir Žilnik,
Crni film (Black Film),
1971, black-and-
white 35mm film,
14min. Courtesy
the artist

To sum it up: identity or, in a slightly broader sense, cultural identification, was what from then on was able to offer a perspective of a life after the end of society. No wonder almost all grasped for it. But not all indeed. Some preferred not to.

The most prominent among those who entered the darkness at the end of society with their eyes — and the lens of their cameras — wide open was and still is Želimir Žilnik, whose entire filmic opus, extending over almost half a century, represents the most radical and consistent expression of its 'blackness'.

Moreover, Žilnik is the only one of the Black Wave film-makers who explicitly responded to the official accusation: 'You are blaming me for making black films. So be it, then.' In 1971 he shot a documentary,

which he titled literally *Black Film*. Žilnik picked up six homeless people from the street and brought them to his home, not only to share the warmth of a middle-class apartment (it was January), but also to actively participate in making a film about their problem. (This would become typical of Žilnik's documentary drama: allowing his amateur actors, whom the film story is about, to consciously participate in its making, or, in other words, to play themselves.)[10] The next day on the streets of Novi Sad he used his camera to enquire about how to solve the problem of homeless people in the city. Neither the passers-by nor the officials have an answer to this question. The film-maker himself doesn't have it either, for 'these stinky people', as he calls them in the film, cannot stay

9 With the new constitution of 1974 multiculturalism became the official ideology of Yugoslav state. The discourse on social justice didn't simply disappear from Yugoslav politics, it was translated into the new language of identity politics, which dominated politics — not, however, as an intra-social cause but rather as an inter-national one. The question of an (un)just redistribution is now posed not in relation of one class of society to another, but rather in relation of one republic — one nation — of Yugoslav (con)federation to another. This is clearly a post-socialist turn as it was defined by Nancy Fraser in her *Justice Interruptus: Critical Reflections on the 'Postsocialist' Condition*, New York and London: Routledge, 1997, p.2. It demonstrates a shift away 'from a socialist political imaginary, in which the central problem of justice is redistribution, to a "postsocialist" political imaginary, in which the central problem of justice is recognition'.

10 'I do not hide from the people I am shooting the fact that I am making a film. On the contrary. I help them to recognise their own situation and to express their position to it as efficiently as they can, and they help me to create a film about them in the best possible way.' Žilnik in an interview in *Dnevnik*, Novi Sad, 14 April 1968. Quoted in Dominika Prejdová, 'Socially Engaged Cinema According to Želimir Žilnik', in Branislav Dimitrijević et al., *For an Idea — Against the Status Quo*, Novi Sad: Playground Produkcija, 2009, p.164.

Želimir Žilnik,
*Pioniri maleni mi smo
vojska prava, svakog
dana ničemo ko zelena
trava* (*Little Pioneers*),
1968, black-and-
white 35mm film,
18min. Courtesy
the artist

in his flat forever. So, finally, after telling them that no solution to this problem has been found and that he is running out of tape, Žilnik asks those people to leave his home.

Again: what is black in this *Black Film*? The reality it depicts? The failure of communists to solve social problems? The notorious gap between a utopian promise and reality? No! It is the film itself, the very idea of art, especially film art, claiming power to change social reality — this is what is really black in *Black Film*. In fact it begins with the author saying to the camera: 'I used to make these films two years ago, but such people [the homeless] are still here.' The film is a radically honest self-reflexive critique of the idea and practice of so-called socially engaged cinema. Žilnik openly considers *Black Film* his own tomb. In a manifesto published on the occasion of the 1971 film festival where the film premiered, he calls the whole festival a 'graveyard'.[11] 'Black' here refers to the 'misery of an abstract humanism' and of the 'socially engaged film that has become a ruling fashion in our bourgeois cinematography'; it refers to its false avant-gardism, social demagogy and left-wing phraseology; to its abuse of a socially declassed people for the purposes of film; to the film-makers' exploitation of social misery, etc.[12] But, what is even more important, 'black' doesn't refer at all to a 'lack of freedom', which is usually presented from today's post-communist perspective as the worst 'blackness' of the communist past. In the 1971 manifesto Žilnik explicitly states: 'They left us our freedom, we were liberated, but ineffective.'[13] 'Black' refers to a chasm that no freedom can bridge, a chasm that will survive the fall of communism.

For Žilnik a film, and in a broader sense culture, however liberated from totalitarian oppression, will never provide a remedy for social misery. For him the emancipatory promise of culture is a bluff. In his mocking the authors of the socially engaged films from 1971 who search 'for the most picturesque wretch that is prepared to convincingly suffer', he already makes fun of the liberal inclusivism that twenty years later will impose its normative dogmatism on the cultural producers of the new (and old) democracies. We know that picture very well: one discovers somewhere on the fringes of society the victims of exclusion, those poor subaltern creatures with no face and no voice. But luckily there is an artist around to help them show their faces and make their voices heard. How nice: what a bad society has excluded, good art can include again. For, as one believes, what has been socially marginalised can always be made culturally central, that is, brought to light — to the transparency of the public sphere — from the dark fringes of society. The rest is a democratic routine: a benevolent civil society, sympathetic to the suffering of the poor and excluded, makes a political case of the social darkness; and as soon as party politics are involved, a political solution searched for and finally found, a law is changed and democracy is reborn, now more inclusive than ever before.

Not with me, answers Želimir Žilnik, already in 1971. He, who has been working his entire life with different kinds of so-called marginalised people — from street children, unemployed and homeless people to transvestites, illegal migrants, Roma, etc. — knows well what their 'blackness' is about. It is about where the society as society is absent and about what politics, however democratic, cannot represent: a 'blackness', which is rapidly swallowing that light we have historically gathered around.

11 Želimir Žilnik, 'This Festival Is a Graveyard', manifesto to the 18th Yugoslav Festival of Short Film, Belgrade, 1971. Published in Heinz Klunker (ed.), *XVII. Westdeutsche Kurzfilmtage Oberhausen* (exh.cat.), Oberhausen: Westdeutsche Kurzfilmtage Oberhausen, 1971.
12 *Ibid.*
13 *Ibid.* Reporting from the festival in Belgrade the same German critic, Heinz Klunker, criticises Žilnik for seeing the situation 'too darkly' and for underestimating the freedom that film-makers in Yugoslavia have been granted, a freedom that Žilnik, as Klunker writes, 'equates with pure complacency'. From H. Klunker, 'Leute, Filme und Politik in Belgrad', *Deutsches Allgemeine Sonntagsblatt*, 28 March 1971.

Concrete Analysis of Concrete Situations: Marxist Education According to Želimir Žilnik

— Branislav Dimitrijević

There is a widespread impression that cultural production of the Socialist Federal Republic of Yugoslavia (SFRY) followed a simple formula. On one side was the official, opportunistic culture which served ideological purposes, and on the other was the rebellious opposition, which took the form of 'dissident' political and artistic counter-action. Both positions are routinely presented as seamless and almost without any internal contradictions, and it is usually taken for granted that the 'dissident artist' was primarily an anti-communist critic of the Titoist regime. This is best borne out perhaps by the most prolific phase in Serbian cinema (from the mid-1960s to the mid-70s), when the ruling political structures grouped the films made during that period under the title 'Black Wave', and alleged that they distorted the image of the 'socialist reality'. However, when we look into the examples of the work of leading film-makers who began their production in that time (Dušan Makavejev, Živojin Pavlović and Želimir Žilnik), it is clear their political orientation did have Marxist foundations and, moreover, that their sceptical approach was motivated by a belief in the potential for critical thinking in the development of a socialist society.

With more than fifty films produced since the mid-1960s, Želimir Žilnik (born in 1942) might be the most prolific film-maker in the history of Serbian and Yugoslav cinema. His films, usually categorised as documentary fictions ('docu-dramas'), share a remarkable consistency in their cinematographic 'anti-style', their specific mode of production and their direct political engagement. Žilnik's films can be put in the ranks of leading cinematographic authors of the 1960s and 70s. His fictional documentarism (or his participatory docu-fiction) is characterised by his method of working with non-professional actors, which blurred distinctions between what is 'acted' and 'scripted', and what is 'spontaneous' and 'authentic'. This orientation, which has always been on the margins of 'film professionalism', was an integral part of Žilnik's mode of production — allowing him to work with budgets that have been miniscule even for the standards of local cinematography.

Branislav Dimitrijević looks at Želimir Žilnik's reinvigoration of socialist discourse and his fidelity to his 'lumpen-subjects'.

Let us start with his first full-length film, *Rani radovi* (*Early Works*, 1969), which won the Golden Bear at the Berlin Film Festival in 1969. At first glance it can be labelled 'Black Wave' if we focus on its harsh representation of the backwardness of rural life. But, as opposed to the documentary-realist intention of showing 'reality as it is', Žilnik inserted into the film an unlikely story about a group of young revolutionaries who embark on an improbable expedition to raise socialist consciousness among the 'folk' in the rural communities of the northern Serbian province of Vojvodina. Unlike official propagandist efforts in the SFRY after 1950s, they were inspired by the experience of post-revolutionary Russia, following the example of the Proletkult project, and attempted to foment direct cultural-political action among the masses.

However, our revolutionary group is confronted with major obstacles along the way: in trying to get from the city to the villages their hip Citroën 2CV car gets stuck in the mud; their highly informed Marxist-Leninist lectures are met with total misunderstanding from the 'masses'; and their attempts to build solidarity with the peasants are hampered by their learned phrases that imply that the peasant class will eventually disappear from the historical arena. Finally, they are beaten up by villagers, and the only girl among them is raped by a mob. In the concluding scene

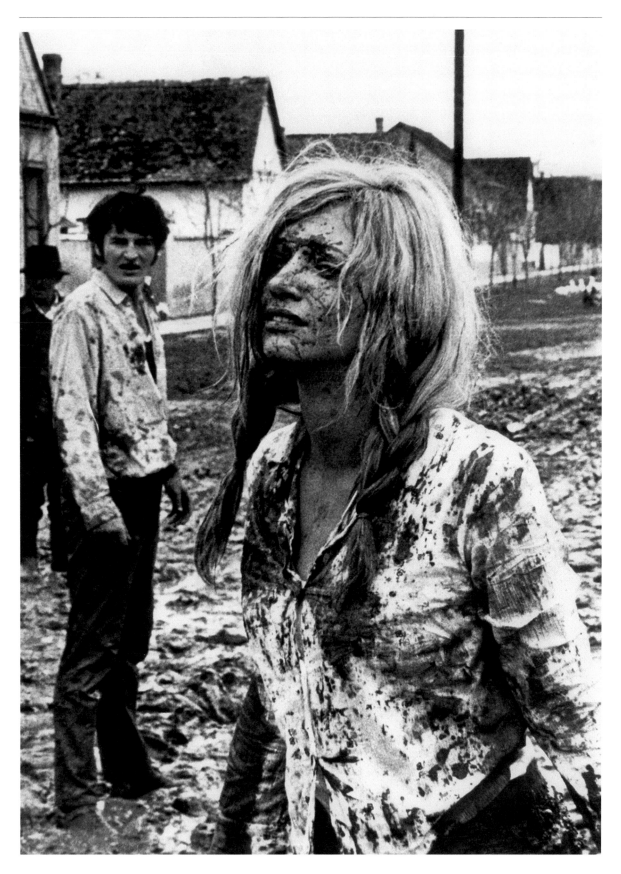

Želimir Žilnik,
*Rani radovi (Early
Works)*, 1969,
black-and-white
35mm film, 87min.
Courtesy the artist

she is killed by her comrades in a farcical revolutionary act.

The film may be seen as critical of the inapplicability of revolutionary discourse: the 'symptomal reading' of the ideological text brings about the deconstruction of the spontaneous experience of its meaning. However, the film is actually about the unleashing of the very enjoyment of revolutionary, avant-gardist behaviour: the group engages in heated theoretical-political verbal exchanges accompanied by sexual ones; they concoct playful Situationistic performances; and ultimately suffer grotesquely and sacrifice for revolutionary ideals. The film plays around with 'the sense for ideas that change the world', as its female protagonist declares. It does not attack the socialist system by ironically exposing the absurdity of the ideological discourse, but rather adopts that discourse over-enthusiastically. It not only makes a critical comment about the inapplicability of ideological discourse to practical circumstances of reality, but it shows a longing for the revolutionary thing — 'the ideas that change the world' — which disappeared in what was officially deemed an achieved socialist society.

So what is Žilnik's position vis-à-vis the notion of artistic and political dissidence within which his films were interpreted? His amateur beginnings in film-making — and also his own personal experience as a young communist activist in the early 1960s — led him to analyse and expose the discrepancy between the learned commu-nist rhetoric and 'desires of the masses'. Like Dušan Makavejev, who also once was a Party youth activist, Žilnik was an 'insider' to the ideology and not a detached, bourgeois critic. When discussing Makavejev, the film historian Daniel Goulding outlined the main subversive feature of some of his films by saying that Makavejev was 'at his best' when 'engaged in a self-irony which exposed the irony itself'.[1] Irony was in fact the main tactical tool of dissidents in social-ism. Films by directors such as Žilnik or Makavejev were not simple dissident pieces, but also quintessential accomplishments of what we might call 'socialist critical art'.

Žilnik's work marks an attempt to reinvent the complexity of Marxist discourse in relation to its concrete living form. *Early Works* is packed with quotations from early Marx that are juxtaposed with conflicting imagery.

Želimir Žilnik, *Rani radovi* (*Early Works*), 1969, black-and-white 35mm film, 87min. Courtesy the artist

1 Daniel J. Goulding, *Liberated Cinema: The Yugoslav Experience 1945—2001*, Bloomington, IL: Indiana University Press, 2002, p.74. Interestingly, in this, the most thorough survey of Yugoslav cinema-tography ever published in the English language, Žilnik's name is barely mentioned and only one of his films is (very briefly) discussed.

In an emblematic scene, one of the protagonists quotes a well-known line from *Capital* about rectifying the idealist core of Hegelian dialectics: 'The mystification which the dialectic suffers in Hegel's hands by no means prevents him from being the first to present its general form of working in a comprehensive and conscious manner. With him it is standing on its head. It must be turned right side up again, if you would discover the rational kernel within the mystical shell.'[2] As he quotes this metaphor, the camera rotates upside down, creating an inverted frame within which Žilnik's protagonists attempt to stand on their heads. This creates an arresting visual and political paradox. Whilst our perspective is turned upside-down, the protagonists trying to stand on their heads appear upright — until they fall down, and assume a position that the camera, as our extended eye, observes as inverted. The ideological or theoretical position here is clearly meant to be that of the viewer: the camera not only reflects but also makes us aware of the 'reality' of our own reflection.

If the above scene from *Early Works* may be perceived as a graph of Žilnik's political and aesthetic position, his statement of defence at a court in 1969 is an equally crucial key to his artistic and political stance. His film had been accused of making a gross attack on 'social and political ethics', but Žilnik overturned the prosecutor's arguments by asserting that the film was in line with the official policy of the time that legislated against depicting ominous deviations from the socialist project. These included: the Soviet intervention in Czechoslovakia, the unequal treatment of the Albanian minority in the SFRY, the policy of collectivisation, the widespread unemployment, etc. Instead of depicting such 'deviations', Žilnik made Marx speak through the mouths of his protagonists. This use of Marx reflected the politics of the student movement of 1968, which, by demanding a return to origins of Marxism in a socialist country, had a complex and contradictory nature. In his defence at the court Žilnik concluded: 'All resistance movements in the world, regardless of their success, are inspired by the ideas of the classics of Marxism. This

only goes in favour of the vitality of these ideas. It is impossible to reserve the ideas of the classics only for some official forces. This film shows that these ideas may inspire tendencies which in their concrete touch with reality show dilettantism, inadequacy, leading to the well-known incongruity of thoughts and actions.'[3]

At the same time, many found the ambiguity of shifting perspectives portrayed in Žilnik's film difficult to accept. Both the official party apparatchiks and a number of local film critics tried to identify an 'objective' perspective which would give meaning to the actions and the thoughts of the film's protagonists. This 'objective' perspective may actually be another word for the *idea*, the governing principle of idealist theory that Marx urged to ground in historical principles. The tragicomic failure of Žilnik's protagonists in this film may be found in the 'idealism' that led to their impossible mission of 'educating' the peasants. When they face the 'material world' manifested in the concrete situations they find themselves in, certain basic tenets of Marxist thinking are not simply contradicted but challenged in accordance with those very same tenets. Žilnik's experimental attitude was an attempt to go beyond simple contradictions (usually manifested in the dichotomy between what was 'official' and what was 'dissident') and, following the logic set out by the 'materialist dialectic' — to use this inverted term as it was originally used by Engels, which seems more appropriate than the 'dialectic materialism' perverted by Stalinism — to locate symptomal opposites in material practices through which they may be set in motion and not left in their idealist contradictions.

Yet neither the official nor the dissident discourse could accommodate the notion that *Early Works* was not a critique of socialist reality but a critical re-invigoration of the socialist discourse. This might also be why Žilnik has been even more marginalised than other film-makers identified as 'Black Wavers', and also the reason why, when the shift of ideology was made apparent in the 1980s and the 'counter-revolution' fully manifested in the 1990s, he remained ostracised by the local cultural establishment.

2 Karl Marx, 'Afterword to the Second German Edition', *Capital*, vol.1, 1873. Available at http://www.marxists.org/archive/marx/works/1867-c1/p3.htm (last accessed on 15 June 2010).
3 Žilnik quoted in Bogdan Tirnanić, *Crni talas*, Belgrade: FCS, 2008, p.73.

As Žilnik recently summed up, the biggest difference between the official ideology under socialism and what happens to be a 'post-ideological' discourse of the 'transitional' politics in states such as Serbia is that whilst today it is impossible to intellectually, artistically and politically challenge a dominant stance in an open discussion with politicians in power, in the SFRY in the 1960s, for example, it was common to have substantial arguments with main ideologists or decision-makers in cultural policy. Žilnik has told an anecdote where Ivo Vejvoda, a leading diplomat and an influential politician in the SFRY, criticised the director for focusing so much on the lumpenproletariat, as it was 'well known that the lumpenproletariat was a regressive force without class consciousness'. This remark perhaps was an expected criticism of Žilnik's work for creating a 'negative' representation of Yugoslav society, one declaratively based on the class consciousness of the working class. It is clear that almost all of Žilnik's early documentary films have as protagonists characters who may be typified as lumpenproletariat: those without jobs in *Nezaposleni ljudi* (*The Unemployed*, 1968), the street kids in *Pioniri maleni mi smo vojska prava, svakog dana ničemo ko zelena trava* (*Little Pioneers,* 1968), the homeless in *Black Film* (1971). Also, after the fall of communism, Žilnik focused on unemployed refugees, smugglers, prostitutes, transsexuals, petty-thieves or vagabonds in films such as *Stara mašina* (*Old Timer,* 1989), *Marble Ass* (1994), *Kud plovi ovaj brod* (*Wanderlust* (1998), *Kenedi se vrača kuči* (*Kennedy Goes Back Home*, 2003), *Europa preko plota* (*Europe Next Door*, 2005), etc.

The lumpenproletariat indeed were an unwanted surplus within socialism, as are the classes who are socially, economically and culturally excluded within liberal capitalism today. Yet, the lumpenproletariat became an important political force when they were grossly manipulated during the regressive nationalistic processes that led to the demise of Yugoslavia in the late 1980s, and during the wars of the 90s. It was actually Marx who callously described the group as 'this scum of the depraved elements of all classes [...]

decayed roués, vagabonds, discharged soldiers, discharged jailbirds, escaped galley slaves, swindlers, mountebanks, pickpockets, tricksters, gamblers, brothel keepers, tinkers, beggars, the dangerous class, the social scum, that passively rotting mass thrown off by the lowest layers of the old society.' [4] In *The Eighteenth Brumaire* (1852), the lumpenproletariat is identified as a 'class fraction' that constituted the political power base for Louis Bonaparte of France in 1848. Marx argued that Bonaparte was able to place himself above the two main classes, the proletariat and the bourgeoisie, by resorting to the lumpenproletariat as an apparently independent base of power, while in fact advancing the material interests of the bourgeoisie. The same move was repeated during the collapse of Yugoslavia and the insurgence of Slobodan Milošević and his clique.

Furthermore, it was Leon Trotsky who rightly perceived the lumpenproletariat as especially vulnerable to reactionary thought. In his collection of essays *Fascism: What It Is and How to Fight It* (1944), he describes Mussolini's capture of power: 'Through the fascist agency, capitalism sets in motion the masses of the crazed petty bourgeoisie and the bands of declassed and demoralised lumpenproletariat — all the countless human beings whom finance capital itself has brought to desperation and frenzy.' [5] Instead of putting out of sight this 'underclass' deprived of any structural role in socialism, Žilnik gave them voice by the simple process of giving them leading roles in his films. He not only intended to make them visible but also to question inherited ideological attitudes towards them. He did not narrow down his approach to a humanistic principle of empathy with the underprivileged, but explored the unpredictability of the political and the social role of this group.

Perhaps the most important social and political impact of Žilnik's films is their timeliness in relation to social issues and political symptoms. Such an attitude was not limited to political events in Yugoslavia. After the widely discussed political backlash against the Black Wave in the mid-1970s, when he found himself fully

4 Karl Marx, *The Eighteenth Brumaire of Louis Bonaparte*, 1852. Available at http://www.marxists.org/archive/marx/works/1852/18th-brumaire/ch05.htm (last accessed on 15 June 2010).
5 Leon Trotsky, *Fascism: What It Is and How to Fight It*, 1944. Available at www.marxists.org/archive/trotsky/works/1944/1944-fas.htm (last accessed on 15 June 2010).

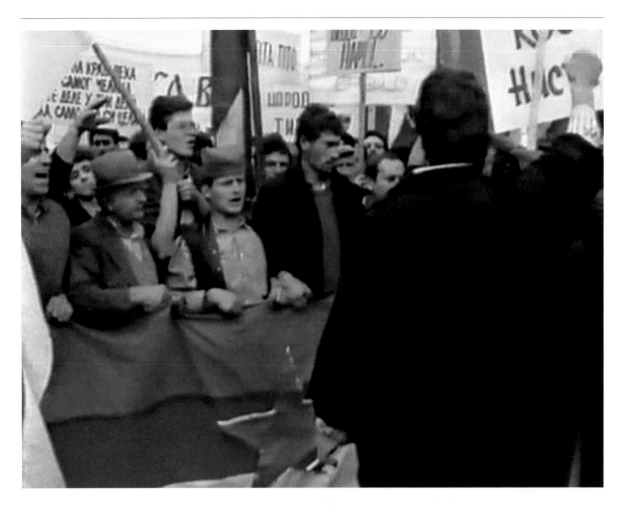

Želimir Žilnik,
Stara mašina
(Old Timer),
1989, colour 16mm
film, 81 min.
Courtesy the artist

isolated and unable to produce any new projects in Yugoslavia, Žilnik moved to Germany, where he managed to make a few short films. His work in Germany did not exploit his socialist experience (as with many dissident writers and artists who had left socialist countries); rather, his interest shifted towards analysing relations between ideological discourse and social practice in Western capitalism. His first film made in Germany, the documentary *Öffentliche Hinrichtung* (*Public Execution*, 1974), remains a rare example of a film prohibited in Germany immediately after its completion. [6] The film is about a group of left-wing terrorists who are shot dead in front of TV cameras after robbing a bank. It presents this event as a public execution, performed in front of the press, who have been informed about the intentions of the police in advance. In such a way Žilnik exposed the role of the 'free media' in the West in creating the anti-terrorist hysteria that still shapes the ideological discourse of liberal democracies. In recent years, he has returned to the political symptoms

of European liberal democracies in films such as *Wanderlust* or *Tvrdjava Europa* (*Fortress Europe*, 2000) and the three films featuring his Roma (anti)hero, Kenedi Hassani (*Kennedy Goes Back Home, Gde je bio Kenedi 2 godine* (*Kennedy, Lost and Found*, 2005) and *Kenedi se ženi* (*Kennedy Is Getting Married*, 2007).

Furthermore, we may interpret his 1980s films made for TV (produced with the support of liberal editors of cultural television programmes in the late years of the SFRY) as foreshadowing major predicaments of the coming economic and ideological transition. The TV series *Hot Salaries* (1987), for instance, explores the tactics of the underprivileged in accustoming themselves to new forms of market economy by unearthing their entrepreneurial promise. His heroes are people with some potentially 'profitable' features or skills: a man who swallows and digests metal and glass objects, strippers performing in village pubs, their shady provincial managers or uneducated labourers learning to sell whatever might bring them an income. In 1988 he produced

6 See Petar Jončić, *Filmski jezik Želimira Žilnika*, Belgrade: SKC, 2002, p.72.

the TV film *Bruklin-Gusinje*, which dealt with Serbian-Albanian relations — whose social and political implications were ignored for decades, causing miscommunication and alienation that proved ominous for the years to come.

In his TV film *Old Timer*, an aging Slovenian rocker who worked as a DJ at a radio station gets sacked and decides to move 'south'. Eventually, he becomes involved in protests against the Party bureaucrats (known as the 'yoghurt revolution') held at that time in Novi Sad. These events ultimately brought Milošević to power, and were indeed not some spontaneous revolt, as it was presented by the media which he already controlled, but were organised by Milošević's own faction in the Communist Party. *Old Timer*

participates in these events but cannot accurately decipher them.

There have been more than forty years between *Early Works* and Žilnik's most recent full-length docu-drama, *Stara škola kapitalizma* (*The Old School of Capitalism*, 2009). The ideological landscape has changed, but not the director's own political and artistic attitude. This time Žilnik's lumpen-subject personifies the fate of the old working class as it is humiliated by new private owners of old socialist companies. In the film this subject is caught in a paradoxical space between unkept promises made by these 'new capitalists' and the idealistic demands for direct action advanced by the group of young anarchists (comparable to their predecessors in *Early Works*),

is a film about ideological confusion, about the inability to understand new political events with the old mindset of things being either 'official' or 'non-conformist'. Žilnik detected a form of politics in which the revolution is not the domain of freedom but a form of a state-organised, in-house coup. What was understood as normative ideology with its dichotomies was turned upside down. Now the underprivileged had become a dangerous force in the implementation of the new form of fascism, and the main protagonist of this film, unaware of this new ideological current, displays the confusion characteristic of 'ageing' non-conformists raised on an ideology of protest. He observes and partly

who offer their help to coerce the capitalists to pay their dues to the workers. Again, we may observe this film as a harsh criticism of the unjust and bizarre manifestations of the post-communist moment, but the film first of all is a complex political essay that seeks to define and locate the subject of politics today and to determine how in conditions of social fragmentation one can find common ground for political action.

Žilnik's films never offer a righteous point of view but instead critically explore the film-maker's own beliefs and assumptions. For a concluding argument, there is no better example than his short docu-drama *Black Film* from 1971. The camera follows Žilnik, who comes across

a group of ragged homeless men in the middle of the night in the town of Novi Sad, and offers to let them stay in his two-room flat until he can find some way to help them out. By tackling the topic of homelessness, Žilnik took a critical position in relation to official socialist discourse which, in spite of declared social equality, was unable to resolve problems of poverty and homelessness (which officially 'did not exist' in the SFRY). He presented himself as someone whose task and conviction was to intervene, and to intervene not on the level of declaration (as was typical for the dissident position) but to intervene with concrete actions.

The scene which follows his offer is shot in the film-maker's apartment, where he brings the homeless from the street and

appendix to this story, the Žilniks allegedly divorced soon after this film.)

Black Film shows the self-justifying and self-serving position of humanistic compassion, characteristic of left-wing liberals, to be fundamentally misleading. Žilnik even caricatures his own position by suggesting that his attempt to help the homeless is carried out just for the purposes of shooting the film. Finally, he also opens up one much-less discussed topic of the relation between someone's public goal and his or her personal or intimate concerns: the film chronicles not only a social failure but also a failure in intimate life, stressing the problems of negotiating social engagement alongside family life. By literally bringing social issues to his private home Žilnik intervenes in both domains, and

Above and left:
Želimir Žilnik,
Stara škola kapitalizma
(*The Old School of Capitalism*), 2009,
DV and HDV,
122min.
Courtesy the artist

wakes up his wife and young daughter in order to make room for the five men in their home. The same logic of spontaneous, participatory documentarism of this film applies both to the public and the private sphere. The film-maker's wife was not prepared for the sudden 'humanitarian work' of her husband nor for the unpleasant invasion of her privacy she suffers in the following few days. Meanwhile, the film crew are again on the streets, exploring all possibilities of finding a lasting solution for his 'guests', but without any success. All Žilnik's attempts end up in failure, and after a few days he is forced to announce to his protégés that he must kick them out, back onto the streets. (To add a biographical

in both domains he meets with failure. The formal dualism of the social and the personal is to be overcome in this attempt, but the mode of overcoming this dualism is precisely in the failure and not in some successful utopian synthesis. The dialectic method looks for the transcendence or fusion of opposites; in this case failure, as a binding factor, provides the justification for rejecting both alternatives as false and thereby helps clarify a real but perhaps veiled integral relationship between opposites that are normally held to be kept apart and distinct.

Another Criteria... or, What is the Attitude of a Work *in* the Relations of Production of Its Time?

— Marion von Osten

I just wanted to do it and get it over with so I could go home and watch TV.
— Frank Stella [1]

The editors of *Afterall* have asked me to reflect on an article titled 'Producing Publics —
Making Worlds! On the Relationship between the Art Public and the Counter-public',
a consideration of art and curatorial practices of the 1990s that I originally gave as a lecture
in the context of 'Never Look Back', an event at the Shedhalle Zurich in 2000. This text
has been published over the last decade in a variety of adaptations and translations. [2]
Even though the published versions differ considerably, the impetus behind their central
arguments remains the same: the methodological shifts of feminist and collective artistic
practices of the late 1990s, which in my opinion constituted new forms of publics or
publicness. Specifically, I referred to what I have called the 'project exhibition', a practice
combining artistic, curatorial and discursive practices that I posited as distinct from
thematic or curated art shows, in which artworks are selected
in relation to a specific topic or issue. Project exhibitions, as
well as other forms of exhibition-making by artists and cultural
producers, established a counter-model to conventional group
and solo show formats. On the one hand, exhibition-making as
an artistic practice belongs to a long tradition that has it roots in
the modern avant-gardes' critique of the museum's institutional
order and the selecting processes of juries, boards and curators.
On the other, it relates to the expansionist mode of artistic practice
itself, as a result of which the gallery space is used as a site for
intervention, action or denial, as Brian O'Doherty suggests in
Inside the White Cube (1976). [3] Art institutions, as these practices
exemplified, are not neutral containers for the presentation of works of art but are
historical, material and symbolic frames of reference and influence. Museums and
galleries produce novel spaces and ordering systems of knowledge as well as specific
modes of viewing, and knowing by viewing, in public. [4]

Exhibition-making by artists has precedents in twentieth-century art, starting with
the self-organised Dada Salons, Marcel Duchamp's interventions into installation display,
or, as a particular example, in the almost forgotten counter-exhibition that took place
opposite the International Colonial Exhibition in Paris in 1931. [5] This show, 'La Verité sur
les colonies' ('The Truth about Colonies'), was organised by the Anti-Imperialist League

Marion von Osten looks back on the 'project exhibitions' of the 1990s and how artistic practice has responded to the social and economic shifts of the last twenty years.

1 Quoted in Caroline A. Jones, *Machine in the Studio: Constructing the Postwar American Artist*,
 Chicago and London: University of Chicago Press, 1996, p.121.
2 First in the international feminist art journal *n.paradoxa*, edited by Katy Deepwell in 2001 ('If White
 Is Just a Color, the Gallery Is Just a Sight?', issue 15, July 2001, pp.46—51), and subsequently in the
 Swiss feminist periodical *Olympe*, guest-edited by Ursula Biemann and myself in 2003 ('Dispersion:
 Kunstpraktiken und ihre Vernetzungen', issue 19, December, 2003, pp.59—72); in *Compléments
 de Multitudes 15*, guest-edited by Brian Holmes in 2004 ('art contemporain: la recherche du dehors',
 issue 15, Winter 2004, pp.239—49); in *Critical Readers in Visual Cultures: In the Place of the Public Sphere*,
 edited by Simon Sheikh ('A Question of Attitude', issue 5, 2005, Copenhagen and Berlin: Øjeblikket
 and b_books, pp.142—66); in *Architecture and Participation*, edited by Peter Blundell Jones, Doina
 Petrescu and Jeremy Till (Oxon: Spon Press, 2004, pp.201—10); in the *Publicum: Theorien der Öffentlich-
 keit* reader, edited by Gerald Raunig and Ulf Wuggenig in 2005 (Vienna: Verlag Turia + Kant, pp.124—39);
 and last but not least in the *Curating Critique* reader, guest-edited by Dorothee Richter, Barnaby Drabble
 and Marianne Eigenherr (ed.) in 2007 (Frankfurt a.M.: Revolver, pp.230—45, 246—61).
3 See Brian O'Doherty, *Inside the White Cube: The Ideology of the Gallery Space*, San Francisco:
 The Lapis Press, 1986.
4 See Reesa Greenberg, Bruce W. Ferguson and Sandy Nairne (ed.), *Thinking About Exhibitions*, London and
 New York: Routledge, 1996.
5 See Brigitta Kuster, 'Sous les yeux vigilants/Under the Watchful Eyes: On the international colonial
 exhibition in Paris 1931', 2007, available at http://eipcp.net/transversal/1007/kuster/en (last accessed
 on 29 June 2010).

and sympathisers in the Surrealist movement, and through it artists of the historical avant-garde not only questioned the division of labour between the mediators and the producers of art and culture, they also created counter-narratives to the official racialised, colonialist representations as manifested in the International Colonial Exhibition. Moreover they helped to constitute a specific sociality in which resistance movements, workers' coalitions and artists went up against the colonial propaganda machine of imperialism. Exhibition-making was transformed into a medium, into an intervention and a form of political articulation. The collaborative process put into play in producing the exhibition thus formed a new constellation for the resistance movements and their publicness. 'La Verité sur les colonies' can, in this way, be called a project exhibition, as it used the exhibition format as a communicative platform, as a space and practice for and of a counter-public.

Exhibition projects and spaces generated by postmodern artists also went deliberately beyond linear communication structures, primarily in order to establish new forms of collaboration that pointed beyond the actual site of the exhibition and the field of art itself. In the late 1960s, for example, women discussed the ongoing issue of exclusion from art institutions and took a range of stances on the art-space context, its claims and antagonisms, and its power to constitute Western societies. The feminist art movements of the 1960s and 70s utilised self-organised exhibitions and spaces for the establishment of new publics — publics outside the boundaries of dichotomous sexuality who would be capable of developing new forms of collaboration and cooperation. These activities came about partly because female artists were then even more forcefully excluded from the official spaces of art than they are today, and partly because the underlying conditions of production and representation were patriarchal and Eurocentric. Another important aspect was that of collaboration, which in High Modernism had mostly been the province of white men. Feminist art actions took place as well in the urban space, involving a new public — for example in performances by VALIE EXPORT, Adrian Piper or Mierle Laderman Ukeles.

At the same time, female artists continued to use 'white cube' exhibitions as a form of communication and, in the course of the 1970s and into the 80s, increasingly began to open these up to everyday cultural and experimental practices. Feminist groups tried out new working methods and concepts of publicness that contrasted with the abstract public of the exhibition space, such as *Womanhouse* (1971—72), the large-scale cooperative project executed as part of the Feminist Art Program at CalArts in Valencia, California by Judy Chicago and Miriam Schapiro, or the A.I.R. Gallery in New York.[6] The focus on women-related subjects was central in the 1970s, but — like feminist discourse in general — feminist artists' exhibition-making underwent a process of change throughout that decade. Feminist artists moved to stress not only identity issues ('we women') but also macropolitical discourses. What was feminist about non-identity or post-identitarian projects was their method: their emphasis on informal networks, on the formation of new publics and a collectively developed, embodied knowledge and aesthetic practices.[7]

Against this background, the 'project exhibition' of the mid-1980s united several of the debates described above and attempted to integrate the experience of alternative artistic practices into the exhibition: again, the opening up of the art space to a non-art public; the collective production of new 'knowledge spaces'; the self-assertion of social groups as opposed to their symbolic representation; the use of the art space for political discussions; and the establishment of transdisciplinary networks that could be active and productive in areas of society beyond the exhibition context.[8] Alongside classical counter-public strategies, which were key in the 1970s, artists tried out new production and distribution models, adapting the format of the exhibition by including curatorial, theoretical and research processes in their production. Thus the practice of artist-led exhibitions was also informed by the counter-cultural use of the exhibition space by small leftist, anti-racist and most of all feminist collectives, which established tactical, marginal uses of exhibition spaces for possibilities of self-articulation and action. One criterion of a project exhibition is that the exhibition itself would be used to intervene in a specific and local hegemonic setting or context and its representational politics, rather simply selecting and staging existing knowledge and artworks.

The format of the project exhibition I referred to in 'Producing Publics — Making Worlds!' was mainly established in the late 1980s and 90s by artists who curated shows

Current Issues
series event,
mid-1980s, A.I.R.
Gallery, 97 Wooster
Street, New York.
Courtesy A.I.R.
Gallery

in collaboration with actors from other social or cultural fields with specific purposes in mind. The exhibition 'If You Lived Here...' at the Dia Art Foundation in 1989, organised by the artist Martha Rosler, is a paradigmatic example.[9] In the show Rosler focused on homelessness and the related processes of gentrification, not just because they were relevant issues at the time, but because the gallery was located in a gentrifying area and was thereby involved in the transformation process itself. The exhibition also addressed the gallery's surroundings in terms of audience — in that potential visitors to the gallery were simultaneously actors in the gentrification process — and in terms of how other audiences could enter the gallery space and participate in the project, despite their not being generally acknowledged as an art public nor as producers of culture. The fact that each exhibition space defines a specific type of public that has normative force also implies the potential of its alternative use: to address and involve audiences who are generally separated from the art public due to disciplinary divides or the social or class order.

As opposed to classical curatorial or scientific approaches, project exhibitions involve people from diverse fields of knowledge in developing the concept or the realisation of the show. Project exhibitions, in this sense, use the white cube of the gallery or museum

6 A.I.R. (Artists in Residence, Inc.) was the first women's cooperative gallery in the US, founded in 1972 as a response to the resistance of the art world to art made by women. It is a non-profit organisation supported and run by its membership: twenty New York artist-members and fifteen affiliate-members from around the country. See http://www.artseensoho.com/Art/AIR/air.html (last accessed on 29 June 2010).

7 See, for example, Julie Ault (ed.), *Alternative Art New York, 1965—1985*, Minneapolis: University of Minnesota Press, 2002. Or another volume edited by J. Ault on Group Material, *Show and Tell: A Chronicle of Group Material*, London: Four Corners Books, 2010.

8 From 1996 to 1998 I worked in a changing team (Sylvia Kafhesy, Renate Lorenz, Rachel Mader, Brigitta Kuster, Pauline Boudry, Justin Hoffmann and Ursula Biemann) as an exhibition curator at the Shedhalle Zurich, a venue which can be considered a paradigmatic space for this type of practice. See Shedhalle Zürich (various authors), *Jahresberichte 1994—98*, Zürich: Verlag der Shedhalle Zürich, 1994—98 and Ursula Biemann and Marion von Osten (ed.), 'Dispersion, Kunstpraktiken und ihre Vernetzungen', in *Olympe, Feministische Arbeitshefte zur Politik*, no.19, 2003.

9 See Nina Möntmann, *Kunst als sozialer Raum*, Cologne: Verlag der Buchhandlung Walther König, 2003, and in *e-flux* journal '(Under)Privileged Spaces: On Martha Rosler's "If You Lived Here..."', issue 98, October 2009, also available at http://www.e-flux.com/journal/view/89 (last accessed on 13 July 2010).

as a communicative platform where ideas about collaborative and collective practices, new spaces of possible discourses can be established or used for a local intervention.[10]

Expanding the field of visual arts into other social realms and changing subject positions in the process of cultural production is a form of resistance against the functions that have been assigned to the artist in capitalist societies. Thus new, flexible figures have developed in the art context in the last decades, standing in a critical relation to normative transformations in society. On the one hand the appearance of these new figures emphasises the fact that artistic practice is a varied field of action, extending beyond the art context and the production of single works of art. As many shows in the German-speaking realm of the 1990s show, aesthetic production was liberated from the single author's contribution and moved towards project-related production. This complex process of differentiation of artistic practices also manifested itself in the establishment of self-organised spaces, alternative venues and the use of a variety of media; constant crossovers between high and low; de-skilling and re-skilling. This development is also a trigger for debates on art as knowledge production or research-based practices. As the collective kleines postfordistisches Drama (kpD) wrote in 2005:

> We employ the term 'cultural producers' in a decidedly strategic way
> [...] we are not speaking of a certain sector [cultural industry], nor of an
> ascertainable social category [...] or of a professional self-conception.
> Instead, we are speaking of the practice of travelling across a variety
> of things: theory production, design, political and cultural self-organisation,
> forms of collaboration, paid and unpaid jobs, informal and formal economies,
> temporary alliances, project-related working and living.[11]

Martha Rosler, 'If you lived here...', 1988, organised by Martha Rosler. Installation view, Dia Art Foundation, 77 Wooster Street, New York. Courtesy Dia Art Foundation

10 See Miwon Kwon, 'Ortungen und Entortungen der Community', in Christian Meyer and Mathias Poledna (ed.), *Sharawadgi*, Verlag der Buchhandlung Walther König, 1999, p.214; and *One Place After Another: Site-Specific Art and Locational Identity*, Cambridge, MA and London: The MIT Press, 2002, pp.154—55.
11 Quoted from kleines postfordistisches Drama/kpD, 'Prekarisierung von KulturproduzentInnen und das ausbleibende, gute Leben', *Arrancal*, no.32, Summer 2005, pp.23—25. KpD are Brigitta Kuster, Isabell Lorey, Katja Reichard and Marion von Osten.

This mobility between different positions, formats and practices is no longer unique to artists; many other actors are also increasingly changing their position in the cultural field, and the notion of the 'cultural producer' tries to grasp this new formation of activities as a transversal practice. At the same time, however, this expansionism in the arts corresponds handily with the shifts in the capitalist economy and to the development of ever more flexible labour markets.[12]

Art Work

In his groundbreaking essay 'Other Criteria' (1968), Leo Steinberg argued that art of the 1960s no longer understood itself as art, but rather as labour, as work.[13] He called for a new form of art critique, made from a socio-cultural perspective, that would be able to measure up the artwork according to its new criteria. The exhibition 'Work Ethic', which was first shown at the Baltimore Museum of Art in 2003, focused on this paradigm shift in art production and critique.[14] The show's curator, Helen Molesworth, presented avant-garde practices from the past forty years that addressed art's relationship to, debate on or inscription into the socio-economic changes of its time. 'Work Ethic' defined such shifts as a series of upheavals within Western capitalist-industrial societies: from a Fordist consumer society to a post-Fordist, service-based system, which today goes hand in hand with the globalisation, informatisation and deregulation of economic markets and the privatisation of resources or industries that were previously public. The show included works from different artistic movements, predominantly from the US in the 1960s and 70s, such as Fluxus, feminist, process, performance and Conceptual art practices.

The exhibition, as well as the publication, was divided into four analytical categories: the first, 'The Artist as Manager and Worker: The Artist Creates and Completes a Task', referred to works by Frank Stella, Chris Burden and Robert Morris; the second section, 'The Artist as Manager: The Artist Sets a Task for Others to Complete', showed works by Sol LeWitt and others from historical Conceptualism. The third section, 'The Artist as Experience Maker: The Audience Completes the Work', highlighted Allan Kaprow and Fluxus, and the fourth section, 'Quitting Time: The Artist Tries Not to Work', looked at the strategy of refusal to work (the strike) and the conversion of leisure time activities into artistic work as by such artists as Lee Lozano, Tom Marioni and Gilbert & George.

In choosing these categories ,'Work Ethic' focused on processual, cognitive and immaterial aspects of artistic practices. Molesworth, however, does not describe the emphasis on 'process' as dematerialisation, but rather as the manner in which something is produced, the steps that are necessary for the creation of an object, a sign or emotion. Process becomes the 'work' of art. Despite the fact that cognitive processes such as thinking were privileged, especially in historical Conceptualism, emphasis on process also offered artists of that period the opportunity to attach an integral importance to production itself, or rather to the interconnection of manual and cognitive processes behind production. The performance of the production process as 'art' turns the process into an aesthetic form. The object, the action, the image become signs of their time, of a collective, or of the division of labour in place for producing art. The exhibition made clear that modernist and postmodernist artists have redefined their practices not only along institutional contexts and the art system as such, but also in relation to transformations of social and economical conditions and concepts of labour. Thus artistic labour performed as repetition, process, management or teamwork was on the one hand a critique of stereotypical assumptions of the artist as creator and single author, and on the other a reflection on societal changes of the composition of labour in the society as a whole. In doing so, these artists not only shifted and broadened the notion of what visual art could be, but also redefined the production of meaning itself, its conditions, its media of presentation, spaces and social

12 See Beatrice von Bismarck, 'Kuratorisches Handeln. Immaterielle Arbeit zwischen Kunst und Managementmodellen', in M. von Osten (ed.), Norm der Abweichung, Vienna and Zurich: Springer, 2003, pp.81—98. See also M. von Osten, 'Fight Back the Determinator', in Christian Kravagna (ed.), AGENDA: Perspektiven Kritischer Kunst, Bozen and Vienna: Folio Verlag, 2000, pp.23—41.
13 See Leo Steinberg, 'Other Criteria', Other Criteria: Confrontations with Twentieth-Century Art, Oxford and New York: Oxford University Press, 1972, pp.55—91.
14 The exhibition 'Work Ethic' was shown at the Baltimore Museum of Art from 12 October 2003 to 4 January 2004, at the Des Moines Art Center from 15 May to 1 August 2004 and the Wexner Center for the Arts from 18 September 2004 to 2 January 2005. See Helen Molesworth (ed.), Work Ethic (exh. cat.), University Park, PA: Penn State Press, 2003.

contexts. This reflexivity has led to a massive differentiation of art production, which is described as an artistic practice, or in a more inclusive sense, as cultural production.

The term 'art worker', which was used regularly by artists to describe themselves during the 1960s and 70s, not only brought to mind left-wing labour struggles and traditional definitions of work, but also explored the relation between manual and cognitive labour during a time in which the production and consumption of common goods entered a new, cyclical relationship and the production of signs and symbols became increasingly important. Simultaneously, in addition to the production of useless objects and actions, the artistic and creative aspects of these actions were made profane, passed over, denied. 'Working on something' became an aesthetic concept and procedure — an aesthetic experience — because the process of participation was anticipated in many of these works. As 'Work Ethic' demonstrated, art contributed to the vocabulary and representation of labour. It proved that the artistic production of meaning is to be understood as a discourse in its own right, for it creates a declarative text, which does not signify but rather speaks about something already signified in a new manner. It is a discourse that connects manual and cognitive processes instead of separating them in the sense of the industrial division of labour.

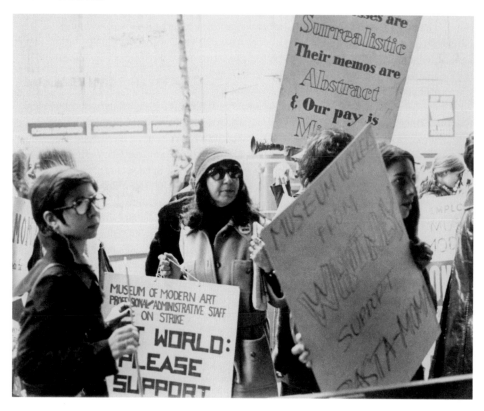

Picket line outside the Museum of Modern Art, New York during the seven week staff strike, 1973. MoMA film curator Adrienne Mancia in centre. © 1973 The Museum of Modern Art/Scala, Florence

In the twenty-first century, artists are confronted with a social situation that has radically changed from that of the 1960s and 70s. In the mid-1990s, creative professions were ascribed an integral and trendsetting role in economies based on information and innovation.[15] Under the term 'creative industries', governments at the end of that decade promoted new forms of work that they hoped would result in the creation of employment and more innovative markets, and therefore facilitate the move away from national industrial economies. Today, the attempt to regulate 'creative' work in the free market under the term 'creative industries' seems to have lost its appeal. But the 'creative industries' discourse is one of many that calls for cultural producers to position themselves as integral to the economy, because cultural production is considered an economic factor and artists themselves are being stylised as blueprints of economic discourses of innovation and self-responsibility.[16] The notion of the artist as a never-ending source

15 See Gerald Raunig and Ulf Wuggenig (ed.), *Kritik der Kreativität*, Vienna: Verlag Turia + Kant, 2006; and Geert Loving and Ned Rossiter (ed.), *My Creativity*, Amsterdam: Institute for Network Cultures, 2008.
16 See M. von Osten, *Norm der Abweichung*, Vienna and Zurich: Springer and Voldemeer, 2003.

of new ideas and emotions was captured by Bruce Nauman in his *Self-Portrait as a Fountain* (1966), formulated as a critique of bourgeois fantasies of an endlessly productive, exceptional subject. Today, however, this mocking self-portrait of the artist as a self-powered source might not only be read as a bourgeois invocation of the artist, but also as the allegory of the flexible, self-motivated individual working subject of late capitalist society.[17]

This recent shift to the artist as exemplary of a norm affecting all of society is a reversal of the production conditions presented in 'Work Ethic'. When cultural and usually un(der)paid work and creative professions — formerly considered exceptions to the rule of paid labour — are stylised as role models of flexible, self-determined work in post-Fordist societies, the artist subjects, their value creation and working life become central to political and economic interests.[18] Fields not considered part of the economic world in Fordist society (communication, personal services, social relations, lifestyle, subjectivity) are increasingly organised in markets and production systems today. Antonio Negri and Michael Hardt argue that the current stage of capitalist socialisation has dissolved the boundaries between economy and politics, reproduction and production.[19] Negri and Hardt use the term 'biopolitical' to refer to the blurring of traditional distinctions such

'Be Creative! Der kreative Imperativ', 2003, installation view, Museum für Gestaltung, Zurich. Photograph: Regula Bearth, Museum für Gestaltung. © zhdk

that the 'social' and 'cultural' have become significant resources for the accumulation of value.[20] But according to the authors of *Empire* (2000), and as opposed to many interpretations, the relation between the 'biopolitical' and the 'social' is causal: biopolitical labour creates not only material and immaterial goods, but also social conditions — and thereby social life. In this way, the production of social conditions must necessarily include

17 See Diedrich Diederichsen, *Eigenblutdoping, Selbstverwertung, Künstlerromantik, Partizipation*, Cologne: KiWi, 2008.

18 See Brian Holmes and Marina Vishmidt in conversation with M. von Osten in 'Atelier Europa, Conversations, Kunstverein Munich', 2004, available on www.ateliereuropa.com (last accessed on 7 July 2010); Anthony Davies and Simon Ford, 'Art Futures', *Art Monthly*, no.223, February 1999; Isabell Lorey, 'Vom immanenten Widerspruch zur hegemonialen Funktion: Biopolitische Gouvernementalität und Selbst-Prekarisierung von KulturproduzentInnen', in G. Raunig and U. Wuggenig (ed.), *Kritik der Kreativität, op. cit.*, pp.121 — 36.

19 See Michael Hardt and Antonio Negri, *Empire*, Cambridge, MA and London: Harvard University Press, 2000; and *Multitude: War and Democracy in the Age of Empire*, Harmondsworth: Penguin, 2004.

20 For further discussion of this, see Marianne Pieper (ed.), *Empire und die biopolitische Wende: Die internationale Diskussion im Anschluss an Hardt und Negri*, Frankfurt a.M.: Campus, 2007, and Justin Hoffmann and M. von Osten (ed.), *Das Phantom sucht seinen Mörder: Ein Reader zur Kulturalisierung der Ökonomie*, Berlin: b_books, 1999.

possible grounds for change in political and economic arenas. In their analysis, Negri and Hardt highlight the emergence of multiple forms of critique and practice as well as that of a 'multitude' of singularities with the potential to provoke transformations in other ways than by neoliberal politics. Affective and communicative skills are considered as productive forces, and these changes in value production can also bear facilitating effects and not only destructive ones. The production of relationships and of knowledge as well as reflective forms of work can signal revolutionary potential, which in turn allows the re-negotiation of terms such as occupation, collectivity and ownership. By predicting the end of the capitalist binding of money, labour power and use-value, they foresee a new vision for a different model of accumulation, describing the terrain for new struggles.

The outlook in the sociologists Luc Boltanski and Ève Chiapello's *The New Spirit of Capitalism* (1991) is not quite as optimistic.[21] The current ideology of self-responsibility, as promoted by the governing model of neoliberalism, was only able to establish itself, according to the authors, because the transformation of the Fordist model of capitalism went hand in hand with the integration of 'artistic critique' — as addressed in Molesworth's exhibition or in Sabeth Buchmann's publication *Denken gegen das Denken* (2007) — into

'Atelier Europa', 2004, installation view, Kunstverein München, Munich. Photograph: Dorothee Richter

the economic vocabulary. Boltanski and Chiapello claim that the structures of desire and models of critique of formerly (sub)cultural counter-worlds have now become part of an increasingly globalised economy. The theorisation and analysis of post-Fordist socialisation follows this antagonism between calls for liberation of the self and new forms of control and discipline. Dissident subject positions and so-called artistic critique, however, are never completely identical to their adaptations in the economy or their invocations in politics. Even if, as Buchmann demonstrates, it were verifiable that Conceptual and critical artistic practices contributed to the development of Negri and Hardt's 'societal factory', 'this transformation is infused with temporal discrepancies and heterogeneities. Thus one cannot speak of a continuous parallel between socially dominant manners of production and artistic practices.'[22]

21 See Luc Boltanski and Ève Chiapello, *The New Spirit of Capitalism* (trans. Gregory Elliott), London and New York: Verso, 2005.
22 See Sabeth Buchmann, *Denken gegen das Denken: Produktion — Technologie — Subjektivität bei Sol LeWitt, Hélio Oiticica und Yvonne Rainer*, Berlin: Polypen, 2007.
23 See M. von Osten, 'Irene ist Viele: Oder was die Produktivkräfte genannt wird', in Thomas Atzert, Serhat Karakayali, Marianne Pieper and Vassilis Tsianos (ed.), *Empire und die biopolitische Wende*, Frankfurt a.M.: Campus, 2007. English version available at http://e-flux.com/journal/view/83 (last accessed on 3 August 2010).

Despite this, artistic investigations — if we take their production of meaning and discursive ability seriously — make a more important contribution to the possible critique of predominant economic discourses than has been assumed.[23] As a producer of discourses, of critical translations of societal trends, art stands discursively in partial opposition to the modern industrial and service society, which continues to perpetuate the difference between the cognitive and the manual under the notion of immaterial labour.[24] As the conditions of production changed over the past fifty years, the artist as producer did too.

Fighting the Imperative

It is thus not surprising that current socio-economic changes have brought forth debate on the artist or the cultural producer as a new political subject. Especially when this figure of innovation is used to further reduce governmental responsibilities and the entrepreneurially oriented self-optimisation of the individual becomes the norm.[25] The problem of one's own involvement in the current normative change becomes even clearer when the self-organised creative professions are attributed central significance for economic growth, as in the talent-led economy proposed by British Prime Minister Tony Blair during his time in office.[26] Together with the complementary discourse on 'capitals of talent', the Europe-wide competition for location advantages in the global market has, since the late 1990s, led to labour markets being rehabilitated and neighbourhoods enhanced, not only in Britain but all over the world,[27] while cuts in social and cultural spending are legitimised under the paradigm of the self-sufficiency of (cultural) entrepreneurs. But the reality of the labour conditions summarised under the construct of creative professionals (self-employed media creators, multi-media, sound and graphic designers) is blurred or idealised in these optimistic assumptions. At the same time, the labour conditions of artistic-creative professions and those of the remaining industrial production and other precarious service occupations are camouflaged. Creative action and thought are now demanded from all the citizens of Western industrialised societies. They are the customers of the booming market for creativity promotion and are supplied with the relevant manuals, seminars, software programmes and so on. These learning techniques and tools call for and encourage approval of the social conditions whilst at the same time liberating creative potential. Thus on the one hand creativity proves to be the democratic variation of ingenuity: everyone is credited with the ability to be creative. On the other, however, everyone is forced into having to develop his or her own creative potential. The imperative to turn oneself into a 'creative being' and 'entrepreneurial self' has absorbed the slogans for autonomy of the 1960s and 70s. The call for self-determination and participation no longer only denotes an emancipatory utopia, but also a social obligation in globalised economies. Individuals apparently subject themselves voluntarily to the new power conditions that encourage them to be accountable, autonomous and self-responsible — they are 'obliged to be free'.[28] Their behaviour is not regulated by a disciplinary power, but by government practices that are built on the neoliberal idea of a 'self-regulating' market and are more likely to mobilise and stimulate than to monitor and punish. We are now meant to become as contingent and adaptable as the market.

It is not surprising that artists have dealt with this normative change in recent years. The exhibition 'Be Creative! The Creative Imperative', at the Museum of Design (Museum für Gestaltung) in Zurich in 2003, was realised by a collective of artists, architects, designers, theoreticians, students, sociologists and cultural theorists, and looked at the changing concepts of creativity and the social design process that goes with them.[29]

24 See T. Atzert (ed.), *Umherschweifende Produzenten: Immaterielle Arbeit und Subversion*, Berlin: ID-Verlag, 1998.

25 For a discussion of these trends, see Atelier Europa, Kunstverein München, Munich, 2004, initiated by Marion von Osten and Angela McRobbie. For a discussion of these trends, see http://www.ateliereuropa.com (last accessed on 29 June 2010).

26 See A. McRobbie, 'Everyone is Creative?', in Tony Bennett and Elizabeth B. Silva (ed.), *Contemporary Culture and Everyday Life*, Durham: The Sociology Press, 2004, pp.186—99; A. McRobbie, 'From Holloway to Hollywood: Happiness at Work', in Paul Du Gay and Mike Pryke (ed.), *Cultural Economy*, London: SAGE, 2002, pp.97—114.

27 See M. von Osten and Peter Spillmann (ed.), *Be Creative! Der kreative Imperativ*, exhibition leaflet, Zurich: Edition Museum für Gestaltung, 2002; see as well www.k3000.ch/becreative (last accessed on 4 July 2010).

28 See Nikolas Rose, 'The Death of the Social? Re-figuring the Territory of Government', in Roger Cotterrell (ed.), *Law in Social Theory*, Farnham: Ashgate, 2006, pp.395—424.

29 'Be Creative! Der kreative Imperativ', Museum für Gestaltung, Zurich, 2003. Initiated by M. von Osten and B. von Bismarck, see http://www.k3000.ch/becreative (last accessed on 29 June 2010).

The project observed the demand for cognitive abilities that are assigned terms such as creativity and intelligence, and brought attention to the boom in training manuals for a wide variety of professions. It questioned their applications and reflected on the appropriation of artistic production processes and subcultural ways of life for the worlds of advertising and real estate, pursuing the transformation of emancipatory models from calls for participation to techniques of political control. It also included company mission statements, design concepts and motivational tools that are new elements of everyday life in the workplace, and it analysed changes in the higher education system as well. It considered recent town planning developments and conducted interviews and film projects where designers, artists and employees had their say about their working lives. In addition the exhibition took a new look at utopian models for living, learning and working against this contemporary background. The character of the show corresponded to that of a production site for social processes, design and communication. It therefore did not seek to teach the 'right' information, but instead involved the wide range of visitors in the above-mentioned antagonisms through a scenographic layout and compositions of the thematic clusters. The image of the factory — a space somewhere between an artist's loft, a sweatshop and a marketing floor — was selected as the basic architectural metaphor, reconstructed within the gallery space in the Museum of Design,

which is at the same time the (hidden) administrative wing of the building. As the show took place not in an art gallery but in institution dedicated to the applied arts, a very popular place in Zurich, the exhibition and the following publications successfully linked the critique of artists, designers, theorists and art students with that of a larger public that is similarly involved in these new imperatives. Thus the project had many reviews in non-art related publications such as architecture and design magazines or leftist journals.

At the same time 'Be Creative!' had to carve out a number of paradoxes, as this hybrid practice, located between the realms of art, theory and design, is based on disciplinary flexibility — as well as being reliant on an anti-institutional, flexible economy of underpaid but highly motivated freelancers. Therefore the project itself came into being under working and production conditions very similar to those documented, analysed and criticised in the exhibition. But the practice developed in making the show radically questions the assumptions of the neoliberal commodity economy, even or precisely because it finds itself in the antagonism between radical critique and the current, normative transformation. Its criticism was directed towards three specific discourses on knowledge production: the disciplinary division and elitism of theory production;

the division of theory and practice, mind and hand, the social and the cultural; and the split between a linguistic and a visual culture. It also questioned the tradition and future of art and design universities, specifically the College of Art and Design (Hochschule für Kunst und Gestaltung) in Zurich, where the museum is located. The project was constituted by a 'multitude' that was transversal to established job hierarchies in the university and constructed a new public sphere for concrete critique.

As 'Be Creative!' attempted to show, the term 'creativity' has not only left behind its shadowy existence but also its innocent reception; moreover, it has broadened the perspective of a common understanding of design processes. A current examination of notions of creativity calls not only for reflection on the methods of creation in art and design, but also for creation to be used as a description of a social process that has a political and cultural dimension. Thus the project created a counter-narrative to the normative discourse on creativity. It made room for interventions into visual and linguistic paradigms and created a public for dissidence and disobedience.

Exhibition-Making as Public Action

In the last decades artistic practices have created an epistemic space that is structured transversally to social invocations and regulations, while still remaining symbolic.

Left and this page:
kleines postfordis-
tisches Drama
(kpD), *Kamera läuft!*
(*Roll Camera!*),
2004, video, 32min.
Courtesy kpD

These transversal practices can also be detected in current governmental initiatives, for example in the institutionalisation of artistic knowledge production in university research; the adoption of modes of institutional critique in so-called 'New Institutionalism'; or in projects funded by local or national governments in which art takes over the role of social work (in programmes such as 'community work'). Any attempt to integrate artistic or cultural practices into governmental knowledge for application-orientated or benefit-oriented purposes is a contradiction of these practices' mode of action because their strictures continuously and repeatedly evade institutionalised regulation. Furthermore, governmental or institutional regulations are never static, as Nicos Poulantzas demonstrates, but rather operate through the governing of the surplus that results from the frictions, conflicts and struggles against control and regulation.[30] It is all the more important to emphasise the paradox of incompatibility and immanence that contemporary art practices posed and continue to pose for social improvement.

But still, cultural practices that challenge and question their own involvement in and within the normative discourse may differ from or even contradict each other. They cannot

30 See Nicos Poulantzas, *State, Power, Socialism* (trans. Patrick Camiller), London: NLB, 1978.

be systemised and do not form the 'other' to hegemonic social discourses, because their lines of flight have become immanent to these discourses. At the same time, artistic practices, acting as shapers of discourse, are able to adopt new points of view on economic change and introduce ruptures to its seeming logic. Thus, cultural producers today have created a new arena in which a decentring of modernist universalisms or normative subjectivation can be practiced, in which imaginaries of the political can not only be expressed and visualised, but also worked through in changing constellations that are not fixed.

Moreover, those who are subjected to processes of precarisation — like increased social and economic uncertainty — create strategies and tactics in their everyday life that work both against and within hegemonic structures. They are not only experts in the very contradictions inherent to relations of production and contemporary governance, but are also the creators of new relations of production and new ways of making a living, and these need to be considered alongside techniques of control and processes of recuperation.[31] Can such tactical moves then become public, political action? This question calls for an analysis of histories of ongoing struggles that have produced transversal movements within seemingly stable, Western concepts of governability. These tactics and strategies likewise call for a new language to articulate the composition of the present situation, and, at the same time, to decentre and decolonise the *common* production of knowledge.[32] When vocabulary and subject positions are borrowed from cultural producers in management theory and political fantasies, it is the cultural producer who has the possibility to resist, to critique and to intervene. The production of an exhibition can be radically transformed into public action.

Paolo Virno regards the chief challenge of the present to be the establishment of new forms of publics. In his book *A Grammar of the Multitude* (2003) he describes the necessity of inventing publics, proposing that this is one of the central issues of politicisation under post-Fordist conditions: 'The shifting-to-the-foreground of fundamental abilities of human existence (thought, language, self-reflection, the ability to learn) can take on a disconcerting and oppressive character, or it can result in a new form of public, a *private public*, which establishes itself in a place far removed from the myths and rites of statehood.'[33] And in his book *Publics and Counterpublics* (2002), Michael Warner has shown how publics evolve in practice and in context, and do not satisfy universal expectations but identification-related ones. In his discussion of gay and lesbian counter-publics, Warner explores their opening up of new subject positions that reject the normativeness of attributions as lesbian or gay, i.e. as category of identification, and the creation of new worlds corresponding to a singular in the plural. In other words, the production of a public — and this holds for project exhibitions that form specific publics on the side of producing them as well on the side of being involved in them as a participant or viewer — always goes together with specific subject positions, which are brought about in the process and constitute themselves publicly. Thus, publics are highly situated, contextual and positioned as well as constitutive. This post-identitarian perspective reflected by Warner was a major factor in my own exhibition-making practice, as well as the idea that,

> *As opposed to other curatorial approaches, the project exhibition establishes a discourse, a practice that challenges the neutrality of the art space and the related representational regime.*

31 For example, MoneyNations (1998—2000) or Transit Migration (2003—06) resulted in different communities during their development processes; the same was true of the related forms of communication. MoneyNations communicated with cultural producers from Central and Southern Europe by way of the internet and personal contacts. On that basis, it generated not only an exhibition — in the more classical sense — about discourses on EU border production and border-crossing, but also a whole series of other activities. These included a conference in which artists, film-makers and political initiatives from south-eastern Europe participated, a seminar with radio producers from ex-Yugoslavia, a video producers' network and, most significantly, a mailing list which facilitated the active exchange of information between anti-racist projects, events and initiatives for more than four years. A kind of supranational community of artists, scholars and political activists thus emerged from the project. See: http://www.moneynations.ch or http://www.transitmigration.org (last accessed on 13 July 2010).

32 See Walter Mignolo, 'Epistemic Disobedience, Independent Thought and De-Colonial Freedom', *Theory, Culture, and Society*, vol.26, no.7—8, 2009, pp.1—23.

33 See also Paolo Virno, 'Das Öffentlichsein des Intellekts. Nichtstaatliche Öffentlichkeit und Multitude', in G. Raunig and U. Wuggenig (ed.), *Publicum, op. cit.*, pp.124—39.

34 The concept of 'ground for possibilities' has been introduced by J.K. Gibson-Graham in *A Postcapitalist Politics*, Minneapolis: University of Minnesota Press, 2006.

because of its artificiality and publicness, the art space can be turned into a space for the desire for new subjectivities, as a 'ground for possibilities'.[34]

With this article I hope to show that project exhibitions and the critical perspectives and interventions they generate emerged from concrete demands and social struggles which are increasingly concealed today in the reception of art practice. Project exhibitions do not serve to simply illustrate or exhibit a theme, but rather generate a potential for new positions of speech, articulations and cultural practices on the sidelines of hegemonic discourses; they also reflect the knowledge and body policies of the 'exhibitionary complex', as Tony Bennett calls it, and reinterpret its paradigms of depiction.[35] Moreover, in the project exhibition a process, usually dissociated from representation, takes on central significance: the 'development' of the content and research within a framework of collective authorship. Therefore, not only new audiences but also specific related socialities that form in the context of the project come to exist in the development process; the same is true of the related forms of communication.

In addition to the collective experience, project exhibitions by artists can thus chart an imaginary map of oppositional cultural practices and experimental knowledge spaces, pointing beyond the symbolic space of the exhibition and academic disciplines. Moreover, the imaginary public of the art space is not rejected as being 'alienating' and neutralising, but understood as productive and with potential for micropolitical action and the creation for new public spheres. As opposed to other curatorial approaches, the project exhibition establishes a discourse, a practice that radically challenges the neutrality of the art space and the related representational regime. These practices take their place consciously within the art discourses of the modern and postmodern eras, as well as within the context of political and economic transformations and social struggles and movements.

In the face of this, it is obvious that exhibitions in general would need to be read beyond their representational intention or composition of narratives. A critique of exhibitions would need to include a discussion on how, why and by whom they have been produced, under which conditions and, most importantly, what they finally enable. As Walter Benjamin asks in 'The Author as Producer' (1934): 'What is its attitude *in* the relations of production of its time?'[36] Benjamin was calling for practice that transforms the cultural apparatus in such a way that readers (in our case, viewers) are turned into producers.

To conclude I would like to propose a concept in which the production of publics, the constitution of new forms of subjectivation and public action is seen as entangled within critical artistic practices, rather than sticking to the terms 'labour' or 'production'. Following Hannah Arendt's theory of action and her notion of praxis, one might come to new criteria to understand the specificity of self-organising strategies such as exhibition-making by artists. By distinguishing, as Arendt does in *The Human Condition* (1958), action from labour and fabrication/production by linking the former to the freedom to begin the unthought and the plurality of singularities, it might be possible to articulate a conception in which exhibition-making by artists can be read under other parameters than those of neoliberal recuperation or 'multi-tasking'.[37] To understand the self-articulation of the role of the artist and the use of the exhibition space and format as action leads to an aesthetic conception of politics — one that is not reduced to a form of (productive) work or *poiesis* and marketable authorships, but which creates new publics and therefore new forms of subjectivation in the middle of the public sphere. To act means to appear in public, to be able to get rid of one's self and to do the unanticipated and unpredictable.

35 See Tony Bennett, *The Birth of the Museum: History, Theory, Politics*, London and New York: Routledge, 1995.
36 Walter Benjamin, 'The Author as Producer', *Reflections: Essays, Aphorisms, Autobiographical Writings* (ed. Peter Demetz, trans. Edmund Jephcott), New York: Schocken Books, 1986, pp.220—38.
37 See Hannah Arendt, *The Human Condition*, Chicago: University of Chicago Press, 1990.

This essay forms part of Afterall's collaboration with FORMER WEST, a long-term international research, education, publishing and exhibition project that aims to reflect upon the changes introduced to the world (and thus to the so-called West) by the political, cultural, artistic and economic events of 1989. This series of texts, commissioned by Afterall's editors, will develop lines of investigation and areas of interest that emerge throughout the project. FORMER WEST is realised through the partnership of BAK, basis voor actuele kunst, Utrecht with the following co-organisers: Van Abbemuseum, Eindhoven; Museo Nacional Centro de Arte Reina Sofía, Madrid; Museum of Modern Art, Warsaw; and associate partners of the Centre for the Humanities, Utrecht University, Utrecht; the International Documentary Film Festival (IDFA), Amsterdam; and Afterall Journal and Books, London. The main part of the project, which will result in a major exhibition and publication in 2013, will be realised through an extended partnership consisting of BAK, Afterall, Akademie der bildenden Künste, Vienna, Haus der Kulturen der Welt, Berlin, Museo Nacional Centro de Arte Reina Sofía, Madrid, and Museum of Modern Art Warsaw, with additional associate partners.

Translated by Margarethe Clausen.

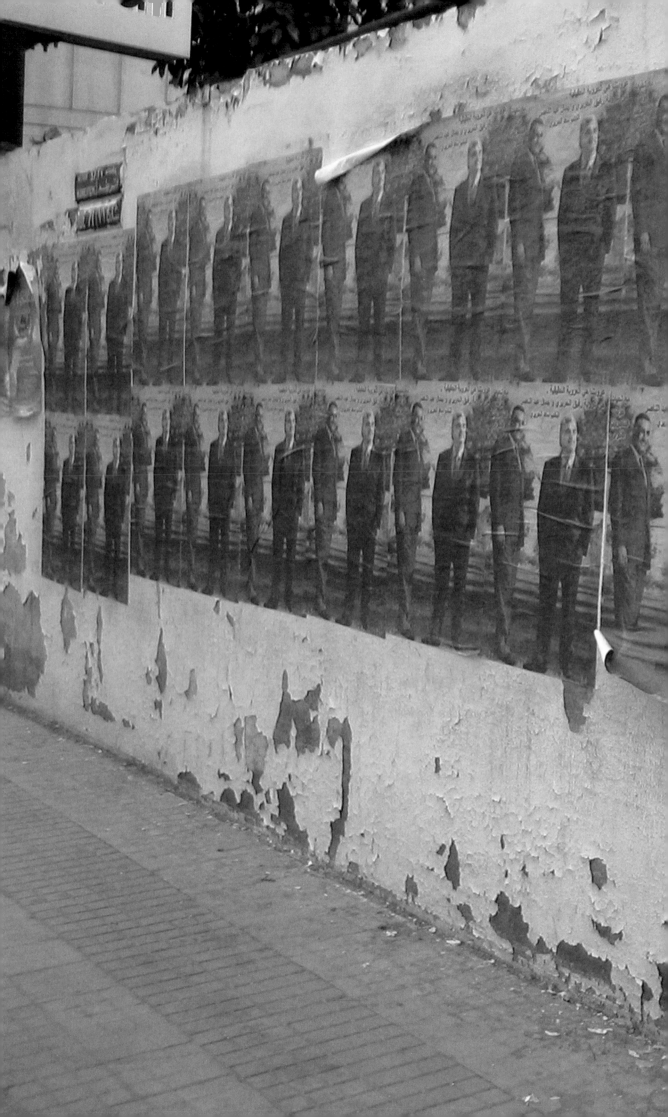

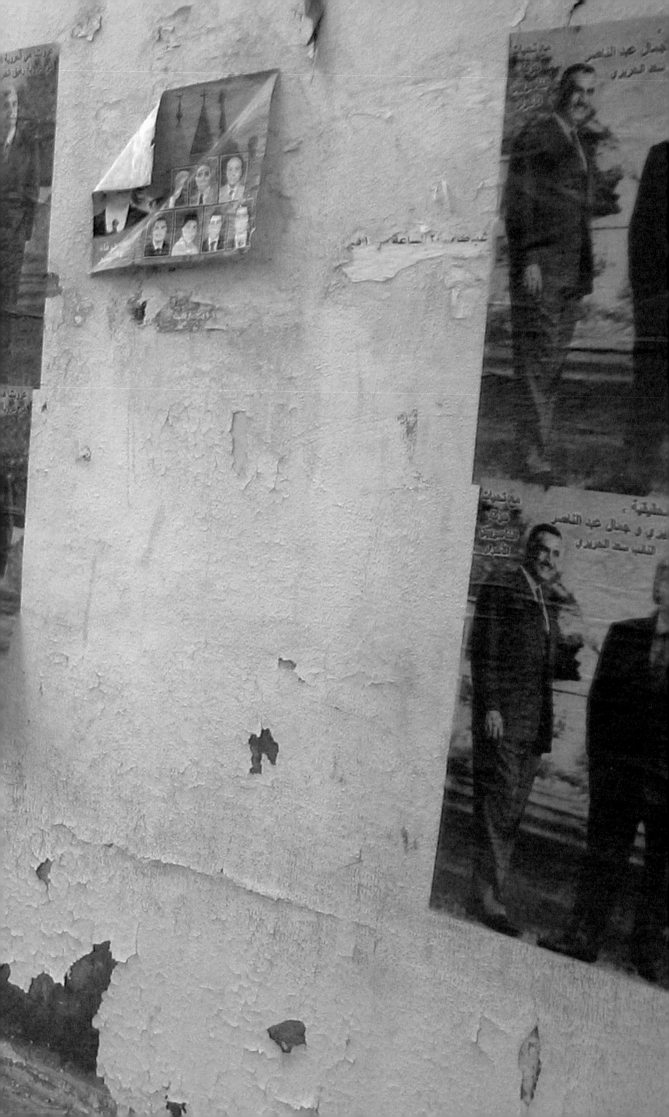

Rabih Mroué and
Lina Saneh,
Photo-Romance,
2009, stills from
a performance.
Photographs:
Sarmad Louis.

Previous spread:
Rabih Mroué,
*The Inhabitants
of Images*, 2009,
still from a lecture-
performance.
Courtesy the artists

The Body on Stage and Screen: Collaboration and the Creative Process in Rabih Mroué's *Photo-Romance*

– Kaelen Wilson-Goldie

The premise behind *Photo-Romance* (2009), a ninety-minute performance by Rabih Mroué and Lina Saneh, is the adaptation of a film that is never mentioned by name and only obliquely referenced on stage. Ettore Scola's *Una giornata particolare* (*A Special Day*, 1977), starring Sophia Loren and Marcello Mastroianni, takes place over the course of a single day in the spring of 1938, when Adolf Hilter pays a visit to Benito Mussolini in Rome. Loren plays Antonietta, a beautiful but long-suffering housewife, married to a card-carrying fascist and limited in her worldview. Antonietta's entire family has

Kaelen Wilson-Goldie surveys the issues of adaptation, theatrical convention and contemporary politics that have fuelled Rabih Mroué's collaborative practice over the last two decades.

gone to join the parades and celebrations marking the historic encounter, leaving her alone for the day. Mastroianni plays Gabriele, a radio broadcaster, recently sacked from his job and about to be deported by the authorities for harbouring not only anti-fascist but also homosexual inclinations, who happens to live in the same apartment block. The two meet when Antonietta's bird escapes its cage, flies out the window and lands on Gabriele's ledge. They befriend one another, fight, form an unexpectedly intimate bond and feel, throughout the film, for the edges of each other's solitude.

As the background story of *Photo-Romance* goes, at some point during the conceptualisation of the piece, Mroué sought out one of Scola's heirs to ask for permission to adapt the film — a gesture of courtesy more than legal compliance. To Mroué's surprise, the heir turned him down. Who knows what shape or structure the performance might have taken had Scola's heir said yes, but the refusal seems

to have pushed Mroué and Saneh to peel back and reflect on their artistic practices and critical intentions. The result is a performance that sifts through the sediments of collaboration and the creative process. Constructed as a conversation about a script in progress, *Photo-Romance* questions what it means to make original work, what it means to adapt the work of others, to appropriate, alter, manipulate, craft and finesse a work into being. It also asks what it means to do so with a partner, in life as in art, in a manner that constantly needles the substance of the relationship, which itself exists in a context that invariably imposes its own ideas of what the substance of that relationship should be. That context is defined by the codes and mores of Lebanese society, by the machinations of the country's sectarian political system and by gender roles prescribed by a thin body of law, which — on matters of sex, marriage, family, inheritance and personal status — tends to revert back to the religious community to which one belongs, not as a matter of choice but by birth and paternal lineage. The piece represents the most densely layered articulation of a question that has preoccupied Mroué and Saneh's work for more than two decades: how to use the presence of the body on stage as a metaphor for the struggle to be a complex, multi-faceted individual in a sectarian state, and how to access a just, equitable and participatory experience of citizenship in a functional but deeply flawed democracy.

❊

Both born and raised in Beirut (in 1967 and 1966, respectively), Mroué and Saneh met when they were students at the Lebanese University. They collaborated on a stage adaptation of Elias Khoury's novel *The Journal of Little Gandhi* (published in Arabic as *Rihlat Ghandi al-Saghir* in 1989) when they were still in their early twenties. Since then, they

have worked together formally and informally on an ever-more multi-disciplinary body of work, which includes experimental performances, single-channel videos, installations combining photography and text and a few 'proper' theatre works. (They also married at some point, though they rarely, if ever, refer to one another as husband or wife.) For the jointly authored performance *Biokhraphia* (2002), Saneh interrogates herself onstage with a tape recorder and video screen, demanding to know the story of how she got shot during Lebanon's 1975—90 civil war, whether or not she was politically active at the time, what the point of theatre is, how her sex life with her husband is, why she is such a confronta-tional woman and why her generation is such a mess.

Mroué's magisterial play *Who's Afraid of Representation* (2004) introduces a game played by himself and Saneh, replete with rules and references to an art-historical textbook that runs through anecdotes from the history of performance art (VALIE EXPORT in *Action Pants: Genital Panic* (1969) and *Tap and Touch Cinema* (1968); Chris Burden's *Through the Night Softly* (1973); Marina Abramovic's *Rhythm O* (1974)) but soon bleeds into the story of a civil servant who went to work one day and gunned down his co-workers, killing eight and wounding four. In the play's dramatic climax, the civil servant gives, with mounting desperation, a number of justifications for his crime — his motives were financial, or sectarian, or psychological, or political — before lamenting that never once in the process of his legal prosecution was he ever asked to re-enact his crime.

Saneh's *Appendice* (2007) is a performance accompanied by an interac-tive website, for which she tries to circum-vent religious laws prohibiting cremation in Lebanon by asking other artists to sign various parts of her body as artworks to be incinerated in the event of her death. The performance is particularly chilling as Mroué delivers the entire monologue on behalf of his wife, who sits on stage, silent, throughout. *How Nancy Wished That Everything Was an April Fool's Joke* (2007), a piece written by Mroué and Fadi Toufic, offers a garrulous, episodic history of the civil war through the experiences of four fighters who served in different militias and never seem to die, despite the fact that they are killed at the end of every story they tell.

Nancy suggests a preoccupation with Lebanon's civil war, which, while certainly prevalent in Beirut, is otherwise absent from the oeuvre that Mroué and Saneh have assembled. As artists, they are less enthralled with documents, archives and engagements with memory and history than are other Lebanese artists of their generation. Mroué's performance *Make Me Stop Smoking* (2006) is a subtle satire of the archival genre. (Taking the form of a lecture or an artist's talk, the piece finds Mroué on stage, alone, sharing the contents of a personal, idiosyncratic archive that consists not only of historically significant documents but also bank receipts, project proposals and press reviews of his work. 'What is all this for?' he asks, before explaining that his archive has become a burden, and that he wants to share it, in essence, to be rid of it.) Instead, Mroué and Saneh are more concerned with conditions prevailing in the era after the civil war, and beyond that, with how to replenish theatre with potential and eke out an emotionally fulfilling and intellectually sustaining existence in a particularly troubled part of the world.

❊

The prop dominating the set of *Photo-Romance* is an enormous white screen that cuts the depth of the stage in half. On one side the musician Charbel Haber sits with his guitar, surrounded by amps and pedals. On the other side Mroué perches on the edge of an armless, black leather chair, hands clasped together, elbows resting on his knees. Saneh, meanwhile, bounces periodically from a high stool behind a lectern to a low-slung seat next to Mroué. *Photo-Romance* does not so much adapt Scola's film as disembowel and reconfigure it, with each of the three characters transmitting different elements of sound and image onto the screen between them, which operates as a kind of public space, a site of contestation where opposing and competing visions may be played out.

Haber is the lead singer of Scrambled Eggs, a well-known post-punk band in Beirut. He runs his own label, composes soundtracks for films, collaborates with visual artists and juggles a sizable number of side projects, including La Chambre, the Grendizer Trio and the Moukhtabar

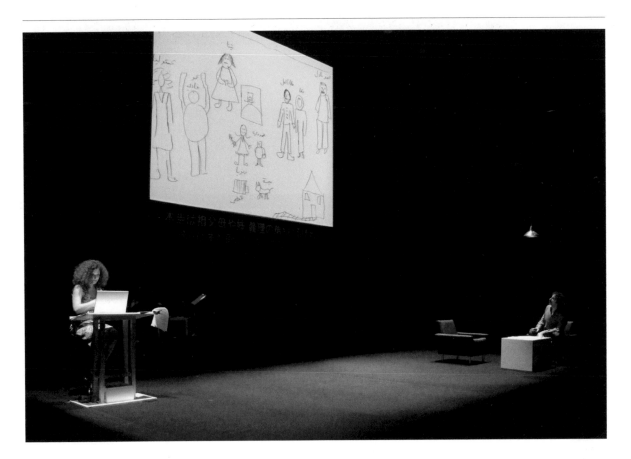

Rabih Mroué
and Lina Saneh,
Photo-Romance,
2009, still from
a performance.
Photograph:
Sarmad Louis.
Courtesy the artists

Ensemble. In *Photo-Romance* he plays himself, providing the performance with a live score, interjecting a few lines of dialogue here and there, and generally serving as friend, witness, comic foil and occasional decompression switch for the action between Mroué and Saneh. Saneh also plays herself, in a manner of speaking. She steps onstage to present, explain, justify and defend the work on behalf of herself and Mroué. Mroué's character is more slippery, as he interprets both himself and his nemesis, namely, a censor tasked with advising an artist, from a position of ill-begotten authority, on what to keep and what to cut from a work she has made with her partner. In the script for *Photo-Romance*, Mroué's lines are interchangeably attributed to 'Rabih' and 'The Judge'. On several occasions, Saneh addresses Mroué and in the same breath says that, unfortunately, Mroué couldn't be there to partake in the conversation.

The doubling of Mroué's character is a nod to the process by which a theatre director in Lebanon must run his script by the censorship apparatus of the state before presenting his work to the public. Here, by inhabiting both the artist and the censor at once, Mroué directs attention to the worst consequence of that process, its internalisation as self-censorship. It is worth noting

that censorship is a rather arbitrary affair in Lebanon, a structurally weak and economically laissez-faire state. The laws tend to be loose and archaic, and their enforcement applied in unpredictable bursts, often for the sole purpose of scoring quick political points on the local scene. Censorship falls not under the Ministry of Culture but rather under the Ministry of the Interior, and so it is meted out haphazardly by soldiers. For artists across different disciplines, this leaves a lot of wiggle room in terms of what one can get away with, and how one can manoeuvre. But it also raises a number of prickly issues about artistic integrity and autonomy, particularly as those soldiers in the security forces often hilariously or sadly overstep their bounds in deciding what is appropriate for the public to see. One story, repeated often enough to suggest it is apocryphal urban lore, says that in the mid-1990s, when Quentin Tarantino's *Pulp Fiction* arrived in Lebanon, the censors were so appalled by the temporal disjunction of the plot that they re-cut the film so local cinemas would screen it in chronological order, protecting the public, as it were, from the sinister fragmentation of time.

After some preliminary banter among the characters, *Photo-Romance* begins with Mroué asking Saneh: 'Okay, so what's the

story?' She responds by stressing the need for them to go through and evaluate the work at hand.

> Rabih: *What are you afraid of?*
>
> Lina: *Everything. Political censorship, religious censorship, sexual censorship, exceeding the allotted budget, evaluating the work's originality. Everything.*
>
> Rabih: *Wow, all that? The budget and the production are not my business. Censorship and originality, fine.*[1]

Saneh explains that she is concerned about the relationship between their work and a certain film. Mroué asks for a description of their approach. A free adaptation? A source of inspiration? 'I cannot explain it this way,' Saneh responds. Mroué asks for a broad outline and says, as an aside, that he

has, in fact, seen the film in question, and found it very beautiful. From there, Saneh runs through the decisions she and Mroué made to distinguish their work from the film. First, they shifted the setting from Rome in 1938 to Beirut in 2007, placing their work in the context of Lebanon's increasingly tense political situation in the aftermath of the war with Israel in 2006. That war divided the country even more starkly into opposing camps — the ruling March 14 coalition and the opposition March 8 coalition — which were named for competing demonstrations that took place in downtown Beirut in the spring of 2005, on 14 March and 8 March, respectively.[2] Instead of a meeting between Hitler and Mussolini, Mroué and Saneh imagine a reprise of the two March demonstrations, in their performance held in the same space on the same day, so that the entire population is out onto the streets at the same time, leaving the characters (played by Saneh

1 *Photo-Romance* is performed in Arabic with English supertitles.

Rabih Mroué,
*Make Me Stop
Smoking*, 2006,
stills from a
lecture-performance.
Courtesy the artist

and Mroué) alone, like Antonietta and Gabriele, for the day.

Saneh explains that in their adaptation, the characters from the film have also changed. Lina is the female protagonist, a divorcee whose ex-husband, revealed to have been an abusive brute, has nonetheless taken custody of their children. Since her marriage fell apart, Lina has returned to Lebanon from Saudi Arabia, and now lives with her mother, her brother and his family. Rabih is the male protagonist, a print journalist who lost his job for questioning the extent to which the war of 2006 was really a catastrophe. By sectarian profile, both characters are nominally aligned with the resistance and the March 8 camp. Lina's character limply follows the

2 These two alliances formed in the aftermath of former Prime Minister Rafik Hariri's assassination on 14 February 2005. Demonstrations began on the night of Hariri's death, as people gathered in downtown Beirut to hold vigils and demand an international investigation into his murder. These gatherings escalated into calls for an end to Syria's de facto occupation of the country (Syrian forces had been deployed in Lebanon for more than 30 years, and Syria was widely accused of orchestrating the assassination). The demonstrations, which were staged day after day and night after night, gained momentum with the resignation of Omar Karami's pro-Syrian government on 28 February 2005. On 8 March pro-Syrian parties such as Amal and Hezbollah staged counter-demonstrations to thank Syria for its support and supervision. On 14 March pro-Western parties such as the Future Movement, the Lebanese Forces, the Phalange Party and the Democratic Left staged a massive demonstration in response, demanding the withdrawal of Syrian troops, which were indeed withdrawn on 29 April. Both groups claim that their rival demonstrations drew a million people to downtown Beirut. Although the alliances are primarily marriages of political convenience, the March 14 coalition is, in general, pro-Western, economically liberal and seeks the political normalisation of Hezbollah, which would mean disarming the group and putting an end to the resistance against Israel as it exists now, in the hands of a non-state actor. The March 8 coalition is pro-Syrian, supports Hezbollah's right to remain armed and views the economic policies of the March 14 group as self-serving and corrupt. Both the March 8 and March 14 camps are multi-confessional and include both secular and religious parties. On the local scene, where Mroué's works are read for their politics well before they are considered for their aesthetics, some have criticised *Photo-Romance* for being one-sided, heavily critical of the March 8 coalition and the all-consuming ideology of resistance, without subjecting the March 14 coalition to the same scrutiny.

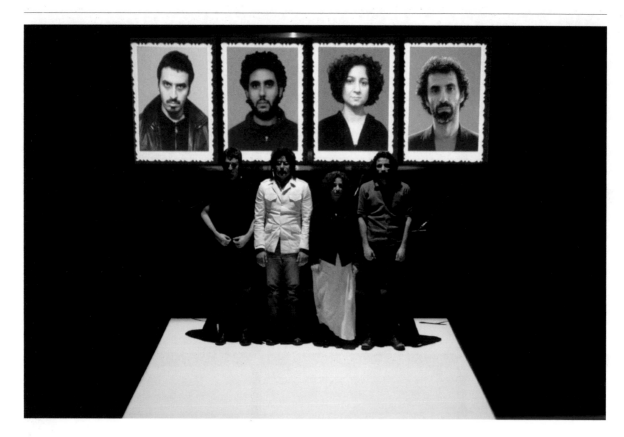

Rabih Mroué
and Fadi Toufic,
*How Nancy Wished
That Everything
Was an April Fool's
Joke*, 2007, still
from a performance.
Photograph:
Kohei Matsushima.
Courtesy the artists

party line, but Rabih's character is more of an activist and political dissident, a former communist who fought in the resistance back when it was a leftist concern and was detained in Israel's notorious Khiam prison in South Lebanon. Like so many former leftists and communists in Lebanon, the character Rabih plays was politically marginalised and intellectually sidelined by the rise of Hezbollah as the entity that took charge of the resistance against Israeli incursions into Lebanese territory. He is also a somewhat enlightened figure in his understanding of how gender roles, and housework, might be more beneficially distributed.

As Saneh reads the script to Mroué (and, by extension, to the audience), she periodically cues visual material to be projected on the imposing screen. The first bit of footage is a mock documentary about the simultaneous demonstrations in Beirut. After that, she projects portions of the 'film' she and Mroué are in the process of creating. The film is in fact a stop-motion animation, which consists solely of black-and-white photographs. The conceit captures the very different strengths of Mroué and Saneh as intensely physical performers — Saneh seems to act from the core of her body and conveys meaning through grand gestures with her shoulders and hips, versus Mroué's far more micro-

scopic shifts in facial expression — without capturing a single fluid movement. The film, of course, is silent, so Saneh, with great virtuosity, races through all of the dialogue from her seat behind the lectern. Haber adds the music to the mix, and Mroué, at Saneh's prompting, is called on to provide a few sound effects. In between the stretches of film, Mroué and Saneh discuss various aspects of it, with Mroué, in his role as the censor, occasionally declaring that bits of material must be cut lest the piece provoke sectarian strife.

While the themes of collaboration, partnership, authorship and authenticity reverberate broadly, there are a few elements of the performance that carry particularly local resonance. One is the fact that a moment before the lights dim and the performance begins, Lebanon's national anthem blares over the sound system. When *Photo-Romance* premiered in Beirut, during the fifth iteration of the Home Works Forum in April, more than half the audience automatically rose to its feet. This is a knee-jerk reaction. For more than half a century after Lebanon gained independence from France in 1943, the national anthem preceded most cultural events in the capital — up until the early 1990s it was even played in cinemas before the start of feature films, and on state-owned television stations before the nightly

news began. Outside of government-run venues, playing the national anthem as a prelude to an evening has since fallen out of favour. But for a local crowd, its incongruous reprisal signals a sly forcing of the audience's hand — do you sit, or do you stand? — which underlines the sensitive and notably subtle connection that Mroué and Saneh draw between fascism, nationalism and the competing loyalties demanded amid the absurdities of Lebanon's current sectarian system.

The significance of the setting portrayed in the mock documentary is key. Martyrs' Square, the physical and symbolic heart of Beirut, currently is little more than a long stretch of gravel due to the fact that Solidere, the private real-estate corporation that has been managing the urban renewal of Beirut's city centre since the mid-1990s, has largely ignored this patch of public space in favour of the more commercially lucrative plots that surround it. 'Whatever one wants to say about the reconstruction plan currently being put into effect in central Beirut is almost (but not quite) beside the point,' writes the scholar Saree Makdisi in a critique of the economic imperatives behind Solidere's scheme. 'For the object of discussion — the centre of the city — virtually does not exist any longer; there is, in its place, a dusty sprawl of gaping lots, excavations, exposed infrastructure and archaeological digs.' Makdisi continues:

> Blank or not, the city centre is a surface that will be inscribed in the coming years in ways that will help to determine the unfolding narrative of Lebanon's national identity, which is now ever more open to question. For it is in this highly contested space that various competing visions of that identity, as well as of Lebanon's relationship to the region and to the rest of the Arab world, will be fought out. The battles this time will take the form of narratives written in space and time on the presently cleared-out blankness of the centre of Beirut; indeed they will determine the extent to which this space can be regarded as a blankness or, instead, as a haunted space: a place of memories, ghosts.[3]

Makdisi's criticism, articulated in the essay 'Laying Claim to Beirut: Urban Narrative and Spatial Identity in the Age of Solidere' in *Critical Inquiry*, appeared ten years before the setting of *Photo-Romance*, and eight years before Martyrs' Square was transformed into a site of real contestation, first teeming with the demonstrations that led to the formation of the ruling March 14 coalition, and then, throughout much of 2007 and 2008, surrounded by soldiers and occupied by the March 8 coalition's opposition sit-in. But the sheer spectacle of these events smoothes over the ways in which this carved out space represents a low-burning conflict over a city ravaged by real-estate speculation, which has led to the destruction of as many buildings as the wars that preceded the reconstruction era. Despite the specificities of the site, the blankness of Martyrs' Square, like the blankness of *Photo-Romance*'s white screen, also represents a version of the public space Chantal Mouffe imagines as a site of agonistic confrontation, where an individual, 'inscribed in a multiplicity of social relations, the member of many communities, and participant in a plurality of collective forms of identification', as she wrote in *The Return of the Political* (1993), might reclaim his or her role as an active protagonist in political life.[4]

A final component worth lingering on in *Photo-Romance* is the fanciful notion, explained to Mroué by Saneh onstage, that the camera used to produce the projected film is only capable of capturing individuals. It cannot detect communities or groups. Comparing two scenes from the beginning and the end of the film, Saneh explains about her own character in the performance: 'And here, as you've noticed, we could still hear the family talking when she appeared in the image [...] Because contrary to the first scene, where she doesn't appear, when she is still integrated in the communitarian discourse, here she alone appears. That's because she has started to feel herself an individual, distinct from her group. But this newfound individualism will condemn her to solitude and anguish, you see?'

3 Saree Makdisi, 'Laying Claim to Beirut: Urban Narrative and Spatial Identity in the Age of Solidere', *Critical Inquiry*, vol.23, Spring 1997, p.664.
4 Chantal Mouffe, *The Return of the Political*, London and New York: Verso, 1998, p.97.

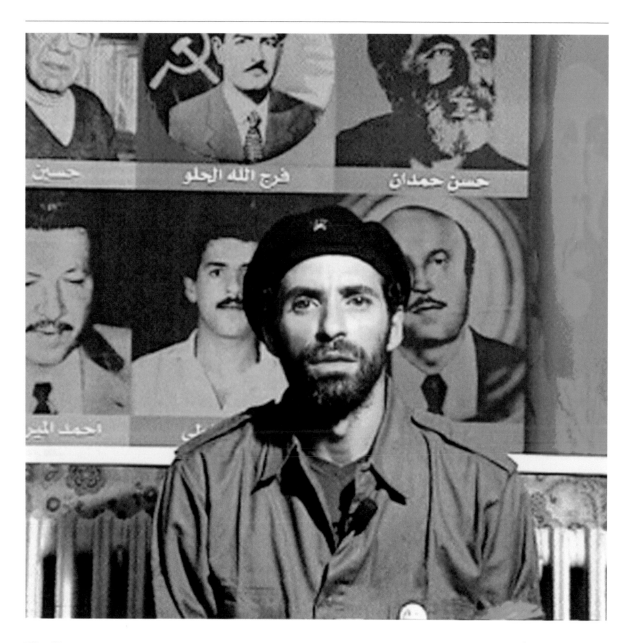

Elias Khoury
and Rabih Mroué,
Three Posters,
2000, stills from a
video-performance.
Courtesy the artists

Conciliations:
Witness
and Spectator

– Juan A. Gaitán

*The spectacle, being the reigning
social organisation of a paralysed
history, of a paralysed memory,
of an abandonment of any history
founded on historical time, is in effect
a false consciousness of time.*
– Guy Debord, *The Society of the
Spectacle* (1967)

In this essay I will put forward the
argument that the spectator is the
contemporary incarnation of the witness
of history. By 'witness of history' I mean
the figure who authenticates the narrative
by presenting him or herself as both
narrator and eyewitness. There are fictional

Juan A. Gaitán analyses the place of the spectator in Rabih Mroué's performances, putting forward an expanded notion of theatre where the classical dramaturgical distinction between active and contemplative positions has been surpassed.

versions of this figure, most famously
Robinson Crusoe. There are actual ones,
such as Francisco Goya with *Los desastres
de la guerra* (*The Disasters of War*,
1810–15). More marginal is a short tale
by Maurice Blanchot, *L'Instant de ma
mort* (*The Instant of My Death*, 1994),
from which Jacques Derrida extrapolated
a brilliant discussion on fiction and
testimony. That this witness of history
has become a spectator implies not just a
proto-objective estrangement of the witness
and the events he or she encounters; it also
implies the consciousness of a very modern
discourse on representation – that of
realism – and of a series of mediations
that lie between the subject and the world.
Today the most conspicuous of these
mediations belong to the technologies of
mass communication and the spectacle,
but history must also be counted: history,
not as historical time, but as the spectacle of

the unfolding of time in which the present
is affirmed as the fundamental *act* of
history. For the present pathology of history
is *explanation*, insofar as the aim of history
is not to make sense of itself, but to make
sense of the present *qua* its outcome. It is
in this sense that critique, which acts on
the present either by way of distance or by
proximity, has attempted to formulate itself
as an alternative to history, which is to say,
as an alternative to narration. The funda-
mental critical question therefore is how to
establish a response to the present without
recourse to pre-ordered narratives.

All these motifs are to be found, I think,
in the performance *Three Posters*, made in
2000 by the artist Rabih Mroué in collabo-
ration with the writer Elias Khoury. The
work focuses on the figure of the contempo-
rary suicide bomber. Like others of this
generation of Lebanese artists and writers
– Jalal Toufic, Walid Raad – Mroué and
Khoury sidestepped the psychopathological
question of motivation in order to engage
with the problem of the aesthetics of
politics: what position does the figure
of the suicide bomber, as the executed
executioner, occupy in the contemporary
socio-political landscape? (The figure of the
suicide bomber made its first appearance
in Mroué's work in *Three Posters*.) Like
others of Mroué's contemporaries – the
Palestinian film-maker Elia Suleiman
can be counted amongst them – Mroué's
guiding concern has been how to present a
critique of competing historical narratives
without entering into competition
with them.

Mroué and Khoury stopped perform-
ing *Three Posters* some time after 2001.
Nevertheless, anyone who has come
to Mroué's work only recently will
find uncertain references to this earlier
performance. *Three Posters* provided the
basic material for a text ('The Fabrication
of Truth', 2002), a video-lecture (*On
Three Posters: Reflections on a video-
performance by Rabih Mroué*, 2004)
and more recently the third act in a

lecture-performance (*The Inhabitants of Images*, 2008). At his recent exhibition in BAK (basis voor actuele kunste), Utrecht, for instance, Mroué presented *On Three Posters*, in which he explains that in his and Khoury's view, the history that gave rise to suicide missions in Lebanon has no bearing outside of Lebanon. These missions have become increasingly confused, especially after 11 September 2001, with the two main references in the US mainstream conception of the Middle East: Islamic fundamentalism and the suicide missions led by Intifada militants in Israel-Palestine. In calibrating the performance to take into account changes in reception, *On Three Posters* came to replace the original *Three Posters*, turning it into its supplement. Despite or in spite of Mroué's warning, it is worth taking up the earlier performance, as it displays — much more clearly than the following ones — a range of theatrical motifs that have become increasingly central to contemporary thinking about performance and performativity, especially in their connection to the dramas of everyday life and citizenship that much performance art now ostensibly addresses.

In *Three Posters* an audience is sitting in a theatre watching a small television screen that has been placed above a door.[1] Mroué appears on the screen wearing a military T-shirt and a beret, reading the testimony of the soon-to-be martyred communist militant Khaled Rahhal. Rahhal is a fictional character. Chances are the audience already knows this, recognising Mroué and Khoury, whose performance they have come to see. The backdrop is somewhat realistic, resembling the setting of many such testimonies that are televised in Lebanon and elsewhere, where 'martyred comrades' speak their last thoughts some hours before embarking on a suicide mission. The first act ends once Khaled Rahhal has read a third version of his testimony. The door beneath the monitor opens, and Khoury emerges and sits with the audience. At this point it is clear that the three testimonies delivered by Mroué, in the name of Rahhal, were delivered live. Mroué is standing beyond the doorway. He takes off his T-shirt and beret, revealing his civilian clothes underneath the military uniform. (It will soon become evident that this undressing is in part symbolic of his own transformation

Rabih Mroué,
*On Three Posters:
Reflections on a
video-performance
by Rabih Mroué*, 2004,
video-lecture, still.
Courtesy the artist

1 In the script for this performance, Rabih Mroué is designated as *actor # 1*, Elias Khoury is as *actor # 2*. *Actor # 2* takes care of all the technical changes throughout the performance: opening doors, changing the videotapes and so on. When not active he is sitting with the audience.

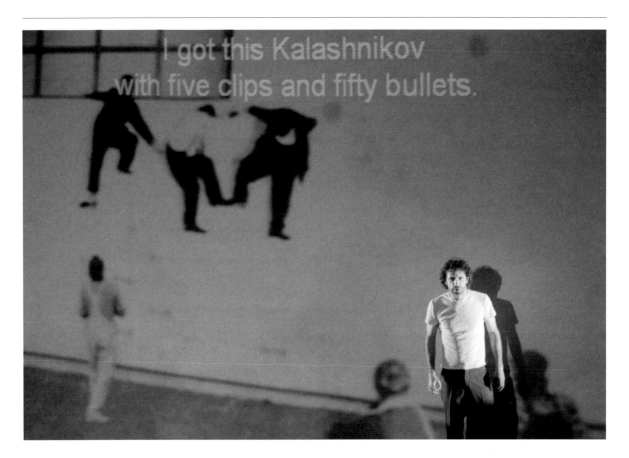

I got this Kalashnikov with five clips and fifty bullets.

Rabih Mroué,
*Who's Afraid of
Representation*,
2004, still from
a performance.
Photograph:
Houssam
Mechiemech.
Courtesy the artist

from a Communist Party militant to an artist and civilian some years before.) He then reads another testimony in his own name, Rabih Mroué, which this time is based on his own biography. Mroué then exits the stage, crosses the doorway (a second symbolic transformation, from actor to spectator), sits amongst the audience and watches the unedited video testimony of a real-life martyr of the Lebanese Communist Party, a man named Jamal Satti, who, dressed as a sheikh and leading a donkey loaded with 400 kilograms of TNT, successfully carried out a suicide mission in 1985 against the headquarters of the Israeli Military Governor in Hasbayya. It was Satti's testimony that provided the foundation for the preceding acts. Like Rahhal in the performance, Satti delivered his testimony three times before the camera. The audience of *Three Posters* gets to see all three versions of Satti's statement, only one of which was broadcast on the evening news on the day he carried out his mission. This is followed in the performance by a video projection in which a politician from the Lebanese Communist Party claims the suicide missions were

perpetrated in spite of the high commands' attempts to discourage them.

I will not delve too deeply into the content of the three acts, but instead will focus on their structure. The three acts roughly correspond to three forms of theatre. The opening act, in which Mroué plays Khaled Rahhal, can be said to represent a classical conception of theatre, in which a passive audience witnesses a spectacle. The television screen in this case only amplifies the existence of a stage. The separation between audience and drama is bridged by the audience's empathetic relationship to the characters in the narrative that guides the play. This includes the expectation, implicit in the delivery of the testimonies of martyrdom, that the 'ideal' audience will empathise with Rahhal's nationalist and/or communist cause. As the door opens, however, we exit the space of classical theatre in order to enter that of defamiliarisation or the distancing characteristic of Brechtian epic theatre.[2] This defamiliarisation is critical in preparing the audience for Mroué's piercing of the illusion of theatre: firstly, Mroué's revelation of his real

2 The German word is 'Verfremdungseffekt'. As there is no direct translation into English (typical translations include 'alienation effect', 'distancing effect', 'defamiliarisation effect'), some critics and writers have left it untranslated or, in the case of Fredric Jameson, abbreviated as 'V-effekt'. See F. Jameson, *Brecht and Method*, London and New York: Verso, 1998.

identity, via the admission that he once was an active militant in the Lebanese Communist Party; and secondly, his wholesale abandonment of the stage, crossing over into the space of the audience in order to play the role of spectator. At this point Mroué and Khoury have abandoned the epic theatre in favour of Antonin Artaud's theatre of cruelty, in which the audience's passive role as spectators is pierced by an actor who has defected from his role as the carrier of the plot. The audience thereby is made active not by distanciation but by being incorporated into the drama — or, better said, by expanding the space of the drama to include the space of spectatorship. Mroué moves towards the audience and takes his place as spectator, emancipating not the audience but the very role of the spectator from its passive condition. If the performer is active as spectator — for he has not ceased to 'perform', he has merely changed roles — then spectatorship potentially becomes an active role. It is only after this double activation, as distanced critics and active spectators, that the audience will experience the three testimonies of Jamal El Sati, whose role in this drama is to render an homage to himself and his comrades, and to take his role as the true actor in the spectacle of history. In other words, Mroué has distanced himself from the role of witness in order to take part in the more symbolic and 'critical' one of spectator.

Khaled Rahhal is a man Mroué could have been. After all, as claimed in his personal testimony, Mroué once belonged to the Communist Party, which he joined in 1983 as an active member of the Lebanese National Resistance Front. Mroué thereby is Rahall *after the fact*. He is the witness who has crossed to the other side, to the side of the living, of the spectator. But Mroué is careful to point out that this should not be understood within the logic of Enlightenment that led to notions such 'critical distance', or the discovery of an alternative that suddenly becomes visible. In the case of Mroué, it is an incidental, even involuntary transformation, as he says at the end of the second act: 'Now, as the liberation of Southern Lebanon had been achieved, I cannot find anything worthy to offer to the memory of all the martyrs of the Lebanese National Resistance Front, other than the following show.'[4] The 'following show' is Jamal El Sati's testimony, which comes shrouded in fictions. I will not linger on the nature or sincerity of such an offering. It seems enough here to say that *Three Posters* belongs to a moment in Lebanese art that includes Toufic and Raad, whose projects have aimed at foreclosing the construction of an over-simplified narrative of Lebanon, particularly one that believes in the truth communicated by images.

There is another, parallel point that must be made with respect to Mroué's 'defection' from the stage and his crossing over to the space of spectatorship. Some years later, in the lecture-performance *The Inhabitants of Images*, Mroué addressed how each dead martyr 'becomes a picture on the wall behind the new person giving testimony. In turn, this person giving testimony [...] will become a picture on the wall' of a future martyr. Rahhal is the militant that Rabih Mroué would have been. Mroué is now a spectator in Jamal El Sati's testimony. To Mroué, this involves a counterfeiting not of identity but of the image: 'In *Three Posters*,' wrote Mroué in 'The Fabrication of Truth' in 2002, 'the image of the martyr Khalid Rahhal appears to the public alongside his real corporeal embodiment in the flesh [...] Hence there arises an essential gap between these two forms of presence [the image and the body], whose effect is to eradicate each other.'[5] It also sets up a disparity between two forms of spectatorship: on one side is Mroué, who has abandoned the image in order to become a spectator; on the other is El Sati, who has abandoned the space of spectatorship in order to remain, posthumously, in the image. I suspect that this is the problem that led Mroué to produce *The Inhabitants of Images*, a meditation on the persistence of the individual's image beyond the death of the body. He writes:

But it is also likely that such sacrifices are the expression of a desire to enter history without the encumbrance of the body, of one's own body. In other

3 In this condition, Khoury is the one whose actions reveal the seams in the theatrical machine. Elias Khoury and Rabih Mroué, 'Three Posters', in Catherine David and Fundació Antoni Tàpies Barcelona (ed.), *Tamáss: Contemporary Arab Representations*, Barcelona: Fundació Antoni Tàpies, 2002, pp.100—14.

4 *Ibid.*, p.105.

5 R. Mroué, 'The Fabrication of Truth', in *Tamáss, op. cit.*, pp.116—17.

words, through the actor's declaration of his readiness to die, a promise is made of a paradise where all the martyrs live together in a single ideal body, an image-icon without any past or personal history.

This is why I don't know if the actor's announcement of his decision to withdraw from theatrical life would be a good end for this story [the actor being Mroué himself in the story of *Three Posters*]; *but it would certainly be the most logical one.* [Just as the martyr, should he decide not to carry out his suicide mission] *would have no other choice than to withdraw from life.*[6]

So perhaps it is acceptable to take a literal approach to El Sati's testimony. El Sati says that he will abandon his country in body only. The absence of his body will unhinge his soul, which will become one with the souls of those good patriots that remain. There is no judgement upon them, just as there is the expectation that they cast no judgement upon him. In the logic of martyrdom bodies are there to suffer, be destroyed and ultimately disappear. This is El Sati's role within the historical reality that he is inhabiting, as militant and as subject of his nation. In the disappearance of the body martyrdom is consummated. In a history whose record is largely composed out of violence and the destruction of bodies, the martyr is the archetypal witness of history: the one who has lived it in the flesh and who has sacrificed the flesh in order to become a witness of that which, up until this point, she or he has only seen (the long list of martyred comrades) from the point of view of the spectator. El Sati will live on not only as a memory, but as the consummate spectator:

As for you dearest and finest mother and father in existence, my beloved brothers and sisters, my will to you is not to mourn and wail but rejoice and dance as you would do in my wedding, for I am the pride [sic] *groom of martyrdom....*[7]

Martyr means witness. But it is also a special kind of witness: one who does not survive the event. Everything in the logic of martyrdom is to be lived in the flesh, only to abandon it: 'Now, as I am departing my country by body only, I will still exist in the souls of all the honest patriots in Lebanon.'[8] So martyrdom in fact is neither a space after life or before death, but the actual moment of death, *'l'instant de ma mort'*, as Blanchot termed it: the moment in which the individual transcends his body in order to become soul or, alternatively, the actor his role in order to become spectator.

In this act of becoming spectator there is a refusal that goes beyond the withdrawals from militancy and theatrical life implicit in *Three Posters*. It is a refusal that must be carefully considered today: the refusal of a distinction between 'action' and 'contemplation' that once lay at the heart of all political motivation. Here we must think of Hannah Arendt's famous opposition between *vita activa*, which defines human existence, and *vita contemplativa*, which extends to include all life forms. The distinction is still powerful as an heuristic device in which 'contemplation' is seen as a state in which everything is perceived as belonging to a natural order of things, and 'action' is seen as the human activity that continuously strives to transcend the present. The task of modern theatre, especially of epic theatre and the theatre of cruelty, has been to transcend the state of contemplation — the former by activating the mind, the latter by psychosomatic shock. But perhaps, as Jacques Rancière suggests in *The Emancipated Spectator* (2008), the real question is whether one should hold on to the classical distinction between active-actor and passive-spectator. Put in terms more specific to the work that I have been discussing, the sense of the experience of war, once exclusively legitimated by the eyewitness — the martyr being the archetypal witness, the witness in the flesh — must now begin to include the space of the spectator, whose role appears outside of history insofar as it is both physically and temporally removed from the events, which is to say, insofar as the events are always subjected to the time and space of spectatorship.

6 *Ibid.*
7 Quoted from Jamal Satti's testimony as it appeared in R. Mroué, *Three Posters, op. cit.*, p.109.
8 *Ibid.*
9 Jacques Rancière, *The Emancipated Spectator* (trans. Gregory Elliot), London: Verso, 2009.

The Fabrication of Truth

– Rabih Mroué

'The Fabrication of Truth' was written in 2002 by Rabih Mroué as a reflection on the video-performance *Three Posters*, which Mroué and Elias Khoury first performed at the Ayloul Festival in Beirut in 2000.[1]

In the Arab countries, political powers, parties, religious communities and various official institutions still continue today to celebrate and praise martyrdom and collective death. This is done in the name 'of the fatherland', 'of the soil', 'of liberation', 'of Arab blood', 'of Islam' and other such slogans. Yet these same societies swiftly forget their heroes, who are relegated to the status of mere names lengthening the list of the martyrs.

In the following pages we will attempt a reading of the video recorded in 1985 by a member of the Lebanese Communist Party, Jamal El Sati, a combatant for the National Resistance Front, just a few hours before the suicide operation he carried out against the Israeli army that at the time was occupying Southern Lebanon. This recording was broadcast on the news program of the Lebanese national television channel, as is often the case for this kind of operation.

By chance, Elias Khoury and I came across the original, uncut videotape. Here, Jamal El Sati repeats his testimony three times in front of the camera before deciding on the best version to present to the public. While the difference between these three versions is minimal and of little importance, the public was supposed to see only one of his attempts, an incontestable, unequivocal document. Upon viewing the original video, we immediately fell under the spell of these repeated attempts; we gave into temptation despite ourselves, and decided to present the tape to the public as is, without editing. We even made it the subject of our theatrical performance, *Three Posters*. We are well aware that by behaving in this way we exposed ourselves to the worst moral accusations:

1. We allow a public which is 'foreign to the party and the family' to witness the martyr's emotions before his death;
2. We present a videotape that does not belong to us;
3. We exploit this videotape to develop an 'artistic' performance from which we will draw both moral and financial profit;
4. We allow ourselves to violate the sacred space of the martyr in order to critique the concept of martyrdom, and therefore the powers that nourish and encourage such ideologies (whether they are official or not — in this case, official, the political party to which Jamal El Sati belonged).

It is not a matter of responding to these accusations here, nor of discussing the problems they raise; rather it is a matter of understanding the meaning of Jamal El Sati's repeated attempts before the camera, and of these unutterable instants of a non-place between life and death. Finally, it is an attempt to understand the effect produced on the public by this exceptional situation during the projection of the videotape.

To begin, let us pause a moment over these repetitions of Jamal El Sati's

1 The essay was originally published in *Tamáss 1: Contemporary Arab Representations* (2002), edited by Catherine David and Fundació Antoni Tàpies, and organised by Fundació Antoni Tàpies, Barcelona, in association with Witte de With, Rotterdam, arteypensamiento, Universidad Internacional de Andalucía (UNIA), Seville and Arteleku, San Sebastian.

Rabih Mroué and
Fadi Toufic, *How
Nancy Wished That
Everything Was
an April Fool's Joke*,
2007, still from
a performance.
Photograph:
Kohei Matsushima.
Courtesy the artists

testimony, which are due to an evident excess of emotion. Jamal El Sati is a fighter who does not fear death. As proof, he goes voluntarily out to meet it. Yet as soon as he steps before the camera to film his testimony, his words betray him, hesitating and stumbling between his lips. His gaze is unable to focus; it wavers and gets lost.

These different takes are like those of an actor getting ready to play his role. Why does Jamal El Sati try to act? Does his martyrdom need some trace more effective than the one that will result from his suicide operation, which is nonetheless supposed to 'cause great damage to the Israeli enemy'? Is the media image more effective than martyrdom in itself, than physical death?

These questions, although simple, are violent.

The young man begins by introducing himself: 'I am the martyred comrade Jamal El Sati...' In an uncertain non-place, antagonistic to both of the known worlds — those of the living and the dead — El Sati presents himself as a martyr through the image. But in reality his martyrdom has not yet been actualised and only will be after a certain lapse of time whose duration is unknown to us, but which stretches from the instant of filming to the instant of his mission's fulfilment.

Does the martyrdom then take place directly before us, through the filmic image of the videotape? Indeed, it seems that the martyrdom is actualised at the very instant the young man announces his martyrdom before the camera, through the very fact of this announcement. This is why it is so natural for him to introduce himself by saying: 'I am the martyred comrade Jamal El Sati...' and not 'I am Jamal El Sati, soon to be a martyr...'. The martyrdom has taken place before the suicide mission, and therefore whether this operation has effectively taken place or not no longer makes any real difference.

When I say 'I am the martyred...' it means 'I am the dead man...'. But I am not yet dead, and it is possible that I will not become a martyr. Despite this, the viewers accept the declaration of the martyr's death, without casting it into doubt. But if I repeat this declaration three times, doubt undoubtedly arises. I think the powerful effect of these repetitions stems from the fact that they refuse life and announce the 'departure' of the announcer even while they put off the act of death to a later,

undetermined date. I don't think the emotion is due only to a calculated desire to gain the sympathy of the audience, nor only to a belated consciousness of what will become of him after his death, but above all to the unformulated and unformulable desire both to defer death and to withdraw from life. Repetition is the sign of this twofold desire for deferral and withdrawal.

I dream that I am before a camera, and that I can't finish filming the testimony I am due to give before going out to execute a suicide operation against the Israeli occupation. I repeat the same text over and over again, on the pretext of trying to obtain a better version. Two times, ten times, a hundred times... I can see that they are all actually the same, but I can't stop myself — a repetition leading nowhere... Repeating to kill time, to gain time... Time passes, I grow older, and I continue repeating my testimony before the same camera... Suddenly my military superior appears... He is in civilian clothing... He tells me, smiling, that the Israeli army has withdrawn from Lebanese territory and the operation is no longer necessary.

An actor wounded his eye during a performance at a theatre festival, and began to bleed profusely. A fact that troubled the audience as well as his colleagues on stage. But the actor refused to leave the stage and stop the play as his colleagues, as discreetly as possible so the public would not notice, tried to suggest that he do so. He truly was suffering; he was in a critical state. The performance continued, and the actor's bloody eye became a spectacle in itself, where reality and fiction mingled in an exceptional way to offer the public's voyeurism a rare and curious object that they were not at all ready to give up. The public and the other actors themselves applauded the actor wholeheartedly at the end of the show, expressing their admiration for his abnegation and their gratitude for his sacrifice, saluting the risks he had deliberately run in order to ensure the play's success. Nobody noticed his eye laying on the stage, staring fixedly at the public.

The actor was awarded the jury's special prize for several reasons, notably, the public's compassion and empathy for this actor continuing to play, to interpret his role, even while struggling and confronting real pain. Acting and dramatic interpretation on the one hand, real suffering on the

other. What does all this mean for the public? What is the relation between this incident and the martyr's repetitions before the camera?

The wounded actor did not leave the stage, his colleagues continued the performance and the public appreciated its own privileged position, which allowed it to witness this spectacle of blood. By carrying this logic to its conclusion, we arrive at a crime in which everyone has participated. No one knows to what degree the wound is dangerous. Will it kill the actor? Will he lose his eye for good? Will he convulse in a nervous crisis paralysing his limbs? No one knows. But the desire for death has been declared before us, and we accept it as a rare object of voyeurism that enflames our desire. This tacit pact to contemplate death in cold blood is at once an expression of the refusal of life and a revolt against its logic; at the same time there exists a desire for the deferral of death until the end of the performance.

Why does the actor accept the experience of death during the performance? Why does the martyr accept the experience of acting and representation, in the dramatic sense of the term, even while preparing to die?

Is it the temptation, the idea of immortality? Perhaps. But it is also likely that such sacrifices are the expression of a desire to enter history without the encumbrance of the body, of one's own body. In other words, through the actor's declaration of his readiness to die, a promise is made of a paradise where all martyrs live together in a single ideal body, an image-icon without any past or personal history.

This is why I don't know if the actor's announcement of his decision to withdraw from theatrical life would be a good end for this story, but it would certainly be the most logical one. Just as it would be for the martyr, if ever he decided not to carry out his suicide mission after his testimony had been broadcast. I think he would have no other choice than isolation and withdrawal from life. That actually is what happened in May 1986 in the case of one resistance fighter: after the broadcast of his testimony on an official TV station, the rumour went out in the country that the operation had not taken place, that the martyr was not dead. What is more, Israel announced no incident inside the Lebanese territories it was occupying at the time.

What happened? We will never know. But, and this is what is most important, we know the body of the fighter will never be found. He has disappeared, and even today no one can say what became of him or what actually happened.

In my opinion it is unimportant to know the degree to which this story is true. Jamal El Sati's repeated attempts before the camera refer us to another question, that of the meaning of the mediated 'truth' when it is broadcast to the public as an exceptional moment when 'truth and fiction' intermingle. Similarly, his repeated attempts question the possibility of constructing an artistic work that aims to be critical about the notion of 'truth', a work that claims to convey the 'truth' without any editing, even while being itself a 'fabricated truth'.

In *Three Posters*, the image of the martyr Khaled Rahhal appears to the public alongside his corporal embodiment in flesh and blood. Hence there arises an essential gap between these two forms of presence, whose effect is to eradicate each other mutually. The image no longer functions as the trace of the real body, or as the representation of the real body, just as the presence of the real body no longer functions as an alternative to the image. This mutual interference denounces not only the usurped identity of the martyr by his appearance in flesh and blood before the public, but even goes so far as to denounce his identity as an actor in the theatre, an actor who reads his own real name, his date of birth and a few other details of his 'personal life' off a piece of paper, before giving up his play-acting to sit down alongside the public and watch the playback of the videotape where the image of the 'real' martyr Jamal El Sati will appear.

I cannot help but interpret the repeated attempts of Jamal El Sati as a desire for the deferral of death, in these depressing lands where the desire to live is considered a shameful betrayal of the State, of the Nation-State, of the Father-Motherland.

Cover of Karl
Holmqvist's *What's
My Name*, 2009,
printed publication

Karl Holmqvist:
Making Space

— Melissa Gronlund

In the well-loved video *Theme Song*, which Vito Acconci made in Florence in 1973, Acconci lies on the floor, on his side, his face close to the camera, crooning. His softly spoken monologue is annotated by a medley of different pop songs playing from a cassette recorder — songs such as Bob Dylan's 'I'll Be Your Baby Tonight' — which Acconci switches on and off, and at times sings along to. The video taps into the power of the pop lyric to seduce both anonymously and universally, and Acconci's own commentary echoes this attempt at general seduction, playing with the multiple possibilities for an 'I' and a 'you': 'You could be anybody out there ... there could be anybody out there... don't you want to come here? Sure you want to come here ... My body's here ... yours could be too...'

Theme Song was one of Acconci's last works before he moved from a poetic and visual arts practice to architecture, and so came at the end of a varied series of investigations into relationality. Works like *Seed Bed* (1971) and his writing for the journal *0 to 9* (1967—70) questioned the relation between people and objects in a space as well as the potentials for words, and in particular borrowed words, to trade meanings on a page. This hybrid dimension is crucial: Acconci's poetry was both influenced by concurrent developments in the visual arts in New York at the time — by artists such as Robert Smithson and Sol LeWitt — as well as by an experimental school of poetry that claimed writers such as John Ashbery and Jackson Mac Low as members. Acconci understood text and performance to be equal arenas of play rather than being hierarchical to one another: he termed the page 'a field for action', for example, or 'a performance area in miniature'.[1]

Melissa Gronlund considers the spatial effects of language within Karl Holmqvist's performances and his 2009 book of poetry, *What's My Name?*

This seems important to mention because Acconci acts in many ways as a precursor to Karl Holmqvist's investigations into traded meanings and the deployment of text in both printed and performed formats. Looking critically at Holmqvist's work, we might return to the question posed by Acconci of how we are meant to understand text on and off the page, in performance, and what these changes in register do to the 'I' who is speaking, writing or borrowing.

Holmqvist's recent book, *What's My Name?* (2009), brings together poems and short prose works — the poems running to a few pages long, and the prose works just a few paragraphs — in a minimally designed, two-columned publication with an Op art cover.[2] Some texts in the book are recognisable from Holmqvist's performance repertoire, and, like his performances, are collages of quotations, pop-song lyrics and often anodyne political slogans. Though it is clear that the poems are printed versions of these performances, it is less so whether they are meant to act as scripts to be read from, or as documentations of the performance. This is not a question without precedent: John Cage's numerous different scores for even such an iconic performance as *4'33"* (1952) — typewritten, musically notated, in programme notes — have made the determination of the 'original' score impossible, and indeed Cage desired that his scores were not to be written as representations of the musical work but as actions to be realised. His written, graphical or gridded scores allowed him to move from signalling time via metrical notation to marking it more directly as function of space. The framing of performance as almost a 'time container' — a duration in which things would happen — was central to Cage's performances: *4'33"* and *The Music of Changes* (1951) are strict about durational

1 Quoted from Liz Kotz, *Words to Be Looked At: Language in 1960s Art*, Cambridge, MA and London: The MIT Press, 2010, p.170.
2 See Karl Holmqvist, *What's My Name?*, London: Book Works, 2009.

READDEARREADDEARREADDEARREADDEARREADDEARR
EADDEARREADDEARREADDEARREADDEARREADDEARRE
ADDEARREADDEARREADDEARREADDEARREADDEARREA
DDEARREADDEARREADDEARREADDEARREADDEARREAD
DEARREADDEARREADDEARREADDEARREADDEARREADD
EARREADDEARREADDEARREADDEARREADDEARREADDE
ARREADDEARREADDEARREADDEARREADDEARREADDEA
RREADDEARREADDEARREADDEARREADDEARREADDEAR
READDEARREADDEARREADDEARREADDEARREADDEARR
EADDEARREADDEARREADDEARREADDEARREADDEARRE
ADDEARREADDEARREADDEARREADDEARREADDEARREA
DDEARREADDEARREADDEARREADDEARREADDEARREAD
DEARREADDEARREADDEARREADDEARREADDEARREADD
EARREADDEARREADDEARREADDEARREADDEARREADDE
ARREADDEARREADDEARREADDEARREADDEARREADDEA
RREADDEARREADDEARREADDEARREADDEARREADDEAR
READDEARREADDEARREADDEARREADDEARREADDEARR
EADDEARREADDEARREADDEARREADDEARREADDEARRE
ADDEARREADDEARREADDEARREADDEARREADDEARREA
DDEARREADDEARREADDEARREADDEARREADDEARREAD
DEARREADDEARREADDEARREADDEARREADDEARREADD
EARREADDEARREADDEARREADDEARREADDEARREADDE

parameters, but allow what is inside these parameters to unfold by chance, opening outward to an infinite number of things. Again, the score functions here not as a description of this event but as an operational model, setting into motion processes that will happen. For Holmqvist, on the other hand, the text is a starting point, a script to read from, and from which he often improvises.

His performances, done at galleries, art institutions and the homes of friends, do not have a fixed length but last from around twenty minutes to hours, depending, Holmqvist says, on how he feels. He reads his poems in a spoken, almost *Lieder* style, elongating some words, repeating lines and relying on a minimal range of notes and a maximum range of affect. A feeling of authenticity, based on Holmqvist's presence, grounds the performances. He is an effective performer, and one goes to see 'him'. His voice is distinctive, and has remarkable projection across the room. He is not especially tall but looks lanky when he sits, his legs crossed and his elbows on his knees, holding his script before him in his hands. He rarely looks up, and the pauses in his delivery seem arbitrary — they come between words, not phrases or sentences — making his performance a cross between the intonation of a Latin mass and someone reading lyrics in a language they don't know.

While Cage set up in his work a direct relation between score and performance, Holmqvist's texts are not interested in the possibilities of marking time and space but in the inability of words to demarcate definitely — or, rather, in the capacity of words, and the means of representing these words, to shift and re-signify. Indeed if Cage's and Acconci's work can be said to be made partly in response to the introduction of new recording technologies, as Liz Kotz argues in her book *Words to Be Looked At: Language in 1960s Art* (2010), then Holmqvist's technological analogue is the emailable, printable, copy-able document, lacking in both preciousness and any indexical mark of the author.

The question of authenticity is a key theme in *What's My Name?*, posed as a question by the very title. In it the notion of an 'I' and its linguistic representation in one's name jut repeatedly against the very mode of writing contained within the book: a field, like and unlike the performances, of quotations. These range from recognisable art phrases, such as John Baldessari's 'I will not make any more boring art' (from *I Will Not Make Any More Boring Art*, 1971), pop anthems (like Beyoncé's 'Single Ladies (Put a Ring On It)') to political slogans ('end capitalism'), and appear alongside Holmqvist's own additions — all of which helps to inhibit the picture of a definite 'I' from emerging.

Karl Holmqvist, 'Dear Reader', from *What's My Name*, 2009, printed publication

In his performances, by contrast, Holmqvist's distinctive delivery flattens the differences between his borrowed words, or rather smoothes them down, making the words recognisably 'his' rather than audibly belonging to the sources they come from. Potential shifts of meaning according to a word's siting in a certain arena or subculture is something familiar to the operations of appropriation within these arenas themselves — from high art's ironic quotation of pop to a subculture's reappropriation of slurs — as well as in Holmqvist's quotations of them, and his modes of authenticity and irony also find echoes in pop music's negotiation between artifice and earnestness, where lyrics display emotional directness, for example, while being authored by hired songwriters. His interest in camp likewise focuses on its play with the connotations of words within it — his project *One World, One Love* (2008) considers Grace Jones's appropriation of homophobic epithets, for example — and *What's My Name?*, in its explicit mixing of linguistic traditions, questions how important it is to know who is speaking — a black woman and gay icon 're-owning' those slurs, or an artist and poet intoning Beyoncé. However, none of these 'identities', or collection of traits, is immediately apparent from the printed page.

Poems in *What's My Name?* include patterned works formed out of the repetition of words, as well as the prose asides about figures from the poetry and music worlds, such as Patti Smith, Allen Ginsberg or the St Marks Poetry Project. These provide soft breaks from the brash visual aesthetic of the poems, which are all written in capital letters and whose repetition is insistent and loud. Violence, throughout the book, is both signalled and performed. For while repetition is part of the style of the performances, it here dominates (or indeed constitutes) the visual appearance of the texts, particularly in the 'patterned' poems. Thus not ignoring the contexts that the quotations are taken from, it seems important first to look at how their repetition functions, and at the questions that this repetition poses of the words' legibility vis-à-vis their performative capacity. Here is a quotation from the poem 'Language Sausage':

IN THE FLESH
BIGGER BIGGER BIGGER
 BIGGER BIGGER BIGGER
BIGGER BIGGER BIGGER
 BIGGER
JIMI HENDRIX
 JACKSON POLLOCK
JIMI HENDRIX
 A BIGGER SPLASH
 JACKSON POLLOCK
JIMI HENDRIX
 JACKSON POLLOCK [3]

The duo 'JIMI HENDRIX / JACKSON POLLOCK' is then repeated about seventy times more. The poem suggests not only a pun on these macho figures' masculinity — 'Language Sausage', 'IN THE FLESH / BIGGER BIGGER BIGGER' — and the double reading of the word 'splash' — as both a drop of paint and an index of the cultural waves they made — but more importantly, it suggests an attempt to make a 'bigness' of language itself through the accumulative repetition of their names. The text relates this performative 'bigness' to the vocation of poet, and an unclaimed identity crisis that seems located both in the body — 'IN THE FLESH' — and in a persona — 'SEXUAL IDENTITY / PERSONALITY CRISIS / TALKING ABOUT A / PERSONALITY CRISIS'.

As echoed by the perceptible meaning of the word 'BIGGER', the text functions here as visual material to be seen as a (big) block of text rather than read sequentially. Indeed legibility versus visuality is one of the book's major themes: the poem 'Dear Reader', for example, is a grid made of the letters 'R', 'E', 'A' and 'D', and the poem 'Eyes yes' is a pattern composed of the letters 'E', 'Y', 'E' and 'S'. In both of these, the problems of legibility and visuality are (mimetically) announced, while also becoming directives or descriptions followed by the reader. If the title of the book points to questions of authorship, the cover's

3 K. Holmqvist, 'Language Sausage', *What's My Name?*, *op. cit.*, p.27.

```
BOMB'EM BACK                BOMB BOMB'EM BACK          OR BLOWING YOURSELF UP     BOMB BOMB BOMB BOMB
                            OO-EE-OOUUM                WON'T DO NO GOOD           BOMB BOMB'EM BACK
BOMB BOMB BOMB BOMB         BOMB BOMB BOMB BOMB        BOMB BOMB BOMB BOMB        BERLUSCONI
BOMB BOMB'EM BACK           BOMB BOMB'EM BACK          BOMB BOMB'EM BACK          WHERE IS THE MONEY?
BOMB BOMB BOMB BOMB                                    BOMB BOMB BOMB BOMB
BOMB BOMB'EM BACK           BOMB BOMB BOMB BOMB        BOMB BOMB'EM BACK          THESE PEOPLE R NOT
BOMB BOMB BOMB BOMB         BOMB BOMB'EM BACK                                     LIKE ME & U
BOMB BOMB'EM BACK           BOMB BOMB BOMB BOMB        BOMB BOMB BOMB BOMB        THE BACKSTREET & THE
OO-EE-OOUUM                 BOMB BOMB'EM BACK          BOMB BOMB BOMB BOMB        AVENUE
BOMB BOMB BOMB BOMB         U GOT ME BLEEDING          BOMB BOMB BOMB BOMB        BOMB'EM BACK 2 WHERE
BOMB BOMB'EM BACK           & DYING                    BOMB BOMB BOMB BOMB        THEY CAME FROM
OO-EE-OOUUM                 U GOT ME COUGHING          BOMB BOMB BOMB BOMB
BOMB BOMB BOMB BOMB         & A CRYING                 BOMB BOMB BOMB BOMB        BOMB BOMB BOMB BOMB
BOMB BOMB'EM BACK           BOMB'EM BACK               BOMB BOMB BOMB BOMB        BOMB BOMB'EM BACK
                            BOMB BOMB BOMB BOMB        BOMB BOMB BOMB BOMB        BOMB BOMB BOMB BOMB
BOMB BOMB BOMB BOMB         BOMB BOMB'EM BACK          BOMB BOMB'EM BACK          BOMB BOMB'EM BACK
BOMB BOMB'EM BACK           BOMB BOMB BOMB BOMB        OO-EE-OOUUM                BOMB BOMB BOMB BOMB
BOMB BOMB BOMB BOMB         BOMB BOMB'EM BACK          BOMB BOMB BOMB BOMB        BOMB BOMB'EM BACK
BOMB BOMB'EM BACK           BOMB BOMB BOMB BOMB        BOMB BOMB'EM BACK          OO-EE-OOUUM
BOMB BOMB BOMB BOMB         BOMB BOMB'EM BACK          COLONEL GADDAFI           BOMB BOMB BOMB BOMB
BOMB BOMB'EM BACK                                      ROCKET LAUNCH             BOMB BOMB'EM BACK
OO-EE-OOUUM                 BOMB BOMB BOMB BOMB        MON COLONEL               OO-EE-OOUUM
BOMB BOMB BOMB BOMB         BOMB BOMB'EM BACK          MUBARAK                   BOMB BOMB BOMB BOMB
BOMB BOMB'EM BACK           BOMB'EM BACK 2 WHERE       EVERYBODY MUST            BOMB BOMB'EM BACK
OO-EE-OOUUM                 THEY CAME FROM             EVERYBODY MUST
BOMB BOMB BOMB BOMB         THE IN & THE OUT           EVERYBODY MUST GET
BOMB BOMB'EM BACK           THE OLD & THE NEW          STONED
                            BACKSTREET & THE           MUBARAK
BOMB BOMB BOMB BOMB         AVENUE                     EVERYBODY MUST
BOMB BOMB'EM BACK           BOMB'EM BACK 2             GET STONED
BOMB BOMB BOMB BOMB         THEIR NEIGHBORHOOD         EVERYBODY MUST
BOMB BOMB'EM BACK           THESE PEOPLE R NOT         GET STONED
U GOT ME BLEEDING           LIKE ME & U
& DYING                     OO-EE-OOUUM                BOMB BOMB BOMB BOMB
U GOT ME COUGHING           BOMB BOMB BOMB BOMB        BOMB BOMB'EM BACK
& A CRYING                  BOMB BOMB'EM BACK          BOMB BOMB BOMB BOMB
BOMB'EM BACK                BOMB BOMB BOMB BOMB        BOMB BOMB'EM BACK
BOMB BOMB BOMB BOMB         BOMB BOMB'EM BACK          BOMB BOMB BOMB BOMB
BOMB BOMB'EM BACK           BOMB BOMB BOMB BOMB        BOMB BOMB'EM BACK
BOMB BOMB BOMB BOMB         BOMB BOMB'EM BACK          OO-EE-OOUUM
BOMB BOMB'EM BACK           IT'S UNDERSTOOD            BOMB BOMB BOMB BOMB
BOMB BOMB BOMB BOMB         AGREED & SIGNED 4          BOMB BOMB'EM BACK
BOMB BOMB'EM BACK           NOTHING 2 STAND            OO-EE-OOUUM
OO-EE-OOUUM                 IN LINE 4
BOMB BOMB BOMB BOMB         THROWING STONES
```

literal background of Op art patterning points to the fact that the visual layout of the poems is just as significant. Rather than a suggestive relationship between score and performance, the texts turn their focus inwards, probing the action of reading words as part of a visual composition, and flipping back and forth between specifically linguistic operations and clear indications of text's ability to occupy fields of vision and space.

More so than his performances, I would argue, *What's My Name?* is able to illuminate a notion of politics, which presents itself through numerous references to foreign policy, domestic violence and homophobia, among other issues. In the poem 'Bomb 'em Back (2 The Stone Age)', for example, the repeated line of four BOMBs stands not as four sequential BOMBs but as one group of four: 'BOMB BOMB BOMB BOMB'. Craig Dworkin, in his book *Reading the Illegible* (2003), relates one use of illegible material in poetry to a means of signalling censorship, with erasures ostensibly subtracting information but in actuality bringing to the poem a discourse of political repression and remembrance.[4] The staging here of the transformation of the word 'bomb' that signifies a bomb — an explosive device, something that goes boom — into a series of repeated upper-case letters could be understood as an act of violence against the signifying potential of the text — which appears here as a visual object — and at the same time a warning to remember the word refers to. This effect of staging and marking indifference is repeated throughout the volume, with other phrases such as 'DOMESTIC VIOLENCE', 'SAFE SEX' and 'MONEY'.

It's worth wondering how seriously we are to take the peacenik implications of the ironically titled 'Bomb 'em Back (2 The Stone Age)', with its tones of martial bravado and faddish aggression. Like pop music, Holmqvist's espousal of rhetoric seems both genuine and ironic: he is mocking the case for war, but his articulation contains enough ambivalence to suggest that he is also mocking pacifist proclamations — how much is a poem in a book, or a performance to a choir of like-minded people, going to contribute to change? Like the importance of context within the appropriation of words, here too the matter of audience comes to infect the textual operations of the poem.

Karl Holmqvist,
'Bomb 'em Back
(2 The Stone Age)',
from *What's My
Name*, 2009, printed
publication

4 See Craig Dworkin, *Reading the Illegible*, Evanston, IL: Northwestern University Press, 2003, pp.140—43.

Karl Holmqvist,
spoken word
performance
documentation,
2009. Courtesy
the artist and
westlondonprojects.
Photograph: KADN.
© westlondonprojects

The possible failure of Holmqvist's exhortations comes from the question of the authorial 'I', in reprise of the Acconci/pop singer 'I' and singular/plural 'you' of *Theme Song*'s anonymous seduction. 'Language Sausage' continues with:

> DO U LIKE THE
> WORLD AROUND
> U?
> > WORLD AROUND
> > WORLD AROUND
> > WORLD AROUND
> DO U LIKE THE
> > WORLD AROUND
> U?
> THERMAL HEATING
> PEOPLE EXPLOSION
> > DO U LIKE THE
> WORLD AROUND
> U?
> SAVE THE PLANET
> SAVE THE PLANET
> > FEED THE WORLD
> > FEED THE WORLD
> > FEED THE WORLD[5]

The intended addressee of a slogan appears both as the individual (someone is urging *you* to feed the world) and, because the individual is unknown to the speaker, the group of individuals of which he or she forms part. The juxtaposition of slogans with pop lyrics suggests a symmetry in their mode of address, which is related to a shared universalist aspiration that both enlivens and undermines them. Are *all* the single ladies really being asked to put their hands up? Can you feed *the world*? Set against these generalisations is Holmqvist's

5 K. Holmqvist, 'Language Sausage', *What's My Name?*, *op. cit.*, p.29.

Karl Holmqvist,
All the Single Ladies,
2009, performance
as part of '27 Senses',
produced by Electra.
Photograph:
Simon Wågsholm.
Courtesy Electra

Karl Holmqvist,
*Schwitters Hutte
in Merz Box*,
2009—10.
Installation view,
'27 Senses',
Chisenhale Gallery,
London. Produced
by Electra. Courtesy
Chisenhale Gallery

overriding problem of the 'I' — as well as that of the reader as the 'U' — whose singularity is at once the goal (*One World*) and the problem (*What's My Name?*, 'IDENTITY CRISIS').

This textual questioning of authorial voice, and its connection, via appropriation, to words from what we might call the 'auditory mainstream' (the TV, the radio, advertisements, all of which constantly repeat themselves), appears in contrast to the centrality of Holmqvist to his performances. In a sense this fundamental difference suggests that the relationship between his poems and his performances is none at all: they are two very different things. While his printed text works rely on clearly textual and linguistic operations in order to mount their arguments, his performances rely on classically performative elements such as his charisma as a performer and his ability to project, and are as undetermined in time as his patterned works are precisely laid out in space.

The measuring of time, it is true, has not much to do with Holmqvist's work, and where Cage's innovation in the 1950s was to map time spatially — an innovation that Kotz argues was derived from his increasing use of magnetic tape, which notates time not through a semiotic system but though actual placement *on* the tape — Holmqvist's printed text work concentrates on the spatial dimension of language: its capacity, for example, to signify BIGGER both through the meaning of the word 'bigger' and through typographic repetition on the page. Holmqvist's installations of language are often just that: houses, to rephrase Wittgenstein, built out of language. In these works printed sheets of block text of Holmqvist's poems, with their collage aesthetic, are arranged and mounted on specially built structures

that themselves often address notions of appropriation. In the touring show '27 Senses' (2009—10), organised by the London-based Electra, Holmqvist built a structure based on Charlotte Posenenske's blueprints for structures (this iterability is built into her work). The show 'Entrevista con el Vampiro' ('Interview with the Vampire', 2009) at House of Gaga in Mexico City, was inspired by the idea of parasitic practices; he made framed photographic collages, a Minimalist-esque sculpture, a video and a stapled collection of his texts, which hung from the wall. Holmqvist has often said that he wants to make a 'sculpture' of language, and indeed his sculptures emphasise the visual, even spatial dimension of language, standing in for walls and supports.

Holmqvist frequently presents his texts alongside images from magazines and advertisements. The images — or at least some of them — are sexy, showing partially clothed or naked women, or reclining boys. A similar immediacy and presence of the body is important also to Holmqvist's performances and to his presentation of language, which, in the various identity crises it speaks of, searches not for an answer in an 'identity' but in a 'name'. This confluence of linguistic referent and physical organisation, like the title 'Language Sausage', suggests that language can stand for identity not only because of its signifying potential but also because of its ability to occupy space: a body of language, perhaps, and a name instead of an identity. The references in *What's My Name?* to a history of poets, particularly those of New York in the 1960s, its allusions to different discourses (pop, SMS-speak, Concrete poetry) and its multiple voices suggest that the answer to this question of 'my' name is 'language' itself.

Vita passiva, or Shards Bring Love: On the Work of Judith Hopf

— Sabeth Buchmann

Judith Hopf's work over nearly twenty years mixes significant genealogies of the 1990s: conceptual/performative, object-like/installation and video and cinematographic forms. Her work is shown not only in art venues, but also in the theatre, in the cinema, on the radio and at bookstores, clubs and 'off spaces'. Like others of her generation, Hopf's way of working is characterised by this decentred quality, which may be rooted partially in the gradually expanding institutionalisation

Starting from its origins in the Berlin art scene of the 1990s, Sabeth Buchmann analyses Judith Hopf's idiosyncratic practice of institutional critique and object-making.

of contemporary art. This decentred quality also has to do with the specific circumstances of Berlin in the 1990s — where Hopf began working — when activities that conceived of themselves as art in the broadest sense occurred at a variety of social sites beyond the confines of art institutions. Affordable rents provided a favourable climate for the production and hosting of event spaces of all kinds, where, for a time, despite the rapid pace of the art scene's ongoing commercialisation, self-organised low-budget projects existed alongside simultaneously emerging 'young' galleries.

It was in this mood that the Free Class was founded at the Academy for Fine Arts (the Hochschule der Bildenden Künste, now the Universität der Künste), which Hopf participated in alongside such artists as Klaus Weber and Katja Reichardt (who later co-established the bookstore pro qm), as well as the future gallerist Alexander Schröder (who went on to form Neu Galerie). Amongst the Free Class's guests in those years were Renée Green, Nils Norman, Stephen Prina, Stephan Dillemuth and others whose work was

then, and in part still is, located in the 'contact zones' between artistic, pop-cultural, academic, urban and social fields. In this situation, the understanding of art as a result of a continuously accumulating studio production was not very appealing. Artists participated instead in joint activities, such as, for example, Weber's *InnenStadtAktionen* (*InnerCityActions*, 1997—98) and the *A-Clips* videos (1997, 2000 and 2003), involving artists such as Hopf, political activists, authors, musicians and others. The *A-Clips* addressed the privatisation of the city centre, the rampant expansion of consumer zones and the social effects of globalisation, and were shown at numerous cinemas in between the advertisements and the feature attractions.

Such varying mixtures of artistic, political and medial forms of production and cooperation required the participants to enact multiple roles of communication, interaction and teaching. This was also a moment in which a post-Fordist turn can be discerned in Institutional Critique. At that time there was a heightened consciousness of the significance — generally omitted by first-generation Institutional Critique — of processes of social subjectification, as theorised in the 1990s and 2000s by authors including Judith Butler, Ève Chiapello and Luc Boltanski, Donna Haraway, Eve Kosofsky Sedgwick, Avital Ronell, Paolo Virno and others. Their discourses found a broad reception within Berlin's politicised art context, which was informed by the necessity for new critical praxes — praxes that no longer defined themselves through the concept of a stylised counter-public who might lead the way towards greater criticality (readily identifiable types such as the class warrior, the anti-racist, the anti-sexist, etc.). Instead the goal was to reflect back on those norms and regulations contained in (post)modern artistic thinking, particularly vis-à-vis the subject.

I mention this because the influence those discourses had on artists such as

Judith Hopf should not be underestimated, and this influence allows for a look at her idiosyncratic relationship to object production, in particular its deviation from institutional critique's repudiation of this kind of object-making.

That such discursive milieus linked to art scenes are fundamental to an understanding of Hopf's work may be seen, for example, in her salons. Hopf organised several of these in the mid to late 1990s, inviting artists, musicians, authors, costume designers and others. The salon evenings took place at b_books, a bookshop in Berlin where the artist was working at the time. They were feminist in scope, addressing the exclusionary logic of male-dominated institutions. Through these salons Hopf made clear what she thought of the gender politics of the galleries and exhibitions then taking shape in the neighbourhood of Berlin-Mitte; her opinions also applied in no small measure to the politicised off-scene, which, in a self-legitimising critique of institutional power and representational relations, overlooked the contradictions of its own gender politics, ignoring the stereotype of the classic male political activist, as well as its complicity with the market serving its own interests. Hopf opposed this by opening discussions, based on historical examples, about the opaque relationship between desire, power and resistance, which she saw as torn between artistic and political claims. The salons would relate Gertrude Stein and Alice B. Toklas to feminist hip-hop, or slapstick performances to discourse analysis, thereby creating a space, enriched by these heterogeneous practices, for an emancipatory subjectification.

Hopf has endeavoured to make subjectivity and corporeality the objects of critical practices that go beyond existing conventions of speaking, writing and acting. Examples of this include the TV show performance inspired by Gilles Deleuze's and Pierre-André Boutang's L'Abécédaire (1988—89), made with the artist Natascha Sadr Haghighian, as well as Hopf's filmic adaptations, produced in collaboration with Stephan Geene, of Pierre Klossowski's La Monnaie vivante (1970) and Herman Melville's 'Bartleby, the Scrivener: A Story of Wall Street' (1853).

These performative video works seek to revise existing perspectives on models of social subjectification. 'Bartleby', for instance, opposes the idealism of a strongly resistant subject or group of people, which is usually thought to be the basis for political action. Instead Bartleby's 'I would prefer not to' creates a moment of indifference considering his position. The videos also did so in the sense of Slavoj Žižek's term 'parallax': that is, taking into account that observation changes the object under examination. Hopf's works separate existing facts from their (own) interpretations, thus making visible ways of perception that cannot be reconciled with each other because of competing perspectives on the various objects under observation.[1]

Hopf's objects are formally permeated by such 'parallaxes', as in her sculptures made of bamboo, a room full of rain (made by installing a water jet in a corner of a gallery) and jute-and-glass palm trees, as well as in her more recent works, such as the Waiting Laptops (2009) and Exhausted Vases (2009). In their ambiguity the objects act like subgenres, with a hybridity that mixes site-specificity with homemade art, the art of the cartoon and of caricature. At the same time, a creatively democratic style is unmistakable, particularly in the materials she chooses. Bamboo and jute suggest the aesthetics of the everyday, and more the DIY-culture of the 1990s than the Pop-oriented design of 'relational aesthetics'. Hopf appears to be interested in watering down the genealogies of institutional critique and opening them up to alternative aesthetics — those ever-mocked subcultures that seek to elevate the health-food shop and other choices in the private sphere to arenas for political positions.

The context of socially and ecologically enlightened post-1968ers in which Hopf was raised also made its way into museum education programmes, such as the creative workshops of the 1970s and 80s. These programmes played a part in forming the pro-culture attitude represented in the Germany of the late 1990s by the 'New Centre' of the Social Democrats and Greens. The turn away from the conservative 1980s, breaking on the level of politics with the era of Helmut Kohl and on the level of art with the dominance

1 See Slavoj Žižek, The Parallax View, Cambridge, MA and London: The MIT Press, 2006. With regard to the parallax, or rather the parallax gap, Žižek speaks of the confrontation between 'two closely linked perspectives between which no neutral common ground is possible'. Ibid., p.4.

Judith Hopf,
'Contract entre
les Hommes et
l'Ordinateur'.
Installation view,
After the Butcher,
Berlin, 2010.
Courtesy the artist

of *Junge Wilde* painting and neo-geometric abstraction, brought with it new approaches that were sensitive to more nuanced demands for the subject and his or her precarious identity. Such approaches also were influenced by an accelerated decline, brought on by the Left's drift towards neoliberalism, of that same middle class whose social situation was akin to that of the precarious art milieu that did not

profit from the big deals of the boom in Berlin-Mitte.

Yet it is evident that Hopf's work does not aim at such trite concepts of an 'enemy', but instead at that social milieu in which her work participates — a milieu that seeks to legitimise its claims to representation and market share through an ever-critical subjectivity, or the non-objectifiable, perception-based process through which

Judith Hopf,
Waiting Laptop 2,
2009, paint, ink,
collage on paper,
103 × 78cm (framed).
Courtesy Croy
Nielsen, Berlin /
Andreas Huber,
Vienna

a subject connects him or herself and is connected to certain contexts. The beliefs of that art milieu — or the willingness to call 'beautiful' exactly those things that are not 'beautiful' in an ideal sense but 'useful' — nonetheless did not hinder the art market from putting 'immaterial' values (communication, interaction) and 'critical' approaches (the repudiation of products) on the table for so many tens of thousands of dollars. The avant-garde credo that art must have a meaning beyond itself, and one which cannot be measured in money, easily built a coalition with neoliberal ideology: creative labour was good because its producers would also be ready to do it without reasonable compensation.

When Hopf foregoes market-oriented 'production values' under these conditions, she does so not in order to question object production as such, but instead to undermine it from within: her jute-and-glass palm trees, her branching bamboo creations, waiting laptops and exhausted vases parade that ridiculous sublime that has historically had the function of striking art with the weapons of its own orthodoxy. Hopf applies this strategy to the 'critical subjectivity' that makes itself both the resource and object of an exploitative production imperative. Her exhausted vases bring up to date W.J.T. Mitchell's comment about the drawing *The Spiral* (1964) by Saul Steinberg, a contemporary of the Abstract Expressionists (Hopf's vases are reminiscent, not coincidentally, of the style of the New York caricaturist):

> *Saul Steinberg has described this as 'a frightening drawing,' one which 'gets narrower and narrower', like 'the life of the artist who lives by his own essence. He becomes the line itself and finally, when the spiral is closed, he becomes nature'. Steinberg gives us an artist's reading of the drawing, a reading from inside. He sees this as a terrifying, sublime image of the danger in self-reflexive art. But there is another view of the drawing which comes from the outside. From this angle, the drawing is not 'art,' but a New Yorker cartoon; it is not sublime but ridiculous.*[2]

Hopf's vases thus are not messages of cultural pessimism in a bottle, but rather humorously faulty interventions into the blind spot that prevents us from distinguishing between meanings of the 'is' and the 'is possible'. It is precisely this distinction that comprises the works' crucial fluctuation between facticity and virtuality, between the 'real thing' and the fiction of a 'real thing': the 'vases' are literally empty vessels that are connoted with artisanal creativity, yet they appear to abolish that ideal 'weight' of the sublime that wishes to be ascribed to works of substance.

Those who want to interpret such objects in light of Hopf's background in the politicised post-Conceptualism of the 1990s must be given pause, however, by her obvious idiosyncrasy with regards to aesthetically dystopian objects. In her works, we encounter things and facts with a reality that appears to be abolished in the perishable fiction of an existence outside of our relationship to them. The form of the objects corresponds to the (self-)formation of a subjectivity over which we can hardly be confident of our powers. It presumably is no coincidence that conditions of passivity linger in the 'waiting' and 'exhausted' objects — as in her film *Bartleby* (1996), in which the famous 'I would prefer not to' is voiced by an employee of an advertising agency, that is, in a 'creative industry'.

Titles of works such as *Exhausted Vases* and *Waiting Laptops* display an indivisibility between the world of objects and the world of subjects that brings to mind the concept, following Thierry de Duve, of 'performative appearance'. This concept should be understood in correspondence with 'allegorical appearance', the term Marcel Duchamp coined in relation to his ready-mades. Performative appearance takes into account the fact that inherent in an art object's existence is a principal alterity of its appearance and meaning. The parallactic gaze is thus a means of regulation anchored in the object, dependant on that physically experienced but at the same time non-objectifiable boundary between the economies of (immaterial) meaning and (material) evaluation. Upon this boundary, decisive for the art system's stability, Hopf's

2 W.J.T. Mitchell, 'Metapictures', *Picture Theory*, Chicago and London: The University of Chicago Press, 1994, pp.40—41. Steinberg's quote within the text comes from Harold Rosenberg's text for the Whitney Museum catalogue, *Saul Steinberg*, New York: Knopf, 1978, p.19.

objects, drawings, performances and texts summon up modes of the subjective that at the same time thematise the reciprocal interfolding of artistic and social conditions of production.

Hopf's objects, like the 'queer' spatial installations of Henrik Olesen, produce corporeal relationships that we enter into and which mark off room for us to physically manoeuvre within. We must look up to the jute-and-glass palm trees, always caricaturing the human measure of things, to comprehend their abnormal, outsized perspective. One must bend down — as I did recently at the small, non-commercial Berlin gallery After the Butcher — to look at the *Waiting Laptops*, fanned out like ten-pack postcards, encouraging us to grasp our fragmented physicality: they bring to mind the body of the round-the-clock laptop user, or, with her towers of glasses, the body of the time-waster and drinker. Or it is the physicality of the artist who now only communicates in networks in which friends are constituted by mutual likes — a Facebook economy. It must rain from the ceiling to the floor in order for the exhibition space to be closely examined as a place in which very not matter-of-fact things (have to) happen; we must think introspectively about the exhausted vases in order to recognise in them those designs that have grown up in ourselves. Art, aware of its complicity with the dominant economy of signs and meanings, has made us into objects of productive reception, objects in which we recognise the source code for our '(self-)critical' subjectivity.

The nimble and trenchant humour served up by Hopf's works, with their testimonials of visibly exaggerated everyday meaning, demonstrates the readiness of producers and recipients to overlook the fact that economy of production is the expression of an overambitious belief in art. Perhaps it is the (self-)recognition in this irrational belief in productivity that prompts laughter on seeing Hopf's works — a laughter that could also be a defensive reaction to the conflicts summoned up by her object scenarios, which prompt questions about how art (today) is produced, received and distributed, and directly address the problem of recognising the bad and often irrational condition of artistic production and functioning as a producing artist. In this way, Hopf's caricature-like secularisation

of art objects sheds light on their logic of utilising human capital for spectatorship and production, allowing us as mere passive participants to perceive our role as active users.

Against this background, Hopf's material aesthetics also takes on the function of literally objective (self-) reflection. Palm trees can thrive even under adverse conditions, and bamboo, though it bends, does not easily break. And the water tumblers, should they be shattered into shards by bibulous party guests, will bring good luck according to German superstition. The aesthetic form signifies its economy: Hopf's objects short-circuit themselves with those economies of signs and meanings within which they are (re-) produced and consumed. The 'added value' is in the surplus of perspectives that we gain on art as a potential opportunity for winning back the public beyond the dictates of 'sensible production'. This may be the basis for Hopf's interest, typical of institutional-analytical forms of production, in multiple enactments of roles. Thus most of her performances and films mime characters who display a structural affinity to the role of the artist: an advertising director, a female master of ceremonies, a nurse, a *flâneuse*, a zombie, a female horse trainer, a female curator.

Reminiscent of Andrea Fraser's performances is the fact that Hopf uses appropriated roles to highlight those 'non-visible' institutional formalities that comprise artistic producers' existence — an existence structured by gender, class, milieu, age, habit, appearance and degrees of being informed and networked — in relation to how art is ideologically constituted. Conceptual art concerned with institutional critique in the 1990s was characterised by a shift from author-centred object production towards performative forms of production. In Hopf's case, this is made into the object of reflection on those economies that claim the artistic subjectivity's most personal terrain as something that must be consumable.

This is the background against which Hopf's negation of both the neoliberal commandment to produce and the neoconservative return to the individual artwork could be understood — two positions that, as strategies of post-institutional critique and neo-institutional critique have shown, can easily merge with one another.

Instead of this, what I have termed 'performative appearance' suggests a rift between precarious conditions of production and the expectations of an art scene long since returned to its core business. The intensifying pressures of career and success that burdened by the mid-1990s a generation born in the late 1960s — a generation then in the process of taking leave of its youth — caused the already fragile alliances between art and discourse, art and politics, and art and partying to decay into more-or-less segregated micro-scenes. Also contributing to this was the loss in stature of still-hyped forms of social praxis, the resonance of which can be heard not only in Judith Hopf's salons, but also in her sculptures, drawings, objects, performances and films. For the critique of the topos of 'context'[3] that Juliane Rebentisch presented on the occasion of 'Messe2ok'[4] in 1996, for example, Hopf created a drawing of folding chairs set up in a circle — a laconic

Waiting Laptops, *fanned out like ten-pack postcards, encourages us to grasp our fragmented physicality: they bring to mind the body of the round-the-clock laptop user.*

image for the design of a scene characterised by a fundamentally dystopian relationship to the new, camp aesthetic then beginning to infiltrate the art world.

I well remember the cleavage that Hopf often thematised at that time. On the one side were the artist friends who, after a phase of collective projects, had moved onto studio practices and proceeded to profit from the art scene that they had sought to distinguish themselves from not long before. On the other side were the collective projects that allowed only limited space for artistic forms of production that did not commit themselves to decidedly political content. Hopf's works participated then, as they participate now, in both worlds — they are shown with equal frequency in the institutional art context

and in self-organised spaces — and they appear to derive their idiosyncratic position from just this basic conflict. It is the 'campness' celebrated in the latter half of the 1990s that Hopf's objects carry with them, like the sometimes visible, sometimes invisible trace of a counter-normalising politics of the body — a trace that manifests itself in her drawings' organic, crystalline ornaments, made up out of growing, floating and meandering patterns, and which also permits aesthetic preferences and subjective taste to be read as an expression of a demarcation of her always institutional critique-inflected negation.

Hopf's fundamental idea of art is as Other to prevailing discourse, as she remarked at a series of short films organised by film curator Ian White for this year's Berlinale film festival. There she took on the role of a speaker giving a talk. Mimicking the avant-garde *gestus* of one proclaiming a new movement, she read out her manifesto 'Contract entre les hommes et l'ordinateur':

1: An urgent situation has arisen through the evolution of my body and spirit in relation to the use of instruments — specifically of the electronic data-processing machine — which compels me, in the full tradition of earlier revolutions, to socially revive the philosophy of emancipation.

Yet then — as at her salons that inspired us all in Berlin at that time — and as now, Hopf has always made corporeal experience, which the dominant norm holds to be irregular, the point of departure for her relationship to the world of objects. She does not reclaim sublime consciousness. Her message tells us that what is comprised by this dimension of our subjectivity is rather ridiculous, for, as her manifesto concludes:

WE DON'T KNOW ANYTHING
YOU DON'T KNOW ANYTHING
[...]
I AM NOTHING
OHO
WITHOUT LOVE.[5]

3 See by Rita Baukrowitz and Karin Günther (ed.), in collaboration with Gunter Reski, Stephan Dillemuth and Thaddäus Hüppi, *Team Compendium: Selfmade Matches. Selbstorganisation im Bereich Kunst*, Hamburg: Kellner Verlag, 1994, p.179.
4 A counter-fair organised in 1996 by Alice Creischer, Stefan Dillemuth, Dierk Schmidt, Andreas Siekmann and others that took place in parallel with 'Unfair', a fair organised by the then-successful young Cologne gallery scene, and which sought to differentiate itself from the Art Cologne fair.
5 Quoted from The Magnetic Fields, 'The Death of Ferdinand de Saussure', *69 Love Songs*, 1999.

Translated by Ben Letzler.

Judith Hopf,
Exhausted Vase 2,
2009, ceramic,
varnish, 31 × 15 ×
15cm. Courtesy Croy
Nielsen, Berlin/
Andreas Huber, Vienna

On Entering the Room

– Tanja Widmann

On entering the room I was overcome by relief. What was displayed before me was comical and exuded something promptly understandable: four hollow plinths made out of flat white panels elevating four ceramic vases. The vases, covered with a milky white glaze, were each upside down. Faces were outlined on them in a few brushstrokes of black lacquer. One of them had wavy lines that flowed down its cheeks from a pair of empty eyes; some had wrinkles drawn across their foreheads; and most of the mouths were straight or slightly frowning, as if reflecting on a serious situation or feeling of despair. The painted faces turned the vases into elongated, pear-shaped heads, sometimes with handle ears, sometimes without. two large collages were also displayed in

Tanja Widmann trips up and over Judith Hopf's use of the comic in her work, finding similarities between the joke's disruption of commonly held norms and the ruptures of aesthetic experience.

the gallery, each of which depicted a figure made of grey folds with a scribbled-on face. They looked like a pair of anthropomorphised laptops, male and female respectively. The light grey screens were their head and chest, while the dark grey keyboards formed the rest of their bodies. And so we saw this pair, sitting there in the slumped position created by the laptop's half-open angle, with empty gazes, ink-drawn hands in their laps, beige packing-paper legs dangling, thick lacquer curls as hair, ink lines shaping a hat. The colour of the works, and the atmosphere they evoked, were restrained and serious. Such was the evocation but not the effect of *Exhausted Vases* and *Waiting Laptops*

(both 2009) in the show 'some end of things', at Galerie Andreas Huber in Vienna earlier this year.

These sculptures and collages at once seemed to me like the punch line to my state of mind in light of current or impending work — including the writing of this text. They were pointing at an exhaustion that now appears to me as caricature. [1] Sigmund Freud describes the technique of the joke as one that effects either a relief of an already existing condition, or the omission of a yet to be mobilised psychic effort. He also refers to a direct connection to the release of a compulsion to critique. If understanding the then-upcoming writing of this text as a yet-to-be mobilised psychic effort connected to the challenge of critique, the *Exhausted Vases* and *Waiting Laptops* in fact 'made a joke' in a quite basic way. In the works' lopsided reflection of my state of mind — not addressing me personally, yet grabbing me immediately — my mood shifted into a sort of cheerfulness. At the same time, the fact that I seemed to have got the joke suggested that it would be easy to write about. And so it was, and then again, it wasn't. Mainly because the joke works as an event: ephemeral, fleeting and in the moment. To write it down and describe it hollows it out, makes it stale. Thus I will not go further into the funny, comic encounter when entering the room, because the momentary understanding, or feeling of alliance rooted in laughing at the joke, has not been easy to pin down. What I will refer to instead is the joke's role in Hopf's aesthetic practice and its structural similarity to the workings of aesthetic experience. But for now I will take another detour and come back to the moment of relief.

The feeling of relief I experienced also stemmed from the work's forthcoming attitude. One may even describe it as

1 This caricature-like quality is no coincidence. In 'some end of things', Judith Hopf refers to or quotes the Romanian-American cartoonist Saul Steinberg, who is predominantly known for his work for *The New Yorker*.

accessible or inviting, yet, at the same time, or maybe in spite of this attitude, it is surrounded by an air of audacity. The work's attitude not only leads directly to questions of style, but also — following Diedrich Diederichsen — to the articulation of a 'social sense'. As he writes in a catalogue essay for Hopf's Secession show in Vienna in 2006:

> [There is] *an unspoken but discernible concern with the communicative process involved in art reception — concern not with whether one is understood, let alone correctly, but with the styles and personality traits that are activated and encouraged — by a work, by a performance, or by a stand at an art fair. [...] In this context, style is an important case of social sense becoming form.*[2]

Diederichsen continues to elaborate how Hopf's specific style is marked by an interest in sub-cultural forms of common-ality, in the sense of a commonly developed aesthetic and common production practices. She develops these in her work without giving away the code, without making it explicit. In working within the frame of this social sense, he argues, Hopf

makes evident not only the 'functionalism of formalism' and the ideological structure of decisions about artistic form, but also the fact that existing grammars — whether formal or pertaining to any form of life — can always be restructured.

This restructuring often displays itself as something nonsensically meaningful in Hopf's work — as, for example, in the video *Hospital Bone Dance* (2006), made in collaboration with Deborah Schamoni, where patients stuck in a more-or-less permanent state of waiting in a hospital break into an awkward dance. (Caught in evident boredom, a number of those waiting have broken limbs in plaster — making them seem rather like mummies or zombies, that is, becoming sculptural within the video piece.) Or, in the video *Bei mir zu dir* (*From Me to You*, 2003), when a medium on a TV chat-show slumps in a chair while intoning about production conditions and instructions from the hereafter. In the sense arising from this nonsense, affective shifts and disruptions of governed, normative settings can be identified. A critically productive mode is revealed in contrast to implicitly accepted orders. And in the course of this process, inherent power structures become visible. My relief also could derive from Hopf's ultimately utopian position — her allegation

2 Diedrich Diederichsen, 'Outboard Motor', in *Judith Hopf* (exh. cat.), Vienna: Secession, 2007, p.8.

Above and left:
Atelier Hopfmann
(Judith Hopf and
Deborah Schamoni),
Hospital Bone Dance,
2006, video, 7min.
Courtesy Croy
Nielsen, Berlin /
Andreas Huber,
Vienna

that things could be different to how they are — as much as from the entertaining nature of the presentation.

One can also detect a proximity to musicals in video works such as *Hospital Bone Dance, Hey Produktion* (2001) or *Held Down* (2003), in the way they link the utopian to the affective.[3] In his text 'Entertainment and Utopia' (2002), Richard Dyer describes the musical genre's capability to entertain as one in which a transformative energy, an affective force, takes effect on real life, on things as they are, as shown in film.[4] This affective power transforms not only space but also the persons and actions within it. In Dyer's formulation, this movement runs from being extensively representative to extensively non-representative, opening a utopian space by means of qualities specific to film (and art) — colour, texture, movement, rhythm, etc. Society's (real) shortcomings are thus confronted with the possibility of a different life: abundance instead of shortage; energy instead of exhaustion; intensity instead of blandness; transparency instead of manipulation; community instead of alienation.

The utopia evoked by entertainment, however, is not one that translates into proposals for political restructuring of the real world, but rather it has the potential to enable feelings that things *can* be different, that things *can* change. Dyer explains: 'the utopianism is contained in the feelings it embodies. [...] It presents, head on as it were, what the utopia would feel like rather than how it would be organised.'[5]

The joke appears to me as a constitutive and recurring approach in Hopf's video works, sculptures, installations and drawings. But what can the joke actually achieve? How does it work as a social sense? And finally, how does it take form? In his book *Multitude: Between Innovation and Negation* (2008), Paolo Virno notes that jokes cannot be made without words.[6] This brings up the question of how what we see in the room — in this case sculptures and collages — can be dealt with as jokes. But although we are not dealing with language per se, we are dealing with a linguistic form, with an act of expression, with an indicating statement.

The joke, which — as might have become clear in the preceding paragraphs

3 These works, among others, are collaborations with Deborah Schamoni.
4 See Richard Dyer, 'Entertainment and Utopia', *Only Entertainment*, London and New York: Routledge,
 2002, pp.19—35.
5 *Ibid.*, p.20.
6 Virno makes this observation throughout the text: '[W]hile the comical dimension can be completely,
 or only in part, non-linguistic, the joke is exclusively verbal.' Paolo Virno, *Multitude: Between
 Innovation and Negation* (trans. James Cascaito), Los Angeles: Semiotext(e), 2008, p.79.

— is for Hopf the operational mode of her artistic practice, exhibits a surprising proximity to aesthetic experience. Virno repeatedly stresses that the joke is capable of demonstrating a crisis in the production of meaning by separating rules from their application — the opening up of a gap, for instance, between grammar and regular word usage. The joke creates meaning while simultaneously undermining it. In particular, this moment of both production and subversion of meaning shows structural similarities to Juliane Rebentisch's elaborations on the specific moment of aesthetic experience in her book *Ästhetik der Installation* (2003). She describes this moment as one in which

is equally not given as such. The materiality itself turns out to be heavily fraught with meaning and provokes the formation of new correlations. Thus the production and subversion of meaning — two forces equally opposing and enhancing each other — necessarily refer to each other.[7]

While aesthetic experience is present throughout the simultaneous separation and potential coincidence of thing and sign — thus opening a space for a different, contingent experience of the given — the joke as a commentary on a crisis of meaning production and as a practice aims

the production of meaning in and through the artwork proves to be essentially contingent:

Any comprehensive identification of significant elements as well as their meaningful connection is ultimately not objectively justified by anything in the artwork [...] The spectator is referred back to the materiality of the artwork, which, however,

at a possible separation of application and rule. It does so by demonstrating in openly fallacious or strange combinations how a rule or convention can be applied in contradiction to what was previously anticipated.[8]

The structurally similar disposition of aesthetic experience and joke also coincides in their need for a disinterested spectator. Drawing on Freud, Virno describes the disinterested spectator as the 'third person'

Judith Hopf, *Vasen (Vases)*, 2008, 3 handpainted vases, ceramic in glass painting. Raw models by Majolica Manufaktur, Karlsruhe. Both images installation view, 'Nose Up!', Badischer Kunstverein, Karlsruhe, 2008. Photograph: Remote, Karlsruhe. Courtesy Croy Nielsen, Berlin / Andreas Huber, Vienna

7 Juliane Rebentisch, *Ästhetik der Installation*, Frankfurt a.M.: Suhrkamp, 2003, p.94. Translation Margarethe Clausen's.
8 See P. Virno, *Multitude, op. cit.*, p.163.

of the joke, the person who ultimately determines the possible success of the act by reaching a judgement about it: 'The author of the joke cannot judge whether it has hit its target or if it is, instead, akin to simple nonsense. [...] So then, the disinterested spectator "has the decision passed over to him on whether the joke-work has succeeded in its task".'[9] The joke (as well as the aesthetic experience) can be understood in the social sense of the word: the third person, the disinterested spectator, is the social marker of the scene of the joke, which depends on a common understanding, some kind of *sensus communis*, in order to be successfully

has to be some kind of common social imaginary of what is talked about, an unspoken yet accepted status quo of rules and their usual applications. And so, Virno writes: 'The grammar of a life-form, that is to say "the substratum of all my searching and of all my assertions," consists, in great measure of opinions and historicosocial beliefs. Or, if we prefer, consists of the *éndoxa* [ethics] ingrained within a determined community. And it is these certainties-*éndoxa* that return to a fluid state in the case of a crisis, thus regaining an empirical tonality.'[10]

Virno's analysis of the joke's being embedded in the collective, and its political

Judith Hopf,
What do you look like?
A Crypto Demonic
Mystery, 2006,
bamboo sticks,
glove, lining

understood. The social dimension, moreover, also implies both a negotiation of the given as well as the possibility of dissent. In both cases — in that of the joke's belonging to the public discourse and the subject position of a disinterested subject who witnesses the gap between application and rule — certainties collapse and fixed structures are 'liquefied', as Virno puts it. In order for the joke — or the artwork — to be successful there

consequences, is also helpful in looking at Rebentisch's approach to aesthetic experience. Rebentisch claims that the specific moment of aesthetic experience, or more specifically its political dimensions, lies in the disruption of our conventional knowledge and certainties, something which takes place in a moment of distancing. This creation of distance from ourselves — that simultaneously throws us back at ourselves — refers

9 *Ibid.*, p.81. Virno is quoting Freud from *Jokes and Their Relation to the Subconscious* (1905).
10 *Ibid.*, pp.155—56.

to our social stratification — as the conventional knowledge and certainites can never be a merely subjective, private matter but always imply a broader intersubjective strata, a set of unspoken and implicitly accepted rules, norms and values. [11] Aesthetic experience in this understanding thus shows itself as always already pervaded by mundane realms of life, and as such, basically impure.

But Virno does not focus on aesthetic experience and Rebentisch does not focus on the joke. It is also clear that the joke does not function as a constitutive moment of aesthetic experience, nor vice versa — that aesthetic experience essentially comes into play in the form of a joke. Nonetheless, I would suggest that the capacity of the joke in the field of aesthetic experience lies in its ability to point out the conventions of the art field itself, and, by relying on them, can even bring them 'down to a base level'. The *éndoxa* that Virno speaks of refers to opinions, points of view, styles, knowledge and attitudes that are presupposed in the (linguistic) practice shared by a community. This is not meant in the sense of facts, but rather refers to unspoken, implicitly assumed codes, conventions and rules. Rendering these visible and re-converting them into a fluid state is the crucial intent of the joke — presuming it is successful. It is then that the joke is able — provisionally and temporarily — to re-negotiate the value of art itself, its symbolic and real capital value as well as the potential inclusions and exclusions that come with it. The joke as an everyday or 'culturally low' practice not only plays a role in the (essentially) impure form of aesthetic experience, it actually pushes this impurity to the foreground. While the subject is 'potentially confronted with its social strata' in aesthetic experience, the joke also brings into play the social aspect of art. [12] In all its structural similarities, the joke thus not only makes the impure status of 'aesthetic experience' visible, it also scratches and even contaminates the

serious surface that the term aesthetic experience already brings with it.

But how is the technique of the joke used here, in these specific works? What form does it take?

Hopf's *Exhausted Vases* are particularly witty in the way that they play with the dominant narrative of art history, which has privileged the abstract over the representational, the nondescript over the expressive, and fracture over narrative. For the critics who backed Modernist abstraction in painting and sculpture — such as Clement Greenberg and Michael Fried — much was at stake in their choice: the autonomy of art, achieved via a path of severe self-reflexivity, and the capacity to counter the commodification of art and, especially with Minimalism, the banal, fallen objects of mass culture. This meant not only turning away from the figurative, but also opposing everything representative, narrative or expressive. [13] The problematic reached a crisis point in Minimalism, which was understood as the simultaneous execution, completion and disruption of the Modernist programme. [14] While the double presence laid out in the objective quality of Minimalist objects — neither thing nor sign, but both at the same time — was cause for the advocates of Modernism to exclude Minimalism on the base of its 'incurable theatricality', critics of Greenberg, Fried et al. understood this moment of theatricality as the constitutive element of a self-reflective performative distance in aesthetic experience and thus as a characteristic of *all* art. [15]

The established here is rooted in an implicit exclusion, which from the outset fixes figurative modern sculpture outside of the relevant discourse of (post)modernity because of its representative and potentially expressive and/or narrative aspects. The *Exhausted Vases* deal with this ambivalent history, exploring new possibilities and shifting fixed orders. The figurative is called upon while simultaneously being stripped of its representative function, remaining

11 See J. Rebentisch, 'Zur Aktualität ästhetischer Autonomie: Juliane Rebentisch im Gespräch', in *Inaesthetik: Theses on Contemporary Art*, no.0, 2008, p.116.
12 See J. Rebentisch, *Ästhetik der Installation*, op. cit., p.289.
13 That the Minimalist practices (industrialised materials and objects, reproducibility, serial and additive logic, the simplicity of geometric forms) aimed at creating distance are also always ambivalent — unable to rid themselves of the shadow of commodified production and the future logo-culture of corporations — has been extensively discussed. See, for example, Hal Foster, 'The Crux of Minimalism', *The Return of the Real: The Avant-garde at the End of the Century*, Cambridge, MA and London: The MIT Press, 1996; Rosalind Krauss 'The Cultural Logic of the Late Capitalist Museum', *October*, vol.54, Fall 1990, pp.3—17.
14 See H. Foster, 'The Crux of Minimalism', op. cit.
15 See Michael Fried, *Art and Objecthood: Essays and Reviews*, Chicago and London: University of Chicago Press, 1996; and J. Rebentisch's elaborate analysis in the chapter 'Theatralität und die Autonomie der Kunst', *Ästhetik der Installation*, op. cit., pp.40—78.

in a limbo of similarity: the vases *appear* to be heads while remaining objects devoid of their original function and purpose. It is a joining of unrelated and at the same time obviously similar things, a marking of the vases with an immediate comicality, a joke: the vases are like empty heads and the moment we — in our exhaustion — see them as such, we become similar to them. If the joke follows a logic, then, in Virno's words, '*erroneous* modes of reasoning', 'semantic ambiguities' and 'defective correlations' are at work. It is through this erroneous mode of correspondence that the relation between subject and object becomes permeable. Seemingly fixed positions are contaminated as the status of both object and subject becomes uncertain. By positioning the inverted vases as heads atop them, the pedestals' simple geometric cubic form, reminiscent of constructivist-

The joke is the moment that deauthorises seriousness, that interrupts relations of power and order while rendering them visible.

formalist design, is irretrievably twinned with the association of physicality. The cubes carry the vase, retaining the convention of a functional museum accessory, a pedestal, while at the same time becoming part of the sculpture, the abstraction of a body in variable sizes.

While production via industrial methods and the use of the series were supposed to assure distance from originality and expressivity in both Minimalist and post-Minimalist sculpture, here this 'danger' of originality and expressivity is averted in the moment of the work's affirmation. For the faces painted on the vases can also be read as the gesture of a singular marking, as they do not shy away from expressivity. Moreover, the individualisation of each piece in form and face sets them apart from the notion of a multiple. The individuality of each vase presents itself like an inventory of possible vases — any vase whatsoever, perhaps. The faces are both expressive and abstractions of a general state in modulation. Hopf continually refers to the order of making art while she has already changed it, restructuring the grammar and exploring new possibilities.

This small sculptural group, loosely filling the room, is theatrical in a straightforward sense. Like a Greek choir, the sculptures inhabit the room and together bring a subject to the stage: fatigue has taken hold of the vases and cubes, freezing them into immobile figures, making them the sheer expression of exhaustion. The function of the Greek choir was to simplify and clarify the events on stage for the audience, at times resorting to means of exaggeration. *Exhausted Vases* perform exactly this task. They appear like a reflex to current conditions, polyphonic voices of everyday life, which leave us hanging in a quite exhausted state — so many things exhausting us and all possible means seemingly exhausted. In a comedic gesture, *Exhausted Vases* reflect the fringes of a constantly sought after or requested realisation — whether of ourselves, a piece of work or our life. The *Waiting Laptops* embed themselves in this scenario, referring to all those things not yet switched on at our desks, already burdening us with exhaustion before we start. It is in exhaustion that the infinite scope of possibilities is revealed.

The text accompanying the exhibition relates the artwork to Gilles Deleuze's remarks on exhaustion. 'One no longer realises, even though one accomplishes something [...] one remains active, but for nothing', writes Deleuze about Samuel Beckett's plays.[16] In current forms of production, in which efficiency and the mobilisation of all skills, including affect, communication and knowledge, play a central role, the call for taking a closer look at the nonsensical and aimless drifting of exhaustion, the possibility to execute something while not realising anything — neither ourselves, nor a piece of work, nor life — is made quite laconically. The joke, lastly, is the moment that deauthorises seriousness, interrupts relations of power and order while rendering them visible. It allows one to feel safe in a short-term alliance with kindred spirits. This may be one or another explanation for why the *Exhausted Vases* and *Waiting Laptops* made me feel so radically cheery.

16 Gilles Deleuze, 'The Exhausted', *Essays Critical and Clinical* (trans. Daniel W. Smith and Michael A. Greco), Minneapolis: University of Minnesota Press, 1998, p.153.

Translated by Margarethe Clausen.

Sophie Berrebi

Sophie Berrebi is a lecturer in the history and theory of photography at the University of Amsterdam, as well as an independent critic and curator. Her writing has appeared in a number of publications, including *frieze*, *Metropolis M*, *Open*, *Art History* and *Art and Research*. She is currently completing a book titled *Equivocal Documents: Documentary and Archive in Contemporary Art*, as well as a writing a monographic study on Jean Dubuffet and modernism and editing several publications on the artist.

Sabeth Buchmann

Sabeth Buchmann is an art historian and art critic. She is currently Professor of Modern and Postmodern Art and the Head of the Institute for Art Theory and Cultural Studies at the Academy of Fine Arts Vienna. She regularly contributes to books, magazines and catalogues. Her publications include *Film, Avantgarde und Biopolitik* (2009) and *Art After Conceptual Art* (2006). She is a Series Editor for *Exhibition Histories*, published by Afterall Books.

Boris Buden

Boris Buden is a writer and cultural critic based in Berlin. He received his PhD in cultural theory from Humboldt University in Berlin. In the 1990s he was editor of the magazine *Arkzin* in Zagreb. His essays and articles cover the topics of philosophy, politics and cultural and art criticism. He has participated in various conferences and art projects in Western and Eastern Europe, Asia and the USA, including Documenta11. Buden is the author of *Barikade* (1996/97), *Kaptolski Kolodvor* (2001), *Der Schacht von Babel* (2004) and *Zone des Übergangs* (2009).

Branislav Dimitrijević

Branislav Dimitrijević is a lecturer in the history and theory of art, and a writer and curator. He is Senior Lecturer at the School for Art and Design (VSLPUb) and Associate Curator at the Museum of Contemporary Art, both in Belgrade. He co-founded and coordinated the 'School for History and Theory of Images', an independent educational project in Belgrade (1999—2003). He publishes essays on contemporary art, film and visual culture, and has edited exhibition catalogues, including *On Normality: Art in Serbia 1989—2001* (MOCAB, 2005). His curatorial projects include: 'Situated Self: Confused Compassionate, Conflictual' (Helsinki City Museum; MOCAB, 2005), 'Breaking Step — Displacement, Compassion and Humour in Recent Art from Britain' (MOCA, Belgrade, 2007) and 'FAQ Serbia' (ACF, New York,2010). He holds an MA from the University of Kent and is currently working on a PhD thesis on consumer culture in socialist Yugoslavia at the University of Arts in Belgrade.

Juan A. Gaitán

Juan A. Gaitán is a writer and curator of contemporary art. Trained as an art historian and aesthetic theorist, his work has focused on two historical moments: anarchism and art in the late nineteenth and early twentieth centuries, specifically in France and Germany, and post-utopianism and the end of humanism towards the 1960s and 70s, in relation to North American art and culture. Currently he is working as curator at Witte de With, Centre for Contemporary Art in Rotterdam, the Netherlands, where he has been developing the year-long project 'Morality'. He has published several monographic essays on contemporary artists and has written on a range of topics, from late antiquity in the Levant to photographic representations of the atomic bomb. Currently he is also working on his PhD dissertation, about the death of utopian optimism and the emergence of the idea of process during the 1960s.

Melissa Gronlund

Melissa Gronlund is Managing Editor of *Afterall* journal and Afterall Online. She writes on art and film for a number of different publications, and is a programme advisor to the experimental film section of the London Film Festival. She is a visiting tutor at the Ruskin School of Drawing & Fine Art, University of Oxford.

Ana Longoni

Ana Longoni is a writer and researcher specialising in the articulations between art and politics in Latin America since the twentieth century. She teaches at the Universidad de Buenos Aires (UBA) on undergraduate and postgraduate courses, at the Programa de Estudios Independientes (Independent Studies Programme) of MACBA (Barcelona) and at other universities. She coordinates the research group 'Culture as resistence?: Interpretations of cultural and artistic productions during the last dictatorship in Argentina' at UBA. She has published, alone or in collaboration, among other works: *Del Di Tella a Tucumán Arde* (2000/07), *Traiciones* (2007), *El Siluetazo* (2008) and *Conceptualismos del Sur* (2009). She is an active membe since its foundation in 2007, of the Red Conceptualismos del Sur (the Southern Conceptualisms Network).

Tom McDonough

Tom McDonough is Associate Professor of Art History at Binghamton University, State University of New York, where he teaches the history and theory of contemporary art. His most recent book is the anthology *The Situationists and the City* (2009); other publications include 'The Beautiful Language of My Century': Reinventing the Language of Contestation in Postwar France, 1945—1968 (2007) and the anthology *Guy Debord and the Situationist International: Texts and Documents* (2002). He has published regularly in periodicals such as *Art in America*, *Artforum*, *Documents*, *Grey Room*, *October* and *Texte zur Kunst*. McDonough has been a visiting scholar at the Canadian Centre for Architecture, a Getty Postdoctoral Fellow, and a recipient of an Arts Writers Grant from Creative Capital/ The Andy Warhol Foundation. He is an editor at *Grey Room*.

Rabih Mroué

Rabih Mroué lives and works in Beirut. Mroué is an actor, director, playwright, visual artist and a contributing editor for *The Drama Review* (*TDR*). He is also a co-founder and a board member of the Beirut Art Center (BAC). Recent exhibitions include a solo exhibition at BAK, Utrecht, 2010; Performa 09, New York, 2009; 11th International Istanbul Biennial, 2009; 'Tarjama/Translation', Queens Museum of Art, New York, 2009; Sharjah Biennial, 2009; 'Soft Manipulation — Who is afraid of the new now?', Casino Luxembourg, Luxembourg, 2008; 'Medium Religion', Center for Art and Media (ZKM), Karslruhe, 2008; Manifesta 7, 2008; 'Les Inquiets. 5 artistes sous la pression de la guerre', Centre Pompidou, Paris, 2008; 'In Focus', Tate Modern, London, 2007; and the Biennale of Sydney, 2006. In 2010 Mroué was awarded an Artist Grant for Theatre/Performance Arts from the Foundation of Contemporary Arts, New York and the Spalding Gray Award, New York.

Marion von Osten

Marion von Osten works with curatorial, artistic and theoretical approaches that converge through exhibitions, installations, video and text productions, lecture performances and conferences. She is a founding member of Labor k3000, kpD (kleines post fordistisches Drama) and the Center for Post-Colonial Knowledge and Culture, Berlin. Since 2006 she has been professor at the Academy of Fine Arts, Vienna. Prior to that she was professor and researcher at the Institute for the Theory of Art and Design & Institute for Cultural and Gender Studies, ZHdK, Zurich from 1999 to 2006, and a lecturer at the Critical Studies Program, Malmö Art Academy. Von Osten co-curated (with Kathrin Rhomberg) 'Projekt Migration' in 2005 and was artistic director of TRANSIT MIGRATION (2003—05). Recent projects include 'In the Desert of Modernity — Colonial Planning and After', House of World Cultures, Berlin and Abattoirs, Casablanca, 2008—09; 'reformpause', Kunstraum of the University of Lüneburg, 2006; 'Atelier Europa', Kunstverein München, 2004; and 'Be Creative! The Creative Imperative!', Museum for Design, Zurich, 2003. Her publications include *The Colonial Modern* (with Tom Avermate & Serhat Karakayali, 2010), *Das Erziehungsbild* (with Tom Holert, 2010), *Projekt Migration* (with Aytac Eriylmaz, Martin Rapp, Kathrin Rhomberg and Regina Röhmhild, 2005); *Norm der Abweichung* (2003); and *MoneyNations* (with Peter Spillmann, 2003). Von Osten lives and works in Berlin and Vienna.

Tanja Widmann

Tanja Widmann works as an artist, author and curator. Sometimes she takes the role of an author in the singular; more often she produces under the form of a label: TJW/ (TJW by). Upcoming projects include Manifesta 8 (Murcia, 2010). She recently participated in 'Solong' (Maja Vukojes Studio, Vienna 2010), 'Solong Salong' (Lot 25, Vienna 2009), 'Empfindung oder in der Nähe der Fehler liegen die Wirkungen' (Augarten Contemporary, Vienna 2009), 'Sich in diesem Sinne ähnlich machen / To Make Oneself Similar in this Sense' (kunstraum lakeside, Klagenfurt, 2008—09) and *Nichts ist aufregend. Nichts ist sexy. Nichts ist nicht peinlich.* (performance series, Mumok, Vienna, 2008). Recent publications include *To Make Oneself Similar in this Sense* (co-edited with David Jourdan, Johannes Porsch, 2010) and *An Ambiguous Case. Casco Issues XI* (co-edited with Emily Pethick and Marina Vishmidt, 2008). Widmann lives in Vienna.

Kaelen Wilson-Goldie

Kaelen Wilson-Goldie is a writer who lives and works in Beirut, where she is a staff writer for *The National*, a contributing editor for *Bidoun* and a correspondent for *Artforum*. She has contributed essays on contemporary art and visual culture in the Arab world to numerous journals, exhibition catalogues and anthologies, most recently on the work of Akram Zaatari, Walid Raad, experimental music and the history of video production in Beirut. Previously the Arts & Culture editor of *The Daily Star* in Lebanon, she has written for *The New York Times*, *The Times of London* and *The Village Voice*, among other publications.

ZOE LEONARD GALERIE GISELA CAPITAIN

WESTERN FRONT

303 East 8th Avenue, Vancouver, BC, Canada

**Exhibitions/
Media Art/
Performance/
New Music/
Front Magazine/**

**ALTHEA THAUBERGER | BENJAMIN HERMAN
QUARTET | KIMBERLY GILBERTSON | MARU |
CHRISTIAN FENNESZ | DEIRDRE LOGUE | ERIN
SHIRREFF | VIVIANE HOULE | DONNA LYTLE |
ELI BORNOWSKY | FIONA HERNÁNDEZ |
SOUNS | ANNA SZAFLARSKI | KIM MYHR
MURAL | INHABITANTS | ZEESY POWERS |
HELEN REED | LEAH ABRAMSON | LISA
VISSER | KEITH LANGERGRABER | MARIAN
BANTJES | MEGAN MORMON | ORKESTRA
FUTURA | PABLO BRONSTEIN | RYAN STEELE |
SARAH GOTOWKA | SYLVANA D'ANGELO |
SCANT INTONE | HILDEGARD WESTERKAMP |
SARAH FOULQUIER | PATRICK CRUZ |**

www.front.bc.ca

Canada Council for the Arts — Conseil des Arts du Canada — CITY OF VANCOUVER — Canadian Heritage / Patrimoine canadien — BRITISH COLUMBIA ARTS COUNCIL Supported by the Province of British Columbia

Marco Poloni
The Majorana Experiment
21.08. - 10.10.2010

Dora García
I Am a Judge
21.08. - 10.10.2010

Kunsthalle Bern

Helvetiaplatz 1
CH-3005 Bern
www.kunsthalle-bern.ch

Marco Poloni, *Bick Hole*, 2009 Dora García, *Real Artists Don't Have Teeth*, 2010

I AM BRUCE CONNER.
I AM NOT BRUCE CONNER.
12. 9. – 17. 10. 2010
CURATOR GERALD MATT

STÉPHANE COUTURIER
MELTING POINT SERIES
7. 11. – 12. 12. 2010
CURATOR MARTIN HOCHLEITNER

Bruce Conner, Still from: CROSSROADS, 1976, ©The Conner Family Trust, San Francisco

Stéphane Couturier, CHANDIGARH, 2006 – 2007, Serie „Chandigarh Replay", Secrétariat n° 1, C-Print

URSULA BLICKLE STIFTUNG GERMANY www.ursula-blickle-stiftung.de

NIKOLAS GAMBAROFF
MICHAEL KREBBER
BLAKE RAYNE
R. H. QUAYTMAN

5 NOV – 22 DEC 2010
BERGEN KUNSTHALL

Curated by Tom Duncan, Solveig Øvstebø and Steinar Sekkingstad

Untitled (Jeu de Paume/Bergen Kunsthall), 2010. ©Jeu de Paume. Photographer: Arno Gisinger

BERGEN KUNSTHALL
8 OCT – 22 DEC 2010

TOMO SAVIĆ-GECAN
Curated by Elena Filipovic
UNTITLED, 2010

JEU DE PAUME
28 SEP 2010 – 6 FEB 2011

Untitled (Bergen Kunsthall / Jeu de Paume), 2010. © Bergen Kunsthall.

Tuesday – Sunday 12.00 – 17.00.
Fridays also 20.00 – 23.00
Friday evening free admission.

www.kunsthall.no
Rasmus Meyers allé 5
5015 Bergen

 SparebankenVest BKVB JEU DE PAUME | BERGEN KUNSTHALL

11.9. – 14.11.2010

Stefan Burger
Under the Circumstances

11.9.2010 – 8.5.2011

Arbeit/Labour –
Set 7 from the Collection and Archives of the Fotomuseum Winterthur

27.11.2010 – 13.2.2011

Mark Morrisroe

FOTOMUSEUM
WINTERTHUR

Grüzenstrasse 44+45
CH-8400 Winterthur (Zürich)
Tel. + 41 (0) 52 234 10 60
www.fotomuseum.ch
Tue – Sun 11–18 Uhr Wed 11–20 Uhr

bezoekadres / visiting address
Lange Nieuwstraat 4 Utrecht

info@bak-utrecht.nl
www.bak-utrecht.nl

basis voor
actuele kunst

bak

A group exhibition on the notion of horizons in art and politics, curated by Simon Sheikh.

With works by: Matthew Buckingham, chto delat/What is to be done?, Freee, Sharon Hayes, Runo Lagomarsino & Johan Tirén, Elske Rosenfeld, Hito Steyerl, and Ultra-red.

A research exhibition within the framework of the project FORMER WEST.

Vectors of the Possible
12.09. – 28.11.2010

Runo Lagomarsino & Johan Tirén, *Waiting for the Demonstration at the Wrong Time*, 2003/2007

29 August – 3 October 2010

Future Park I:
'Teach Me to Disappear'
Paul Elliman &
Nicole Macdonald

17 October – 21 November 2010
Opening 16 October, 17.00

Future Park II:
'Reproduction Direct
from Nature' Zachary
Formwald

29 November 2010 – 13 February 2011
Opening 27 November, 17.00

'Seeing Studies'
Natascha Sadr
Haghighian & Ashkan
Sepahvand

Casco
Office for Art, Design and Theory
Nieuwekade 213–215, 3511 RW Utrecht,
The Netherlands, T/F +31 (0)30 231 9995
www.cascoprojects.org

Pedro Barateiro
12.09.–14.11.2010
Opening: Saturday, September 11, 2010, 7pm

Marieta Chirulescu
26.09.–14.11.2010
Opening: Saturday, September 25, 2010, 7pm

Regionale 11
28.11.2010-02.01.2011
Opening: Saturday, November 27, 2010, 7pm

KUNSTHALLE ⮞ BASEL
STEINENBERG 7 CH-4051 BASEL
T: +41 61 206 99 00 · F: +41 61 206 99 19
info@kunsthallebasel.ch · www.kunsthallebasel.ch
Tue/Wed/Fri 11am–6pm · Thu 11am–8.30pm · Sat/Sun 11am–5pm

Joanne Tatham & Tom O'Sullivan
2nd October – 13th November 2010

Centre for Contemporary Arts
350 Sauchiehall Street
Glasgow G2 3JD
United Kingdom

T: +44 (0) 141 352 4900
gen@cca-glasgow.com
www.cca-glasgow.com

Opening times:
Tuesday – Saturday
11am – 6pm
Closed: Sunday & Monday

The Henry Moore
Foundation

Evelyne Axell

Lorna Macintyre

Kasper Akhøj

22.10–16.01.2010
Opening 21.10.2010
www.wiels.org

Centre for Contemporary Art
Avenue Van Volxemlaan 354
B-1190 Brussels

WIELS

KUNSTHALLE ZÜRICH ON THE ROAD

DURING THE RENOVATION OF THE LÖWENBRÄU ART COMPLEX FROM SEPTEMBER 2010
UNTIL SPRING 2012 KUNSTHALLE ZÜRICH WILL MOVE ITS OFFICES TO THE NEW ART CENTER
HUBERTUS EXHIBITIONS AT ALBISRIEDERSTRASSE 199A IN ZURICH.
FROM JANUARY 2011 TO JUNE 2012 KUNSTHALLE ZÜRICH WILL BE EXHIBITING AT THE MUSEUM
BÄRENGASSE IN ZURICH.
FOR MORE INFORMATION: WWW.KUNSTHALLEZURICH.CH

KUNSTHALLE ZÜRICH

LIMMATSTRASSE 270 CH-8005 ZURICH
TEL +41 44 272 15 15 FAX +41 44 272 18 88
INFO@KUNSTHALLEZURICH.CH WWW.KUNSTHALLEZURICH.CH

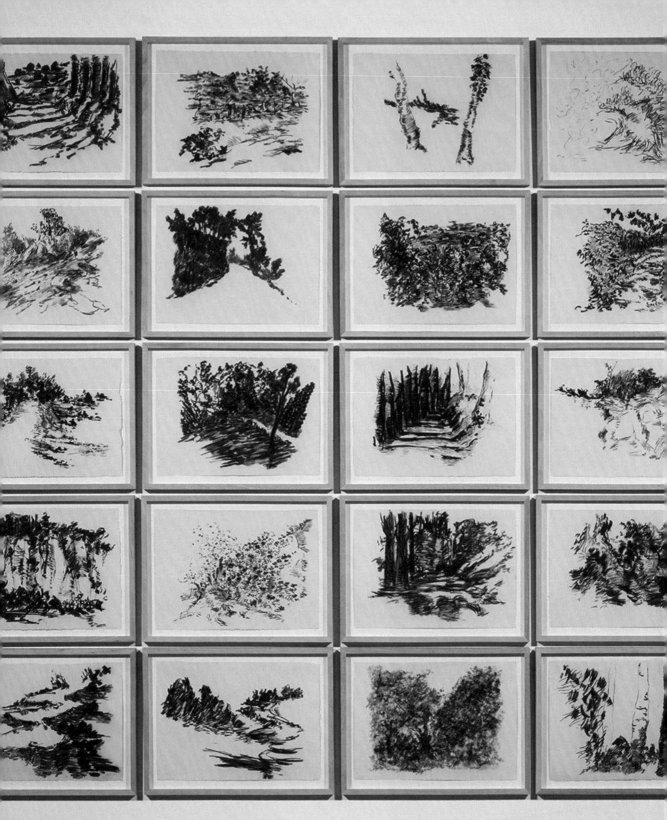

João Queiroz

Culturgest Lisboa
16 October 2010 – 9 January 2011

Edifício Sede CGD
Rua Arco do Cego, Piso 1
1000-300 Lisboa
+351 217 905 454 culturgest@cgd.pt

Pedro Diniz Reis

Culturgest Porto
13 November 2010 – 23 January 2011

Edifício Caixa Geral de Depósitos
Avenida dos Aliados, 104
4000-065 Porto
+351 222 098 116 culturgest@cgd.pt

FUNDAÇÃO CAIXA GERAL DE DEPÓSITOS
Culturgest

2nd FORMER WEST RESEARCH CONGRESS

ON HORIZONS: Art and Political Imagination

4 – 6 November Istanbul

The 2nd FORMER WEST Research Congress revolves around the theoretical notion of the "horizon" in relation to contemporary artistic production and political imaginaries.

With contributions by, among others: Boris Buden, Beatriz Colomina, Jodi Dean, TJ Demos, Bülent Diken, Çağlar Keyder, Vasıf Kortun, Ernesto Laclau, Peter Osborne, Gerald Raunig, Shuddhabrata Sengupta, Simon Sheikh, and Hito Steyerl.

Admission: free (registration is required)
Language: English (simultaneous translation into Turkish is provided)
Venue: Istanbul Technical University, Taşkışla Campus, Room 109

See www.formerwest.org for further details and the live stream of the congress.

The 2nd FORMER WEST Research Congress is developed by BAK, basis voor actuele kunst, Utrecht and SKOR, Foundation Art and Public Space, Amsterdam, and co-curated by Simon Sheikh, FORMER WEST Researcher. The Research Congress is realized in collaboration with IKSV, Istanbul Foundation for Culture and Arts, Istanbul and hosted by Istanbul Technical University.

The 2nd FORMER WEST Research Congress is generously supported by:

 ERSTE Stiftung

FORMER WEST is a contemporary art research, education, publishing, and exhibition project (2008–2013)

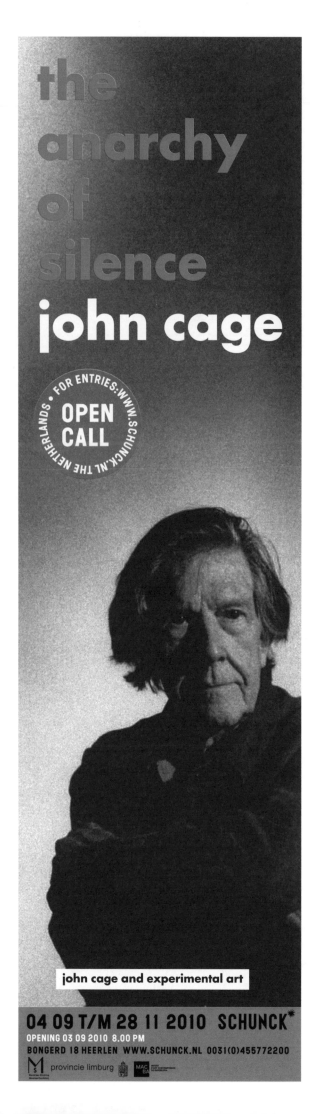

the anarchy of silence

john cage

FOR ENTRIES: WWW.SCHUNCK.NL THE NETHERLANDS • **OPEN CALL**

john cage and experimental art

04 09 T/M 28 11 2010 SCHUNCK*
OPENING 03 09 2010 8.00 PM
BONGERD 18 HEERLEN WWW.SCHUNCK.NL 0031(0)455772200

provincie limburg MACBA

Michel Auder

18
—
14

september
november

2010

Lundskonsthall

Une Idée, une Forme, un Être – Poésie/ Politique du corporel

25th September
– 28th November 2010
Opening: Friday, 24th
September 2010, 6pm

Ai Weiwei
Regina José Galindo
Teresa Margolles
Gianni Motti
Eftihis Patsourakis
Pamela Rosenkranz
Martin Soto Climent
Loredana Sperini
Alina Szapocznikow

Displaced Fractions – Über die Bruchlinien in Architek- turen und ihren Körpern

11th December 2010
– 20th February 2011
Opening: Friday, 10th
December 2010, 6pm

With a.o. :
Phyllida Barlow
Ulrich Rückriem
Oscar Tuazon
Klaus Winicher

A collaboration project with
Siemens Stiftung

Opening hours
Tues / Wed / Fri 12 pm – 6 pm
Thurs 12 pm – 8 pm
Sat /Sun 11am – 5 pm.
Thursdays 5 pm – 8 pm,
entrance is free of charge.

New address for
exhibition visits
migros museum für
gegenwartskunst /
Hubertus Exhibitions
Albisriederstrasse 199 a,
8047 Zürich

The migros museum für
gegenwartskunst is an
institution of the Migros-
Kulturprozent.

migrosmuseum.ch
hubertus-exhibitions.ch
migros-kulturprozent.ch

migrosmuseum
FüR GEGENWARTSKUNST
ZüRICH

Focal Point Gallery
Southend Central Library
Victoria Avenue
Southend-on-Sea
Essex SS2 6EX
T +44 (0)1702 534108
F +44 (0)1702 469241
E focalpointgallery@southend.gov.uk
www.focalpoint.org.uk

20 September — 6 November 2010
Anna Parkina, 'The ticket is for today'

22 November 2010 — 1 January 2011
Anja Kirschner and David Panos, 'The Empty Plan'

17 January — 2 April 2011
'Anti-Photography', curated by Duncan Wooldridge

Cornerhouse
70 Oxford Street
Manchester, UK
M1 5NH
T +44 (0)161 200 1500
E info@cornerhouse.org
www.cornerhouse.org

1 — 7 October 2010
Abandon Normal Devices
Gillian Wearing, The Sancho Plan,
Lawrence Malstaff, xtine burroughs
and many more…

2 October 2010 — 28 November 2010
marxism today
Phil Collins

2 October 2010 — 9 January 2011
UnSpooling — Artists & Cinema
Michaël Borremans (Belgium) / Cartune Xprez
(USA) / David Claerbout (Belgium) / Benedict Drew
(UK) / Sally Golding (Australia) / Ben Gwilliam &
Matt Wand (UK) / Roman Kirschner (Austria) /
Kerry Laitala (USA) / Wayne Lloyd (UK) / Elizabeth
McAlpine (UK) / Sheena Macrae (Canada) / Juhana
Moisander (Finland) / Alex Pearl (UK) / Greg Pope
(UK) / Mario Rossi (UK) / Gebhard Sengmüller
(Austria) / Harald Smykla (Germany) / Ming Wong
(Singapore) / Stefan Zeyen (Germany)

3 December 2010 — 9 January 2011
Edition #2

John Hansard Gallery
Highfield Campus
University of Southampton
Southampton SO17 1BJ
T +44 (0)23 8059 2158
F +44 (0)23 8059 4192
E info@hansardgallery.org.uk
www.hansardgallery.org.uk

7 September — 23 October 2010
Middling English
Caroline Bergvall

9 November — 8 January 2011
Anarcadia
Ruth Maclennan
Commissioned by Film and Video Umbrella

25 January — 12 March 2011
Charlotte Posenenske

Talbot Rice Gallery
The University of Edinburgh
Old College
South Bridge
Edinburgh EH8 9YL
T +44 (0)131 650 2210
F +44 (0)131 650 2213
E info.talbotrice@ed.ac.uk
www.trg.ed.ac.uk

23 October — 11 December 2010
Alasdair Gray
This exhibition presents designs, drafts and
printed posters that reflect the intertwined
nature of Alasdair Gray's visual and literary
work and coincides with the publication
of his autobiographical *A Life in Pictures*

FormContent
51—63 Ridley Road
London E8 2NP
T +44 (0)79 8878 3692
E info@formcontent.org
www.formcontent.org

9 September — 3 October 2010
Modelling Standard
Erik Beltran and Jorge Satorre
curated by Catalina Lonzano
In collaboration with Gasworks residency program,
Catalina Lozano and FormContent present
a collaborative project by Erik Beltran and
Jorge Satorre

7 October — 24 October 2010
extra added bonus material
Edgar Schmitz and FormContent
Taking off from the motif and the logic of the trailer,
the exhibition combines filmic and proto-filmic
components into harshly condensed tableaus
for the gallery space. The exhibition is also an
implicit reflection around the status and condition
of the material Edgar Schmitz will present as his
contribution for the upcoming British Art Show.

4 November 2010 — 16 January 2011
Session_11_Press Release
A show curated by FormContent in collaboration
with *Am Nuden Da*

Raven Row
56 Artillery Lane
London E1 7LS
T +44 (0)20 7377 4300
F +44 (0)20 7377 4333
E info@ravenrow.org
www.ravenrow.org

9 September — 7 November 2010
'Polytechnic'
John Adams, Ian Bourn, Ian Breakwell,
Marc Camille Chaimowicz, David Critchley,
Catherine Elwes, Roberta Graham, Steve Hawley,
Susan Hiller, Stuart Marshall, Cordelia Swann,
Graham Young

25 November 2010 — 6 February 2011
Hilary Lloyd

Nottingham Contemporary

Weekday Cross
Nottingham
NG1 2GB
t: 0115 948 9750

www.nottinghamcontemporary.org

Open Tue – Sun. Free entry.

London to Nottingham in less than
2 hours from St.Pancras.

British Art Show 7
In The Days of The Comet
23 October – 9 January 2011

New Art Exchange
Nottingham Castle
Nottingham Contemporary

A Haywood Touring Exhibition

Anne Collier
and Jack Goldstein
22 January – 27 March 2011

Logo by Klaus Webber

Supported by
ARTS COUNCIL
ENGLAND

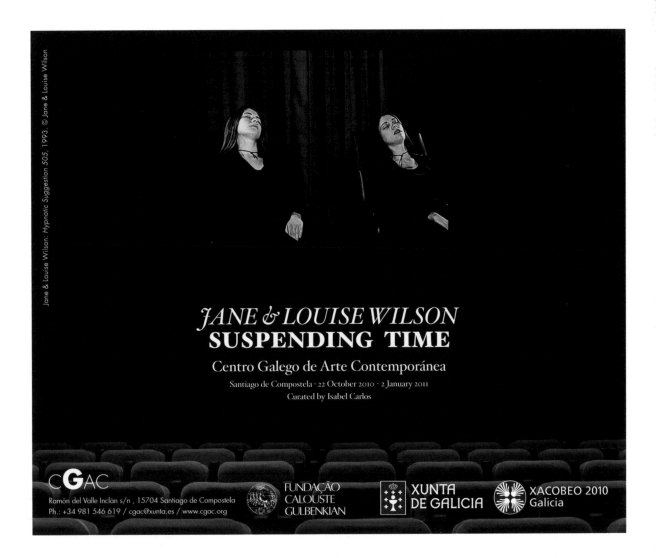

Jane & Louise Wilson: Hypnotic Suggestion 505, 1993. © Jane & Louise Wilson

JANE & LOUISE WILSON
SUSPENDING TIME
Centro Galego de Arte Contemporánea
Santiago de Compostela · 22 October 2010 - 2 January 2011
Curated by Isabel Carlos

CGAC
Ramón del Valle Inclán s/n , 15704 Santiago de Compostela
Ph.: +34 981 546 619 / cgac@xunta.es / www.cgac.org

FUNDAÇÃO
CALOUSTE
GULBENKIAN

XUNTA
DE GALICIA

XACOBEO 2010
Galicia

The new art destination

contemporary
porary
ISTANBUL
'10

25 - 28 November 2010
Istanbul Convention and
Exhibition Center
www.contemporaryistanbul.com

Badischer Kunstverein
Waldstraße 3
D – 76133 Karlsruhe
Germany
T +49 (0)721 28226
F +49 (0)721 29773
E info@badischer-kunstverein.de
www.badischer-kunstverein.de

24 September — 21 November 2010
Stephen Willats — COUNTERCONSCIOUSNESS

7 December 2010 — 9 January 2011
Members' exhibition and Editions

Bonner Kunstverein
Hochstadenring 22
D – 53119 Bonn
Germany
T +49 (0)228 693936
F +49 (0)228 695589
E kontakt@bonner-kunstverein.de
www.bonner-kunstverein.de

18 September 2010 — 31 October 2010
Mathieu Ronsse

19 November 2010 — 30 January 2011
blauorange — Kunstpreis der Deutschen
Volksbanken und Raiffeisenbanken
Klara Liden

Magazin4 — Bregenzer Kunstverein
Bergmannstraße 6
A – 6900 Bregenz
Austria
T +43 (0)557 4410 1511
F +43 (0)557 4410 550
E mail@magazin4.at
www.magazin4.at

4 September — 21 November 2010
Opening: 3 September 2010, 7 pm
Attractive Abstraction in Art and Architecture
Krüger & Pardeller
Pauhof
Public Space With A Roof (Pswar)

4 December 2010 — 20 February 2011
Opening: 3 December 2010, 7 pm
Thomas Moecker

Halle für Kunst e.V.
Reichenbachstraße 2
D – 21355 Lüneburg
Germany
T +49 (0)413 1402001
F +49 (0)413 1721344
E info@halle-fuer-kunst.de
www.halle-fuer-kunst.de

4 September — October 17 2010
Opening: Friday, 3 September 2010, 7 pm
The Absent Forms
Charlotte Moth

20 November 2010 — 16 January 2011
Opening: Friday 19 November 2010, 7 pm
Negative Headroom:
The Broadcast Signal Intrusion Incident
Simon Denny

20 November 2010 — 16 January 2011
Opening: Friday 19 November 2010, 7 pm
CHANNEL TV — A cooperation of cneai=
(Paris, France), KVHBF (Harburg, Germany)
and Halle für Kunst Lüneburg eV as part
of Thermostat

Kunstverein Düsseldorf
Kunstverein für die Rheinlande und Westfalen
Grabbeplatz 4
D — 40213 Düsseldorf
Germany
T +49 (0)211 210 7420
F +49 (0)211 210 74229
E mail@kunstverein-duesseldorf.de
www.kunstverein-duesseldorf.de

11 September 2010 — 16 January 2011
Real Presences. Marcel Broodthaers today
Tacita Dean, Olivier Foulon, Andreas Hofer,
Henrik Olesen, Kirsten Pieroth, Stephen Prina,
Joëlle Tuerlinckx, Susanne M. Winterling,
Cerith Wyn Evans and others

28 August — 17 October 2010
Somber Tones
Jakob Emdal
(Project space)

Kunstverein Nürnberg —
Albrecht Dürer Gesellschaft
Kressengartenstr. 2
D — 90402 Nürnberg
Germany
T +49 (0)911 241562
F +49 (0)911 241563
E mail@kunstvereinnuernberg.de
www.kunstvereinnuernberg.de

9 October — 5 December 2010
Mental Archaeology
Matti Braun, Thea Djordjadze, Jean-Luc Moulène
Cooperation with the Crédac, Ivry,
Co-Curator: Claire Le Restif

9 December 2010 — 6 February 2011
Ausstellung der Jahresgaben 2010

the politics of collecting
the collecting of politics
sep 2010 - jan 2011, eindhoven

vanabbemuseum

INTERNATIONAL PROJECT SPACE

RADIO IPS
20 to 25 September 2010

Monday: Capsule
Tuesday: Pro Choice
Wednesday: The Island
Thursday: Caribic Residency
Friday: Formcontent
Saturday: Longmeg

MORROR
Michaela Eichwald and
Michael Krebber
6 October to
6 November 2010

IPS FILM PROGRAMME
10 November to
17 December 2010

Exodus
curated by David Bussel
10 to 20 November

Crippled Symmetry
curated by Christoph Gallois
24 November to
4 December 2010

Itwan
curated by Jay Sanders
8 to 17 December 2010

International Project Space
School of Art Bournville, Birmingham Institute of Art & Design
Maple Road, Birmingham B30 2AA

Tel. +44 (0)121 331 5763 / www.internationalprojectspace.org
Open Wednesday to Saturday 12 to 5pm, free admission
Supported by Arts Council England and Birmingham City University

ANNA PARKINA

'The ticket is for today'

20 September
to 6 November 2010

The exhibition includes launch events for two new publications: *Biryulevo*, published by Onestar Press, and *Anna Parkina*, published by Focal Point Gallery. The latter book contains texts by Zdenek Felix, Jens Hoffmann, Andrew Hunt and Dmitry Zabavin.

Anja Kirschner and David Panos 'The Empty Plan'
22 November to 1 January 2011

'Anti-Photography' curated by Duncan Wooldridge
17 January to 2 April 2011

Focal Point Gallery
Southend Central Library
Victoria Avenue
Southend-on-Sea SS2 6EX, UK
Tel: +44 (0)1702 534108
www.focalpoint.org.uk

Supported by Arts Council England, Southend-on-Sea Borough Council and Wilkinson Gallery.

Karin Sander
Patina Paintings and Others
Sept. 25, 2010 – Feb. 6, 2011

Museumstrasse 32 | CH-9000 St.Gallen
www.kunstmuseumsg.ch

KUNST MUSEUM ST.GALLEN

art forum berlin

The International Art Show

07.10. – 10.10. 2010

Berlin Exhibition Grounds, Entrance Masurenallee
Messedamm 22, 14055 Berlin, Germany
T. +49 / 30 / 30 38 20 76, F. +49 / 30 / 30 38 20 60
art@messe-berlin.de, www.art-forum-berlin.de

‖‖‖ Messe Berlin

THE NY ART BOOK FAIR
5–7 NOVEMBER 2010

PRINTED MATTER, INC.
PRESENTS THE FIFTH
ANNUAL FAIR OF ART
BOOKS, PERIODICALS
& ZINES AT MoMA PS1
PREVIEW 4 NOVEMBER

www.nyartbookfair.com

Printed Matter, Inc.

Mondriaan Stichting
(Mondriaan Foundation)

Participating Galleries

303 Gallery, New York
Juana de Aizpuru, Madrid
Helga de Alvear, Madrid
Andersen's Contemporary, Copenhagen
Paul Andriesse, Amsterdam
The Approach, London
BaliceHertling, Paris
Laura Bartlett, London
Catherine Bastide, Brussels
Guido W. Baudach, Berlin
Marianne Boesky, New York
Tanya Bonakdar, New York
Bortolami, New York
Isabella Bortolozzi, Berlin
BQ, Berlin
The Breeder, Athens
Broadway 1602, New York
Gavin Brown's enterprise, New York
Daniel Buchholz, Cologne
Cabinet, London
Gisela Capitain, Cologne
Casa Triângulo, Sao Paulo
China Art Objects, Los Angeles
Sadie Coles HQ, London
Contemporary Fine Arts, Berlin
Pilar Corrias, London
Corvi-Mora, London
Sorcha Dallas, Glasgow
Thomas Dane, London
Massimo De Carlo, Milan
Elizabeth Dee, New York
Eigen + Art, Berlin
frank elbaz, Paris
Foksal, Warsaw
Fortes Vilaça, Sao Paulo
Marc Foxx, Los Angeles
Carl Freedman, London
Stephen Friedman, London
Frith Street, London
Gagosian, London
Annet Gelink, Amsterdam
A Gentil Carioca, Rio de Janeiro
Gladstone, New York
Marian Goodman, New York
Greene Naftali, New York
greengrassi, London
Karin Guenther, Hamburg
Jack Hanley, New York
Hauser & Wirth, London
Herald St, London
hiromiyoshii, Tokyo

Hollybush Gardens, London
Hotel, London
Andreas Huber, Vienna
Xavier Hufkens, Brussels
IBID Projects, London
Ingleby, Edinburgh
Taka Ishii, Tokyo
Alison Jacques, London
Martin Janda, Vienna
Juliètte Jongma, Amsterdam
Annely Juda Fine Art, London
Kamm, Berlin
Casey Kaplan, New York
Georg Kargl Fine Arts, Vienna
Magnus Karlsson, Stockholm
Paul Kasmin, New York
Kerlin, Dublin
Anton Kern, New York
Peter Kilchmann, Zurich
Johann König, Berlin
David Kordansky, Los Angeles
Tomio Koyama, Tokyo
Andrew Kreps, New York
Krinzinger, Vienna
Kukje, Seoul
kurimanzutto, Mexico City
Lehmann Maupin, New York
Michael Lett, Auckland
Lisson, London
Long March Space, Beijing
Kate MacGarry, London
Mai 36, Zurich
Giò Marconi, Milan
Matthew Marks, New York
Mary Mary, Glasgow
Meyer Kainer, Vienna
Meyer Riegger, Karlsruhe
Massimo Minini, Brescia
Victoria Miro, London
The Modern Institute, Glasgow
Franco Noero, Turin
Giti Nourbakhsch, Berlin
Lorcan O'Neill, Rome
Office Baroque, Antwerp
Maureen Paley, London
Peres Projects, Berlin
Perrotin, Paris
Friedrich Petzel, New York
Francesca Pia, Zurich
Plan B, Cluj

Gregor Podnar, Berlin
Eva Presenhuber, Zurich
Produzentengalerie, Hamburg
Raster, Warsaw
Raucci/Santamaria, Naples
Almine Rech, Paris
Regina, Moscow
Anthony Reynolds, London
Thaddaeus Ropac, Paris
Sonia Rosso, Turin
Salon 94, New York
Aurel Scheibler, Berlin
Rüdiger Schöttle, Munich
Gabriele Senn, Vienna
Sfeir-Semler, Beirut
Stuart Shave/Modern Art, London
Sies + Höke, Dusseldorf
Filomena Soares, Lisbon
Sommer Contemporary Art, Tel Aviv
Reena Spaulings Fine Art, New York
Sprüth Magers Berlin London, Berlin
Standard (Oslo), Oslo
Diana Stigter, Amsterdam
Luisa Strina, Sao Paulo
T293, Naples
Timothy Taylor, London
Team, New York
Richard Telles, Los Angeles
The Third Line, Dubai
Vermelho, Sao Paulo
Vilma Gold, London
Vitamin Creative Space, Guangzhou
Waddington Galleries, London
Nicolai Wallner, Copenhagen
Barbara Weiss, Berlin
Fons Welters, Amsterdam
Michael Werner, New York
White Cube, London
Max Wigram, London
Wilkinson, London
Christina Wilson, Copenhagen
XL, Moscow
Zeno X, Antwerp
Zero, Milan
David Zwirner, New York

Frame

Altman Siegel, San Francisco
Shannon Ebner
Ancient & Modern, London
Des Hughes
Chert, Berlin Heike Kabisch
Lisa Cooley, New York
Frank Haines
Experimenter, Kolkata
Naeem Mohaiemen
Fonti, Naples
Lorenzo Scotto di Luzio
James Fuentes LLC, New York
Jessica Dickinson
Gaga, Mexico City Adriana Lara
Gentili Apri, Berlin
Daniel Keller and Nik Kosmas (Aids-3D)
François Ghebaly, Los Angeles
Neil Beloufa
Karma International, Zurich
Tobias Madison
Andreiana Mihail, Bucharest
Ion Grigorescu
MOT International, London
Laure Prouvost
Nanzuka Underground, Tokyo
Keiichi Tanaami
Overduin and Kite, Los Angeles
Erika Vogt
Platform China, Beijing Jin Shan
Simon Preston, New York
Carlos Bevilacqua
Renwick, New York
Drew Heitzler
Rodeo, Istanbul
Mark Aerial Waller
Federica Schiavo, Rome
Salvatore Arancio
Micky Schubert, Berlin
Manuela Leinhoss
Seventeen, London Oliver Laric
Sommer & Kohl, Berlin Tony Just
Supportico Lopez, Berlin
Marius Engh
Rob Tufnell, London
Ruth Ewan

Regent's Park, London
14–17 October 2010
www.frieze.com

Tickets available from
+44 (0)871 230 3452
www.seetickets.com

FRIEZE
ART
FAIR

Main sponsor
Deutsche Bank

The Collector's
Guide to New
Art Photography
Vol. 2

Winter 2010/11

HUMBLE hafny.org

GERING & LóPEZ GALLERY

730 FIFTH AVENUE
NEW YORK NY 10019
TEL 646 336 7183
FAX 646 336 7185
WWW.GERINGLOPEZ.COM
INFO@GERINGLOPEZ.COM

 MANIFESTA
JOURNAL
journal of
contemporary
curatorship

Manifesta Journal is an international journal focusing on the
practices and theories of contemporary curatorship. Manifesta
Journal explores and analyzes current developments in curatorial
work, in correspondence with the evolution of the Manifesta
Biennial over the course of the past decade. The main aim of the
journal is to give a stronger voice to an up-and-coming group of
(non-) institutional curators, intellectuals, theorists and critics, and
to function as a platform for the articulation and discussion of their
positions within a pan-European and transcontinental context.

8.

9.

COLLECTIVE
CURATING

HISTORY IN
THE PRESENT

Initiated by:

 manifesta°
Prinsengracht 175 hs
1015 DS Amsterdam
The Netherlands
www.manifesta.org
subscription@manifesta.org
www.manifestajournal.org

UNIA arteypensamiento (artandthinking) is a project organized by the International University of Andalusia with the aim of incorporating the university into the discussion, production, diffusion and consolidation of contemporary creation and thought. arteypensamiento is based on the concept of re/thinking, the relationship between art, culture and society, and as a result aims at re/formulating models, formats, modes of presentation and diffusion

un
i Universidad
Internacional
de Andalucía
A arteypensamiento

www.unia.es/arteypensamiento

ime/Bank is a platform
hrough which groups an
ndividuals in the field c
culture can pool and trad
ime and skills, rathe
han acquire goods an
services through the use
of money.

time/bank

premise that everyone ha
something to contribut
nd can take part i
leveloping an alternativ
economic network tha
connects unmet needs wit

e-flux

untapped resources. Time
Bank is an e-flux project

Afterall Books
One Work

paperback £9.95 / $16.00
cloth £19.95 / $35.00

The *One Work* series is distributed
by The MIT Press:
http://mitpress.mit.edu/afterall

*General Idea:
Imagevirus*
by Gregg Bordowitz
Autumn 2010
5.75 × 8.75in, 136pp

*Dara Birnbaum:
Technology/Transformation:
Wonder Woman*
by T.J. Demos
Autumn 2010
5.75 × 8.75in, 128pp

*Marcel Duchamp:
Étant donnés*
by Julian Jason Haladyn
Spring 2010
5.75 × 8.75in, 120pp

*Richard Long:
A Line Made by Walking*
by Dieter Roelstraete
Spring 2010
5.75 × 8.75in, 96pp

*Sarah Lucas:
Au Naturel*
by Amna Malik
Autumn 2009
5.75 × 8.75in, 112pp

*Michael Snow:
Wavelength*
by Elizabeth Legge
Autumn 2009
5.75 × 8.75in, 104pp

Afterall Books
Readers

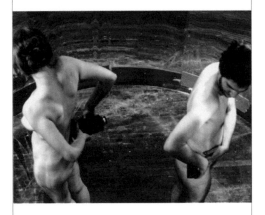

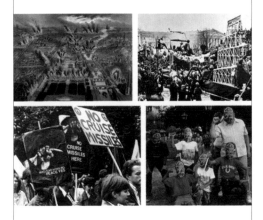

Art and the Moving Image
Edited by Tanya Leighton
Spring 2008
7.9 × 9.75cm, 496pp

Produced by Afterall,
published and distributed
by Tate Publishing:
http://www.tate.org.uk/publishing

Art and Social Change
Edited by Will Bradley and Charles Esche
Autumn 2007
7.9 × 9.75cm, 480pp

Produced by Afterall,
published and distributed
by Tate Publishing:
http://www.tate.org.uk/publishing

Visit our website

www.afterall.org

Afterall would like to thank the following individuals for their generous support:

Tomma Abts, Layla Ali, Pawel Althamer, Hurvin Anderson, Ibon Aranberri, Edgar Arceneaux, Roy Arden, Monika Baer, Fiona Banner, Julie Becker, James Benning, Walead Beshty, Pierre Bismuth, Jennifer Bornstein, Pablo Bronstein, Glenn Brown, Pavel Buchler, Gerard Byrne, John Carson, Mark Camille Chaimowicz, Spartacus Chetwynd, Adam Chodzko, Michael Clark, Phil Collins, Martin Creed, Zoe Crosher, Dexter Dalwood, Enrico David, Tacita Dean, Jeremy Deller, Thomas Demand, Peter Doig, Trisha Donnelly, Sam Durant, Maria Eichhorn, Tim Eitel, Olafur Eliasson, Ceal Floyer, Bill Furlong, Charles Gaines, Ryan Gander, Isa Genzken, Liam Gillick, Douglas Gordon, Antony Gormley, Dan Graham, Rodney Graham, Graham Gussin, Rachel Harrison, Mona Hatoum, Richard Hawkins, Mary Heilmann, Matthew Higgs, Roger Hiorns, Pierre Huyghe, IRWIN, Sanja Iveković, Joan Jonas, Lisa Junghanss, Ilya Kabakov, Emma Kay, Mike Kelley, Janice Kerbel, Jutta Koether, Joseph Kosuth, Surasi Kusolwong, Jim Lambie, David Lamelas, Louise Lawler, Malcolm LeGrice, Judy Linn, Sharon Lockhart, Richard Long, Anne Lydiat, Christina Mackie, David Maljković, Daria Martin, Paul McCarthy, Julie Mehretu, Alan Michael, Jonathan Monk, Sarah Morris, Rosalind Nashashibi, Olaf Nicolai, Nils Norman, Patrick Painter, Maureen Paley, Seb Patane, Toby Paterson, Dan Perjovschi, Manfred Pernice, Marjetica Potrč, Richard Prince, Alessandro Raho, Yvonne Rainer, Tobias Rehberger, Olivier Richon, Daniel Richter, Ed Ruscha, Alex Sainsbury, Anri Sala, Wilhelm Sasnal, Thomas Scheibitz, David Schnell, Maaike Schoorel, Yinka Shonibare MBE, Andreas Slominski, Pete Smithson, Sean Snyder, Nedko Solakov, Frances Stark, Simon Starling, Jemima Stehli, Lily van der Stokker, SUPERFLEX, Anne Tallentire, Wolfgang Tillmans, Hayley Tompkins, Sue Tompkins, Rosemarie Trockel, Chris Wainwright, Jeff Wall, Matthias Weischer, Richard Wentworth, TJ Wilcox, Christopher Williams, Jane and Louise Wilson, Richard Woods, Richard Wright, Cerith Wyn Evans

Afterall Journal
Back Issues

To order back issues, please contact our London office (details overleaf). To subscribe, you can visit the University of Chicago Press website: http://www.journals.uchicago.edu

Afterall Journal
Subscriptions

Individual print and electronic:
£35 / €40 / $48
Institutional print and electronic:
£100 / €120 / $148
Institutional print only:
£80 / €95 / $118
Institutional electronic only:
£60 / €72 / $90

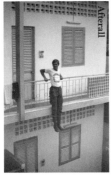
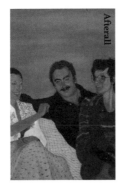
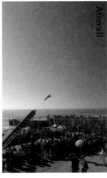
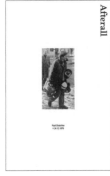

Colophon

Afterall is published by Central Saint Martins College of Art and Design, University of the Arts London in editorial and research partnership with Museum van Hedendaagse Kunst Antwerpen (M HKA) and arteypensamiento, Universidad Internacional de Andalucía (UNIA) and in association with the University of Chicago Press.

In 2007 *Afterall* incorporated *AS* (*Andere Sinema*), a journal previously published by M HKA.

Afterall is funded by Arts Council England.

Printed and bound by Die Keure, Bruges.

Copyright 2010 *Afterall* and the authors. No article may be reproduced or transmitted in any form without the written permission of the editors. The views expressed by the writers are not necessarily those of the editors. Unsolicited material is welcome but will not be returned.

ISBN 978-1-84638-069-3
ISSN 1465-4253

Afterall
Central Saint Martins College
of Art and Design
107—109 Charing Cross Road
London WC2H 0DU
T +44 (0)20 7514 8173
F +44 (0)20 7514 7166
E contact@afterall.org

Editorial

Editors: Nuria Enguita Mayo,
 Pablo Lafuente, Dieter Roelstraete
Managing Editor: Melissa Gronlund
Contributing Editor: Stephanie Smith
Editorial Directors: Charles Esche,
 Mark Lewis
Publishing Director: Caroline Woodley
Editorial Assistant: Bopha Chhay
Intern: Raquel Villar-Pérez

Art Direction and Typography Design

A2/SW/HK: Scott Williams
 and Henrik Kubel

Editorial Board

Will Bradley, Bart De Baere,
Mark Dunhill, Kodwo Eshun,
Elena Filipovic, Jean Fisher,
Eungie Joo, Marta Kuzma,
Dieter Lesage, Jeremy Millar,
Emily Pethick, Tanya Popeau,
Alex Sainsbury, Andreas Spiegl,
Jan Verwoert, Catherine Wood

Advisory Board

Barry Barker, David Bussel, Glen Davis,
Clémentine Deliss, Mark Francis,
Liam Gillick, Cornelia Grassi,
Douglas Gordon, Boris Groys, Oscar Ho,
Stefan Kalmár, Rebecca King Lassman,
James Lingwood, Ute Meta Bauer,
Laura Mulvey, Michael Newman,
Maureen Paley, Julia Peyton-Jones,
Nicholas Serota, Bernhard Starkmann,
Ingrid Swenson, Jeff Wall,
Jack Wendler

Advertising

Advertising Director: Berit Fischer
Advertising Representative
 (US and CAN): Grace Kim
T +44 (0)20 7514 8173
F +44 (0)20 7514 7166
E contact@afterall.org

Visit our website at www.afterall.org

Subscriptions

Individual and institutional subscriptions are available worldwide in both print and electronic formats. Please direct all subscription enquiries, back-issue requests and address changes to:

University of Chicago Press
Journals Division
P.O. Box 37005
Chicago, IL 60637-0005
USA

T +1 877 705 1878 (US and Canada)
T +1 773 753 3347 (International)
F +1 877 705 1879 (US and Canada)
F +1 773 753 0811 (International)
E: subscriptions@press.uchicago.edu
www.journals.uchicago.edu

Distribution

North America:
Disticor Magazine Distribution
Services
695 Westney Road South
Suite 14, Ajax
Ontario L1S 6M9, Canada
T +1 905 619 6565
F +1 905 619 2903
E dkasza@disticor.com

Europe:
Central Books Ltd.
99 Wallis Road
London E9 5LN, UK
T +44 (0)20 8986 4854
F +44 (0)20 8533 5821
E orders@centralbooks.com

Postmaster: send address changes
to University of Chicago Press
P.O. Box 37005
Chicago, IL 60637-0005
USA

Supported by
ARTS COUNCIL ENGLAND